Thames & Hudson

THAMES

PUBLISHED BY THAMES

ISBN 0-500-51134-3

WHY NOT ASSOCIATES

BOOK NUMBER TWO

Cover, intro and divider photographs: Rocco Redondo
Steel fabrication: Campbells Laser Products, Hull
Book design: Why Not Associates

With over 1,500 colour illustrations

First published in the United Kingdom in 2004 by
Thames & Hudson Ltd, 181A High Holborn, London
WC1V 7QX

www.thamesandhudson.com

© 2004 Why Not Associates
Introduction text © 2004 Alice Twemlow

British Library Cataloguing-in-Publication Data
A catalogue record for this book is available from the
British Library

ISBN 0-500-51134-9

Printed and bound in Thailand by Imago

Introduction by Alice Twemlow

'BITE' is spelt out in tubes of white neon light. Receding along multiple lines of perspective are other streaks of typographic information made up of the dots and lines spawned by LED display matrixes and cathode rays. They burn through the darkness with their orange light. Behind them is a background that keeps shifting beyond our reach like the back wall of the Narnian wardrobe.

It is deeply dark but shot with sudden explosions of hot light, colour-saturated with a blown-glass richness, and trails of blurred discs like the reflections of billboard lights on a wet road. The trails disintegrate into delicate filaments, codes of dots and dashes and, finally, hazy vapour. Further still into the distance of this surreal *mise en scène* is the underside of an aeroplane wing searing through eerily moonlit clouds. Despite the bright-coloured verve of this poster for one of The Barbican's International Theatre Events (spring 2000, p. 119), the world barely contained by its edges, like so many of the worlds created by Why Not Associates, is a disturbing and vertiginous one. The extreme dimensionality of the composition plunges you down through layers and slides you sideways across tilted planes; there seems at times little for the viewer to cling to. Regardless of its proximity to chaos, the design has a visual rhythm to it, the subtlest of grids and the confidence born of immaculate typographic craftsmanship, holding image and text in a tense relationship, atmosphere and emotion in measured check.

Thanks to the underlying restraint of this typographic framework, the wild crackles of expressionist light painting that flicker across the work are beautiful rather than merely reckless. There is something about this setting up of rules only to push them to breaking point that suggests quintessentially British sensibilities are at work. Why Not Associates' founders Andy Altmann and David Ellis hail from Warrington and London, respectively, but it is in the combination of their influences that Britishness runs deepest. There you will find the essence of an Eric Gill type specimen, fish and chips on a windy beach, the timing of a one-liner delivered by their beloved comic Tommy Cooper, tea and digestives in front of *Match of the Day* and a first edition of Herbert Spencer's *Pioneers of Modern Typography*.

WNA has clients in every continent, and yet few other British design groups are as rooted in the homeland. At the time when Tomato was publicly declaring its love for New York's skyscrapers and Jonathan Barnbrook was looking towards Japan, WNA was designing stamps for the fortieth anniversary of Queen Elizabeth's accession, working on Tony Blair's election campaign broadcast and creating exhibition graphics for the Department of Trade and Industry. More recently, they have created multimedia exhibitions for two great traders in British iconography, Sir Paul Smith (see p. 28) and Malcolm McLaren (see p. 72), brand identities for two of the nation's controversial but ultimately image-defining art exhibitions, 'Sensation' and 'Apocalypse' (see p. 104), and a typographic environment for a sculpture of the comedian Eric Morecambe in his home town (see p. 64). If there were such a thing as a British graphic-design laureateship, then WNA would be a prime contender for the title.

Poetry is a prevailing current that flows through the work of WNA. In a leaflet for The Poetry Society (see p. 37), text extends out of boxes and reaches to interlace its lines with those across the fold of the page, and quotations about poetry loop and veer as if they have been towed around the page by a

demented bumblebee. In places the text breaks up into beaded strings of repeated letters. The dotted guides and hairline rules of Freehand are in the foreground and behind them thicker rules, in red, black, white and brown, tumble the length of the leaflet like pick-up-sticks. It is a contemporary take on a traditional subject, just as is sandblasting a sixteenth-century curse against sheep rustlers on a polished granite boulder for an underpass in the city of Carlisle (see p. 132), or using the computer to produce letterforms that become the building blocks for a typographic footpath of bird-related poem fragments and song lyrics (see p. 186). Like former poet laureate Ted Hughes, who struck a modern note as a blacksmith of the raw metal of old English, WNA find themselves still connected to the past and to permanence through such things as stone carving, medieval Glaswegian curses and classical typefaces, even whilst dealing in the most contemporary and ephemeral of currencies.

The ability to straddle the two worlds of tradition and new technology has its roots in the unique circumstances of the founders' design education. It was the mid-1980s when Ellis and Altmann were studying graphic design, first at Central Saint Martin's and then at the Royal College of Art in London. It was a transitional moment in terms of design's relationship to technology. 'We were at college setting type in metal while they were wheeling in the first Macs,' Ellis recalls. 'We were among the few at college who wanted to get at the computer and see what it did,' says Altmann, who remembers fondly a particular 'quality' inherent in the early computer, even though at that embryonic stage it filled a whole room and offered only four pixelated fonts.

Almost two decades on, WNA has not tired of experimenting with the potential of new tools. The work contained in this, their second volume, is mature, confident, exhilarating and treads just close enough to the electric fence. The book, conceived, written and designed by WNA, represents a six-year period in which they have moved from their Soho studio to new, more spacious and well-appointed premises near Old Street – 'we have a meeting room; which we never had before,' says Altmann, 'and purpose-built desks with no wires on the floor'. Altmann, with something of the flippancy that led to the group's naming back in 1987, is quick to quash the surmise that massive expansion with a chain of global offices is on the horizon: 'the general functioning of the studio has not changed really. We never started with a plan and we don't have one now. Having never worked for anyone else we have never been sure how you are supposed to run a graphic-design company – we have always made it up as we went along.' A long-time collaborator of WNA, the artist Gordon Young attests to this celebration of ad-hocism, 'when you go into their studio, even today, you could be forgiven for thinking they had only graduated from college six months ago'.

In addition to founding partners Altmann and Ellis, there are four more Associates: designers Patrick Morrissey, Chris Curran and Garvin Hirt and studio manager Malin Wallen. The work of Iain Cadby and Mark Molloy – who have since left the studio to pursue careers in commercial and music video directing in London and Australia, respectively – is also contained in this volume. When Cadby joined the studio he had only completed his MA a year earlier, and for Morrissey and Molloy it was their first job; Cadby explains, 'so you can imagine, there were no rules. Andy said to me, "We don't have a Why Not style, just do what you do, here." I was blown away.'

Business is brisk despite the leanness of the studio and, according to Altmann, is due to the fact that 'the temptation to employ "suits" has never been an option' and that the closest thing they have to a business plan is 'balancing the well-paid jobs against the more interesting, less well-paid ones'. Ellis credits Wallen, the office manager, and Vicky Fraser before her, for organizing the practice. 'They've given us an insight into the practices of larger institutions. Thankfully we have been able to adopt whichever methods suit our way of working and cling on to our naïve ones from the past, which together help to make the company both vibrant and solvent.'

This vibrancy derives in part from the playful dynamics of the studio, which has withstood the move out of Soho. Ellis paints the scene, 'There is always music playing in the office and it's always changing. We all work in one big area together, discussing jobs as they progress. We lunch together around a big table and we talk about our kids, football, films, exhibitions, you name it. People are constantly stopping by to show their work. It's a big melting pot. I think the work clearly reflects that.' Designer Chris Curran, who joined WNA in 2000 and began immediately to work on designing the interactive dashboard instrumentation for a new Lincoln car (see p. 160), notes that 'jobs are always discussed informally as part of larger conversations' and that all the Associates participate in 'a democratic process in which we are not only aware of other people's jobs but we play a part in them too'.

There have been few changes in terms of thought and working practice over the last few years since WNA published their first book; instead, there has been a refinement of graphic tropes and approaches, a concentration of craft skills and an intensification of particular thematic concerns. 'I think a lot of our solutions have become much simpler,' opines Altmann.

For the Royal Academy's 'Apocalypse' exhibition poster and catalogue design (see p. 104), WNA selected a stock-like shot of a perfect couple frolicking in the waves and superimposed on it the exhibition title in a bastardized version of Trade Gothic, in which the counters were filled in black to unsettling, gap-toothed effect. Referring to this project, Altmann says, 'we were not afraid of taking a simple strong idea and applying it in an uncluttered way'. Another example of this hitherto uncharacteristic distillation process is a book WNA made for the artist Antony Gormley that documents the building of his *Angel of the North* in Gateshead. Gormley wanted a simply designed book, so WNA gave him black and red type set in prosaic Interstate, which splayed symmetrically from the book's central gutter to echo the shape of the angel's wings.

When Ellis looks back at some of the early work in the first book, he notices a preoccupation with 'performing graphic gymnastics, especially where there was a lack of content to make up for'. Similarly, Patrick Morrissey, who has been an Associate since 1994, thinks you can trace an evolution from 'typographic flamboyance' that characterized the early days, to a new-found simplicity in recent projects. 'I don't mean we just range Helvetica left and crop an untouched image,' he says, 'but I think we've moved on from the "Why Not style" that we're still sometimes labelled with.'

Simplicity and a down-to-earth attitude reappear at the core of a series of commercials for the telephone banking service First Direct. Director Lucy Blakstad interviewed some regional customers, asking why they liked the service. The designers took phrases from the recordings and underscored the intonations and hesitations of the unscripted speech with typographic treatments that stutter and rush across serene monochrome backdrops. These backdrops depict scenes where a conversation has taken or is about to take place, such as a table with two coffee cups, or a couple of adjacent park benches. With the company's logo as a visual cue, the designers used only Helvetica for the type and black and white for the colour palette. Their television commercial for cricket coverage on BBC Radio Four (see p. 96) similarly relies on the use of typographic vignettes superimposed on abstract cricket-related footage to playfully interpret such snippets of commentators' spiel as 'It looked so plumb' and 'That's cricket'. Even though the cricket trailer, with its use of colour, its wide variety of typefaces, frames, rules and marks, its pulsing light and its bouncing and vibrating typography, gives the appearance of complexity, it is the plainer-looking First Direct spots that necessitated the most intricate editing and animation work that WNA has done to date.

New Mac-based editing technology has certainly had an impact on the designers' working practice. 'Being able to have edit facilities in-house has radically changed the way we can approach motion graphics,' says Ellis. 'After Effects and Final Cut Pro are now so powerful that we can do most things in our own edit suite at our own pace. This means we can experiment and craft things that would not have been possible in a conventional Inferno/Online edit where the clock is ticking away all too quickly.' Morrissey explains, 'After Effects has made us learn completely new skills and makes us consider narrative, movement and pace very differently from when we work in print.' Other new issues have been raised for WNA by the crop of public art projects they have produced in collaboration with artist Gordon Young in such English towns as Morecambe, Plymouth, Penzance and Cheltenham. 'These projects have taken us into new worlds that a graphic designer rarely deals with,' observes Altmann, 'physical space, scale, materials, weather conditions, graphics that may last for a hundred years.'

Dimensionality has always been an important component of the Associates' work, whether through motion and time in their commercials, experimental films and video pieces, or through space in their multimedia compositions, exhibitions and intricate arrangements for print work. It is most evident, however, in the public art projects. *A Flock of Words* (see p. 186) is a three-hundred-metre-long typographic pavement in the seaside town of Morecambe that leads visitors from railway station to seafront and from Genesis to Spike Milligan in its trail of ornithological poetic and lyrical reference. In its scale, impact on the community, gestation period and physical scope, it is about as close to an architectural project as a graphic-design firm can get. Six years in the planning and making, the path combined the skills of an artist, a sculptor and stonemason, steel cutters, stone carvers, quarry workers and engineers, as well as the graphic designers. Gordon Young, the project's lead artist, likens their collaboration to the teamwork involved in film production. 'We have empathy with one another,' he states, citing such shared reference points as artists Ian Hamilton Finlay and Ed Ruscha, typographer Eric Gill and football, of course. 'I think our creativity actually increases in proportion to the number of crafts people we have working on a project,' says Young.

When working with type that people will walk on and around, issues of public use and consumption are paramount. Can a person walk forwards and read backwards at the same time? When wet, are certain materials too slippery to be safe? The project forced WNA to engage fully with the physicality of materials and to think about the qualitative idiosyncrasies of interacting bodily rather than just mentally with typography, not something a graphic-design studio normally has to consider. 'The Why Nots had to get their brains around scale and the qualities of different materials in a way I don't think they'd had to before,' Young says. Consequently, letters set in Gill Sans and Perpetua were made from materials as various as granite, concrete, steel, brass, bronze and glass. 'Some of the materials come into their own when it rains,' says Altmann, 'A grey for example, turns to a deep black.' This work is the logical extension of the studio's mission to respond to what they perceive as people's willingness to get involved with challenging and experimental graphic design.

The very physicality of these materials, the indelibility of the designers' interventions in the fabric of a community and even this book, in its attempt to capture, catalogue and prolong the fleeting life span of design output, inevitably bring up the issue of posterity. Altmann, for example, is ambivalent about the book. He is proud of the studio's work but wonders whether graphic designers should have books made about them at all. Ellis, too, observes, 'There are so many books on graphic design published now that it's almost overwhelming. Sometimes I think it would be better for designers not to look at too much within their own sphere. It's perhaps healthier to look further afield for inspiration.'

It seems as if WNA has stood back and watched with folded arms and wry smiles as journalists and critics over the years have attempted to place their work within this or that camp. When Ellis explains their resistance to any theorizing about their work, his tone is more modest, maybe even awestruck, rather than smug, 'I think there is a bit of magic at a certain stage of the design process. There is a point when all the research, the images in your head and on the page, the restrictions of the brief, the hopes of the client, the conversations in the pub, the ideas discussed, and so on, all kind of come together and you begin to see the solution in your head. I don't want to analyze that too closely. I don't want to turn that into a formula for design. I don't think I could. Equally, I am not really interested in explaining why something feels right. Why a font or a colour or an image is just right, in a certain time, in a certain place. There is an intuition involved and I would rather not rationalize it or theorize it. I don't want to break the spell.'

When Ellis, Altmann and their then partner Howard Greenhalgh graduated from the Royal College of Art and went headfirst into the London graphic-design scene in the late 1980s, they pioneered territory for small young design studios. The ground they broke, however, was not in the arenas of youth culture, music and art; designers such as Vaughan Oliver, Peter Saville and Neville Brody had already done that. The Why Nots stood apart by applying their individual thinking and experimentalism to corporate commissions – they designed elements in the mail-order catalogues for the high-street fashion store Next and created advertising for Smirnoff vodka. At the time, there were few inspirational models for such a practice. Altmann recalls that when they moved into their

first studio on Archer Street in Soho, all they had were three drawing boards, a black-and-white Canon photocopier and a mission: 'We wanted to do mad things on a mass scale'.

To today's graduating designers, WNA and their contemporaries, such as Jonathan Barnbrook and Graphic Thought Facility, are the establishment. Yet, the fact is WNA have continued to innovate and sidestep niches by crossing client and media boundaries with a dexterity and unfailing irreverence that belies their now sanctioned position within the design community. 'In the same day we're working for Lancaster City Council and for Nike and we can switch from doing a postage stamp to three-hundred metres of text to a TV title sequence,' enthuses Altmann. 'For a group of only six people, that's a great range. At the end of the day, they're just graphic-design problems.' Young remarks on the enduring freshness of their work and their avoidance of anything that smacks of formula. 'Perhaps it's because of the public domain work we've been collaborating on,' he offers. 'My role is to be the wicked Uncle Gordon, who comes along from time to time to ruffle their hair and throw a few spanners in the works.'

Another of their wicked tool-throwing relations is Rocco Redondo, the photographer with whom they have worked for sixteen years. He could almost be considered as the seventh member of WNA so frequent are their collaborations. Redondo enjoys the directness of his relationship with the Associates. 'With other design companies, I deal with heads of communications, directors of this or that, or art buyers,' he says, 'With the Why Nots, I talk straight to the designers and work with them from the beginning to the end of a project.' Morrissey thinks, 'the work we've done with Rocco adds a human and random element to our work – it's good going into the studio and creating something spontaneous.' These impromptu photography sessions may involve running around with exploding fireworks (for the exhibition 'powerhouse::uk', see p. 18) or carting neon light sculptures into a forest (for a Virgin Records conference film, see p.100) or, in Curran's words, 'blasting x-rays with Rocco's array of lighting equipment and filming the results on DV' (for *The Trust* title sequence for Channel Four, see p. 168). Redondo believes that 'the trust in each other we've built up over the years means we're willing to try anything, and we're prepared to put the time in to make something wonderful.'

The real reason WNA can extend their reach so variously and still stay so small is because they know how to collaborate. It is a rare art. 'I like people and I like working with people,' says Altmann simply. Eschewing the current vogue for graphic authorship, the group is sceptical of graphic designers who write their own content, believing instead that the potency of graphic design depends on the strength of its message. They choose to collaborate with another specialist practitioner – whether a writer, a photographer like Redondo or an artist who works with stone like Russell Coleman – rather than try to do something for which they are not qualified. 'A lot of people's egos are too big to collaborate,' Altmann remarks.

They regard their enduring clients as collaborators, too. Katherine Jones, head of marketing at the Royal Academy, has enjoyed a long working relationship with WNA that is built on pragmatism and 'free-flowing ideas' in equal measure. 'Their particular genius is their ability to intuit the image that

visually expresses the intention of a show such as 'Sensation' or 'Apocalypse', where we did not want to show the work of any one of the featured artists,' she says. Nigel Butcher of the Rosemary Butcher Dance Company relishes the exchange of ideas and the risks that lead to the creation of publicity announcements for the company's experimental performances. 'WNA easily grasps the conceptual ideas that lie at the core of Rosemary's work,' says Butcher. 'It's got to the point now, I think, where she and Ellis communicate with each other in shorthand.' He cites the 'Scan' invitation (see p. 58) – for which x-ray photography was used to convey a sense of the performance's exploration of the body's hidden inner life, reinforced by the selection of a translucent mailing envelope – as 'the most successful piece of marketing we've ever done'.

The best example of creative dovetailing, however, is found in the studio itself. Several designers, a couple of producers, an office manager, and one of the original founding partners (Greenhalgh, who left in 1993 to pursue a successful career in directing) have passed through the offices. But, the working partnership that Altmann and Ellis have sustained, based on the middle ground between their essential personality differences, is remarkable in its longevity.

Ellis is about economy of means both with his words and his work – 'I tend to design stuff in my head and then put it on paper or screen at the last minute, which makes people a little nervous sometimes' – while Altmann assumes the louder, funny-man role in the double act. Gordon Young sees the strength of the partnership in the combination of 'a dexterous brain and a dexterous eye'. Ex-Associate Cadby says of the partners' working relationship, 'Through collaboration their work took on a vibrant alter-ego of its own. This is what inspired me at the time and why I wanted only to work there. I loved the understanding, beauty and restraint in the use of typography combined with the use of very expressive hand-drawn or ravaged type and image.' Ellis believes that he and Altmann think along similar channels, 'We're both always looking for a new way of telling the story,' he says, 'and that usually means reinventing the wheel for every job we do.'

These talented designers, who, in Morrissey's words, 'have brought in new ideas, new influences, new views as well as just pure hard work,' help to reinvent that wheel and keep it from getting stuck in 'some stylistic rut'. With the support of a working relationship that spans nearly two decades and rigorously articulated typography that keeps all their projects hanging in place, the Associates are free to nurture irreverence, to encourage the fresh input of new design voices, to chase beauty, in Cadby's words, 'to be free to throw things around until they speak to you', to mine all four dimensions of graphic design and to maintain a lightness of touch. This is aptly summed up by a piece of dummy copy used in the layout stages of this book: 'This is some text about the project that could be short or long, funny or serious, true or not. It kind of depends which way the wind is blowing.'

1998

The Department of Trade and Industry organized the exhibition 'Powerhouse::uk', curated by Claire Catterall, to showcase Britain's creative industries. A specially commissioned exhibition hall, comprising four inflatable round pods, was designed by Branson Coates Architecture and was installed on Horseguards Parade in central London.

The plus sign used in the publicity refers to power or electricity and also echoes the shape of the central courtyard between the exhibition pods. To create the effect on page 19, we formed a mould of the plus shape and held a big firework inside it – a method that proved to be pretty scary in the photographer's small studio. The resulting images were then placed against a texture of water to suggest a fizzing, sparkling island of creativity UK.

The layout of the four inflatable pods inspired the use of the double colon in the powerhouse::uk logo. Sadly this and the lack of upper case letters prompted a few school teachers to write and complain about the corruption of their pupils' English education; the cartoonist from *Time Out* simply thought it pretentious.

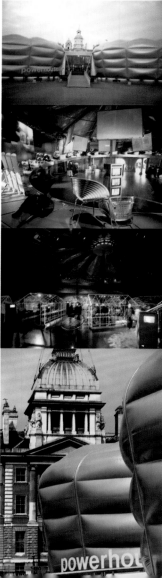

powerhouse::uk

celebrating britain's creativity

experience the energy that makes britain a world leader in design, fashion, technology, engineering and scientific research. dynamic presentations, innovative displays and razor edge graphics make this unique exhibition in a unique location a showcase for british creativity

powerhouse::uk april 4-19, horse guards parade, whitehall, london sw1
advance bookings: 0171 413 1440 (cc 24hrs no booking fee)

10am to 6pm (to 8.00pm april 8 & 15) tickets £3.00. concessions £1.50. bookings in person: site ticket office at horse guards parade (from 9.30am daily during exhibition). a department of trade and industry exhibition

The catalogue had French folds and used four different stocks. Hidden messages and symbols were printed inside the French folds.

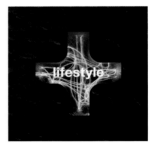

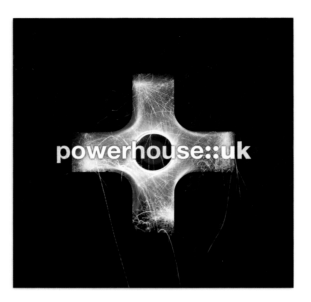

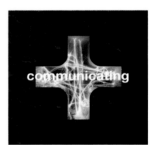

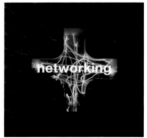

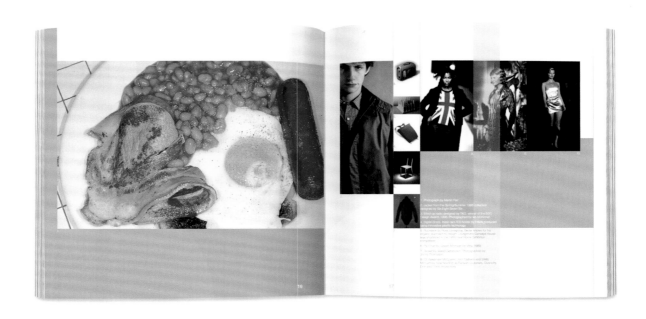

Photographs Martin Parr

1. Jacket from the Spring/Summer 1998 collection designed by Six Eight Seven Six

2. Wind-up radio designed by TKO, winner of the BBC Design Award, 1996. Photographed for the UK Home using innovative plastic technology.

3. Digital Octopus liquid crystal LCD holder by Inflate, produced

4. Illuminated by Nick Crosbie. Peter Marino for his organic approach to design. Longmans Conceptual House was shortlisted in the 1996 Ideal Home Exhibition competition.

5. 'Ply Chair by Jasper Morrison for Vitra, 1989

6. Dress by Hamish Morrow. Photographed by Marcus Tomlinson

7. A collection of UK Fashion, from Galliano and Westwood, new fashion by Hussein Chalayan, Givenchy, Vivienne Westwood and Anna Sui

Photograph by Tim Marshall

'3E.1' all chair by Michael Marriott

Bottle rack by Jasper Morrison

Julian Brown, Attila can crusher

Jug and glasses by Transglass

Julian Brown, Cricket bottle crusher

Vacuum-formed aluminium chair, Ron Arad

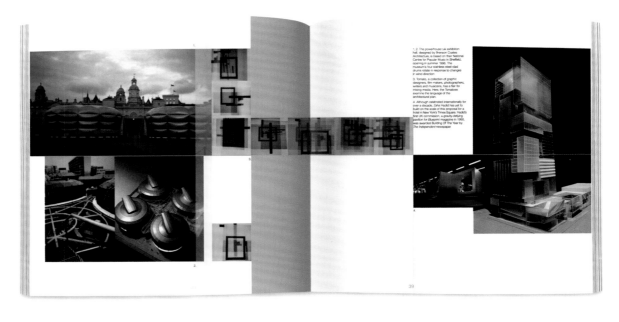

1, 2. The powerhouse::uk exhibition hall, designed by Branson Coates Architecture, is based on their National Centre for Popular Music in Sheffield, opening in summer 1998. The museum's four stainless steel-clad drums rotate in response to changes in wind direction.

3. Tomato, a collection of graphic designers, film-makers, photographers, writers and musicians, has a flair for mixing media. Here, the Tomatoes examine the language of the architectural plan.

4. Although celebrated internationally for over a decade, Zaha Hadid has yet to build on the scale of this proposal for a hotel in New York's Times Square. Hadid's first UK commission, a gravity-defying pavilion for Blueprint magazine in 1995, was awarded Building Of The Year by The Independent newspaper

Created by Antony Gormley, commissioned by Gateshead Council in 1994 and completed in 1998, *The Angel of the North* is Britain's largest permanent sculpture. The book *Making an Angel* charts the development of the project from its inception and includes essays by novelists and historians.

Antony Gormley approached us to design the book, but was at first concerned that our work was a little too off the wall because he was looking for a simple design solution. After a short discussion, however, he felt confident we would produce something that was not only simple but that also had a strong identity to compliment the sculpture.

Gateshead Council and Antony had the foresight to lovingly document the project photographically from the initial meetings through to the finished artwork. As any designer will tell you, having great images to work with makes the task of designing much easier and far more enjoyable!

We used the font Interstate to reflect the industrial processes involved in the angel's manufacture and laid out the text to represent her wings. In the typography, we realized to the full Antony's desire for simplicity, using only black and red and almost 'Janet and John' sized headlines.

At first, the proposed sculpture caused much controversy in the local and national press, but it has now become a much-loved, local icon. Needless to say, there are a few people who will never be happy. One spread in the book contains handwritten comments about the sculpture from local residents, one of which jumped out at us: 'I think it should be taller for the money we spent on it'!

making antony
an gormley
angel gateshead
council

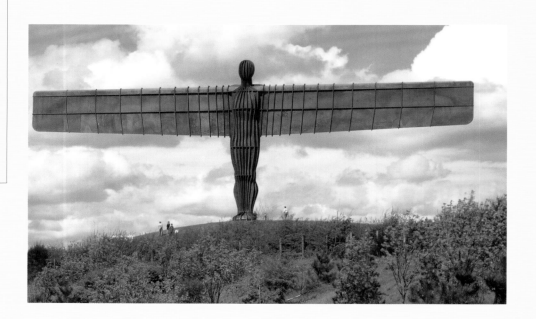

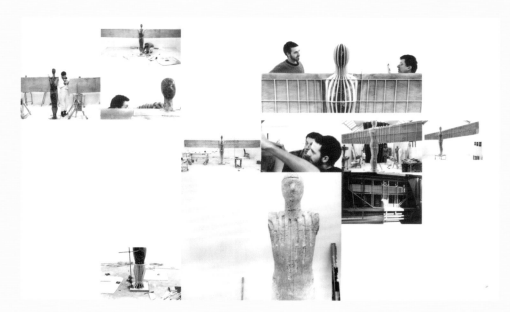

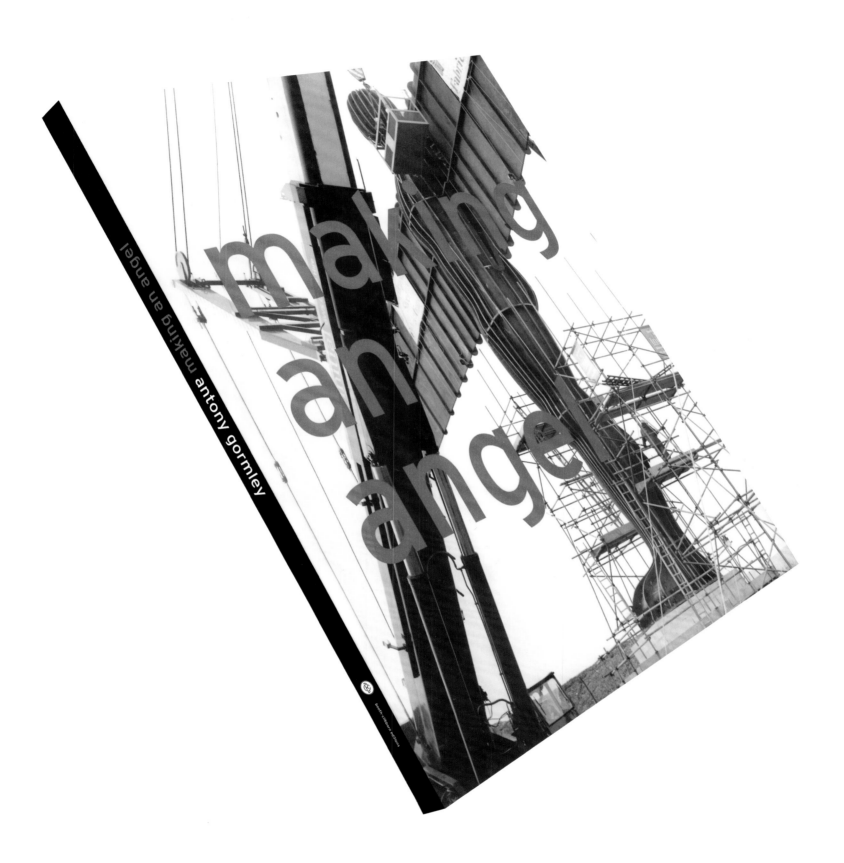

making an angel antony gormley

booth-clibborn editions

STEELWORK HEIGHT 20m
WINGSPAN 54m
WING HEIGHT AT BODY JUNCTION 6.2m
TOTAL WEIGHT 208 TONS
(EACH WING 50 TONS, BODY 108 TONS)
ANKLE CROSS-SECTION 780mm BY 1,400mm
(EQUIVALENT TO AN ORDINARY DOOR IN THE HOUSE)
3,153 PIECES OF STEEL ASSEMBLED
136 BOLTS NEEDED TO ATTACH WINGS TO BODY
(EACH 48mm DIAMETER)
22,000 MAN HOURS SPENT IN FABRICATION
(TWENTY MEN WORKING FULL-TIME FOR SIX MONTHS)
10km OF WELDING IN FABRICATION

DESIGN HORIZONTAL WIND FORCE ON WINGS 70 TONS
(EQUIVALENT TO THE ANGEL BOLTED TO A VERTICAL SURFACE
AND A 35-TON LORRY PARKED ON EACH WING)
450 TONS FORCE IN WING DIAPHRAGMS
1,200 TONS FORCE IN ANKLE RIBS
50 TONS FORCE IN EACH 50mm BOLT
(SO EACH BOLT COULD CARRY A LORRY AND A HALF)
2,500 MAN HOURS SPENT IN ENGINEERING DESIGN AND DRAWING
FOUNDATIONS 5000m³ OF SOIL EXCAVATED
AND LATER REPLACED TO REFORM MOUND
100 TONS OF GROUT PUMPED INTO MINE WORKINGS
UP TO 33m BELOW GROUND
700 TONS OF CONCRETE AND 32 TONS OF REINFORCING STEEL
USED IN FOUNDATION EXTENDING 20m BELOW GROUND
52 BOLTS NEEDED TO HOLD ANGEL UPRIGHT IN WIND
(EACH 50mm DIAMETER AND 3m LONG)

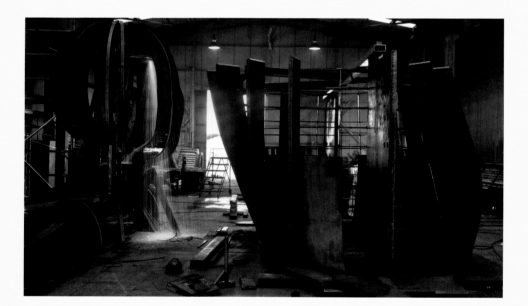

an enlightened icarus
dr stephanie brown

The biggest single sculpture in Britain, made in the closing years not only of the century but of the millennium, Antony Gormley's **Angel of the North** inevitably seems to assume the status of a bold defining moment, a confidently conclusive sculptural statement. On this level it is in a class of its own - though it also relates to a climate of fin de siècle giganticism, evident in the Millennium Dome. The Angel is certainly of its time and cannot escape such associations; but it is also a work that has evolved from an established artist's practice which, in turn, consolidates distinctive strands in late twentieth-century sculpture. Is it possible, then, to view the Angel not as a freakish case for special pleading but as an ambitious and innovative development of Gormley's existing preoccupations, and an instructive pivotal point between modernist and postmodernist sculptural idioms?

The difficulty of comparing this work with other sculptural entities is compounded by its dual identity as figurative sculpture and landmark. Large-scale landmark sculpture of a progressive type is firmly associated with non-figurative, temporary interventions such as Christo's wrapping of existing landmarks and geographical features. Because of its scale, the Angel initially invites comparisons with colossal landmark statuary such as the Rio de Janeiro Christ and the Statue of Liberty rather than with central developments in modern sculpture. The two categories are not mutually exclusive, however, and the former has been used to succinctly illuminate the latter: in 1970 the American sculptor Carl Andre formulated an account of major shifts in twentieth-century sculpture through analogy with changing perceptions of the Statue of Liberty; and this offers a convenient frame within which to discuss the Angel's wider context.

Unveiled in 1886, a present from France to America celebrating both their revolutions, the statue of Liberty **Enlightening the World** was a symbolic personification of an abstract idea. Andre observes that interest was originally focused on the form of this personification and on the way the sculptor Frédéric-Auguste Bartholdi modelled the copper sheets which constituted the outer skin of the statue. Attention then switched to Gustave Eiffel's cast-iron interior structure with its girders and cantilevers; and finally to the place, Bedloe's Island, where the statue was sited. Andre thus proposes the history of twentieth-century sculpture as successively concentrating on form, structure and place. Since 1970, a fourth category, 'socio-cultural space', as opposed to physical locus, has been suggested as completing this metaphorical progression.[1] All these strands are amalgamated in the Angel, and can be loosely applied in relating it to key aspects of sculpture in Britain in the second half of the twentieth century.

The form of the Angel is that of a winged figure, whose fusion of human anatomy with geometric elements links it to sculptures of the 1950s which embodied what Herbert Read termed 'the geometry of fear', expressing art's post-war alienation from technological society. Agitated figure sculptures externalised inner states, mainly anxiety and despair, and sculptors such as Lynn Chadwick and Kenneth Armitage (ill. I), produced hybrid forms fusing the human figure with unwieldy geometric elements - most commonly wing-like extensions. The significance of this was explicit in works entitled Icarus - a subject treated repeatedly by Michael Ayrton - but the Icarian reference was implicit in almost all these works.[2]

The myth of Icarus focused disillusionment with technological progress, which had promised freedom but promoted the terrible efficiencies of Nazi extermination camps and American A-bombs. Icarus was figured as modern man, irrevocably bonded to wings which betray aspiration and accentuate the vulnerability of flesh. Speaking of the Gateshead Angel's direct predecessor, **A Case for an Angel** 1990 (ill. 2), Gormley remarked: 'It isn't a kind of Icarus - you know, little bird feathers.'[3] Yet the wings of the fifties sculptures were not avian but constructed in form, and are formally and thematically closer to Gormley's angels than are the traditional bird-winged angels on funerary and war memorials.

The Gateshead Angel returns to 'the marriage of anatomy and technology', presenting it in optimistic rather than fearful terms.[4] It also echoes the awkwardness of the fifties sculptures, though in a radically different, non-expressive way, and Gormley has stated, 'My version of an angel is a rather uncomfortable mixture between aeronautics and anatomy.'[5] In this sense, the Angel, like all of Gormley's work, can be seen as an attempt to materialise uncertainty', and he draws attention to this in mentioning the 'tension between the angel's slight vulnerability and the toughness of the metal structure that will keep it standing'.[6] Tension is also evident in the use of this particular type of structure both to describe a humanoid form and to ensure that it is rooted to the earth.

In the sixties, steel structures became the most important sculptural idiom - replacing the figure with abstract forms and dispensing with the plinth. Assemblages of steel plates and beams, pioneered by Anthony Caro and his followers from St Martins School of Art, demonstrated the possibility of an almost infinite extension of sculptural form. Caro was anxious to free sculpture of its totemic connotations and to introduce a greater emphasis on the horizontal. The Angel retains the former while stretching the latter to an unprecedented degree, not as a formalist demonstration of sculptural viability, but to maximise the meaning of the work. The result is a clear exposition of Gormley's central idea of a continuum between the body and spirit or consciousness, and between the earthly and heavenly realms. In this relationship the body, no matter how elevated, is finite: terminated by contact with the earth - that is, mortality. Although aspiration and infinity are traditionally represented by verticality, Gormley seems to invert this, using the horizontal

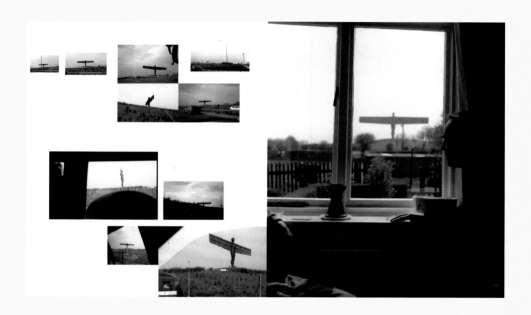

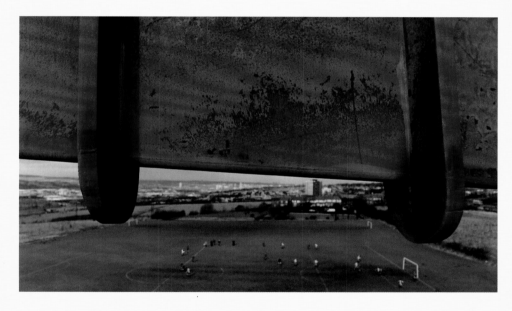

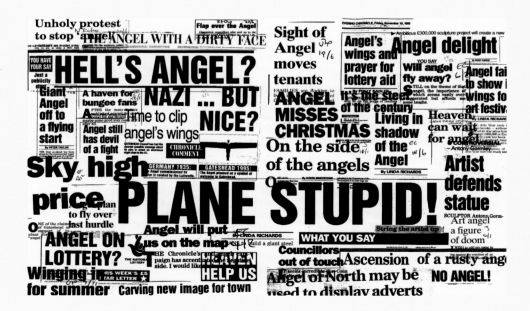

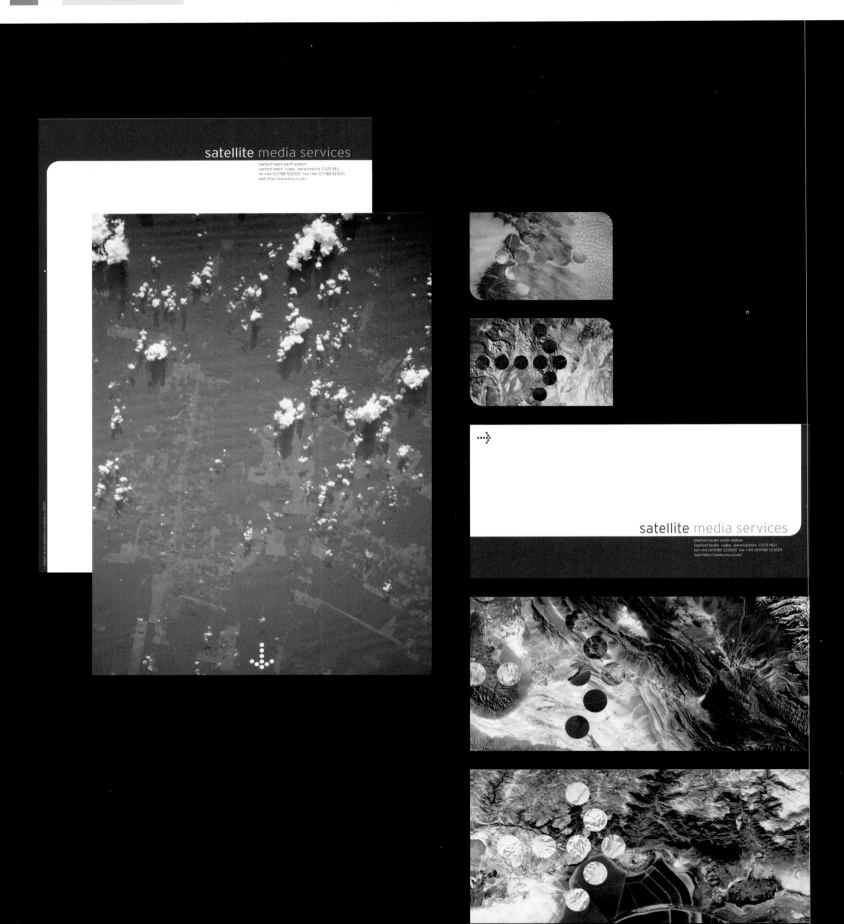

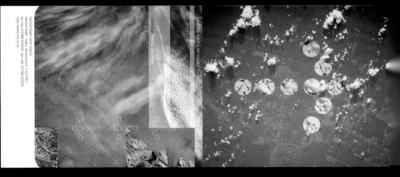

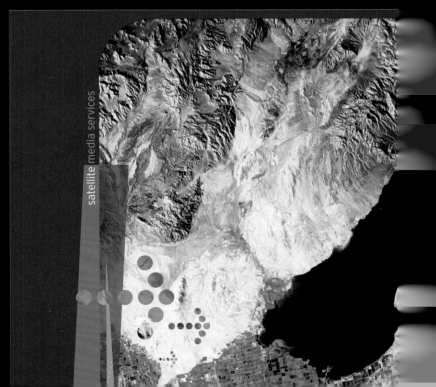

satellite media services

satellite media services

satellite media services

In 1995, Why Not Associates were commissioned by Kobe Fashion Museum
to be the first designers to use the museum's purpose-built audiovisual entrance
facility, comprising twenty-four hidden projectors and descending screens. We
were treated more like artists than designers as the brief was entirely open and
we were invited to do whatever we pleased. The result was 'Synapse', a ten-
minute experience exploring the influences that control the world of fashion
(see *Why Not*, pp. 140–51, Booth-Clibborn Editions, 1998).

In 1998, the museum hosted 'True Brit',
an exhibition on the life and times of British
fashion designer Paul Smith. Alan Aboud,
Paul Smith's art director, was asked by the
museum to produce an audiovisual
installation to accompany the exhibition.
Being a good friend of Why Not and, at
that time, working in the same building,
Alan proposed a collaboration.

We scanned and manipulated thousands
of images to produce an eight-minute
celebration of Paul's work, life and
influences, from baked beans to *haute
couture*. The piece was accompanied by
a soundtrack that featured The Jam,
The Kinks and Noel Coward.

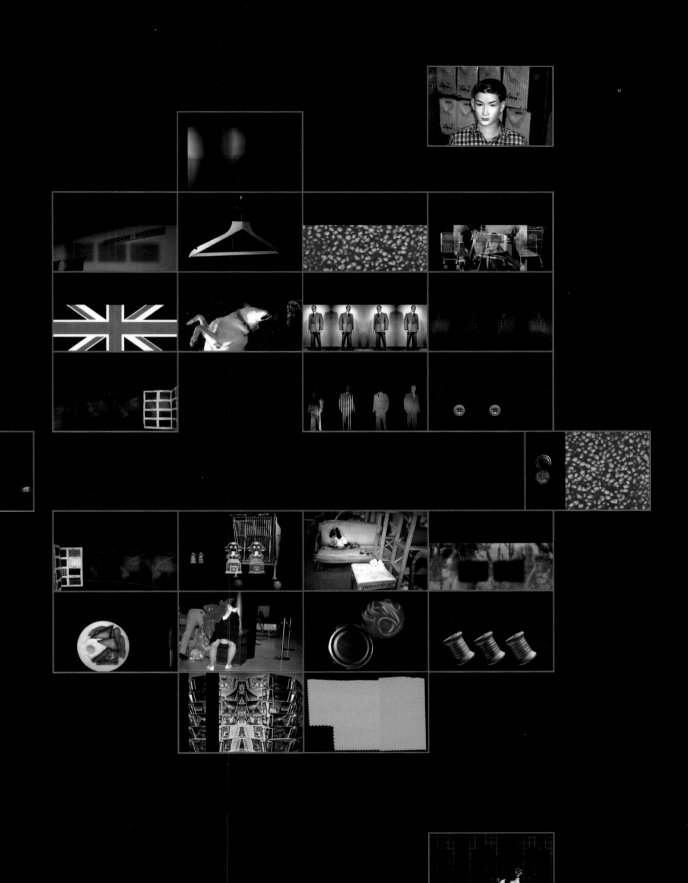

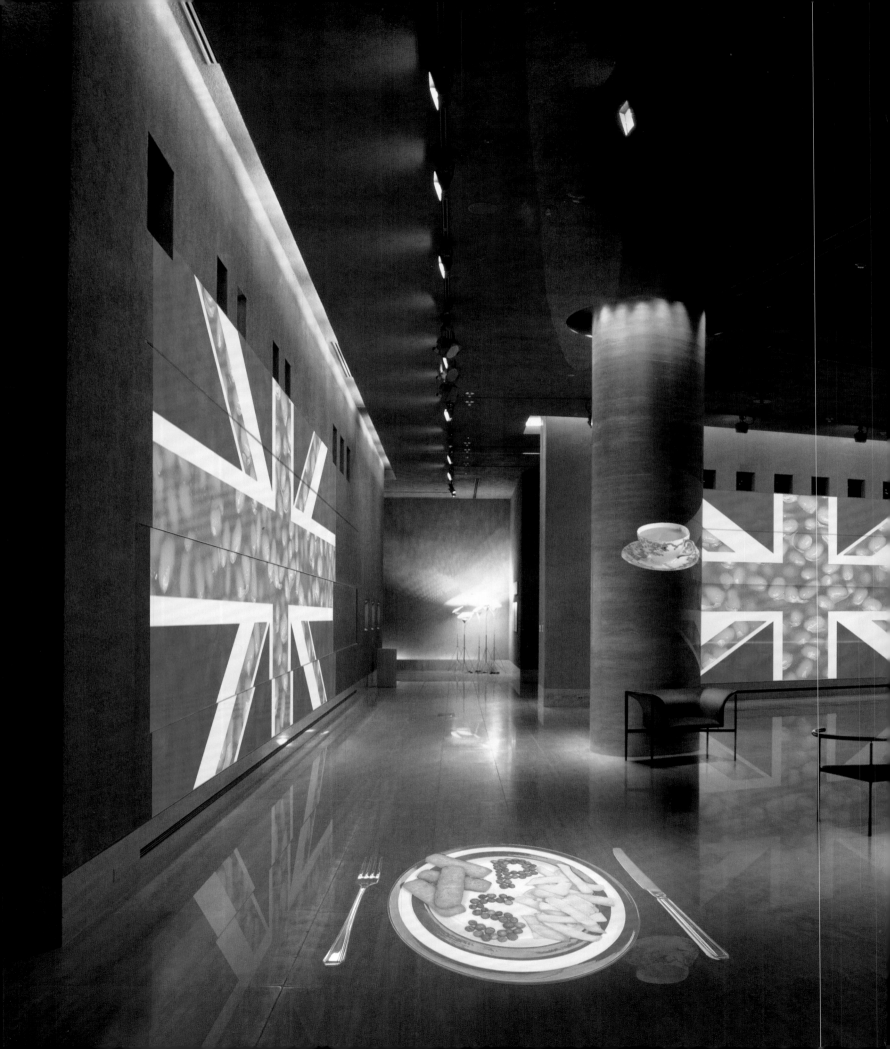

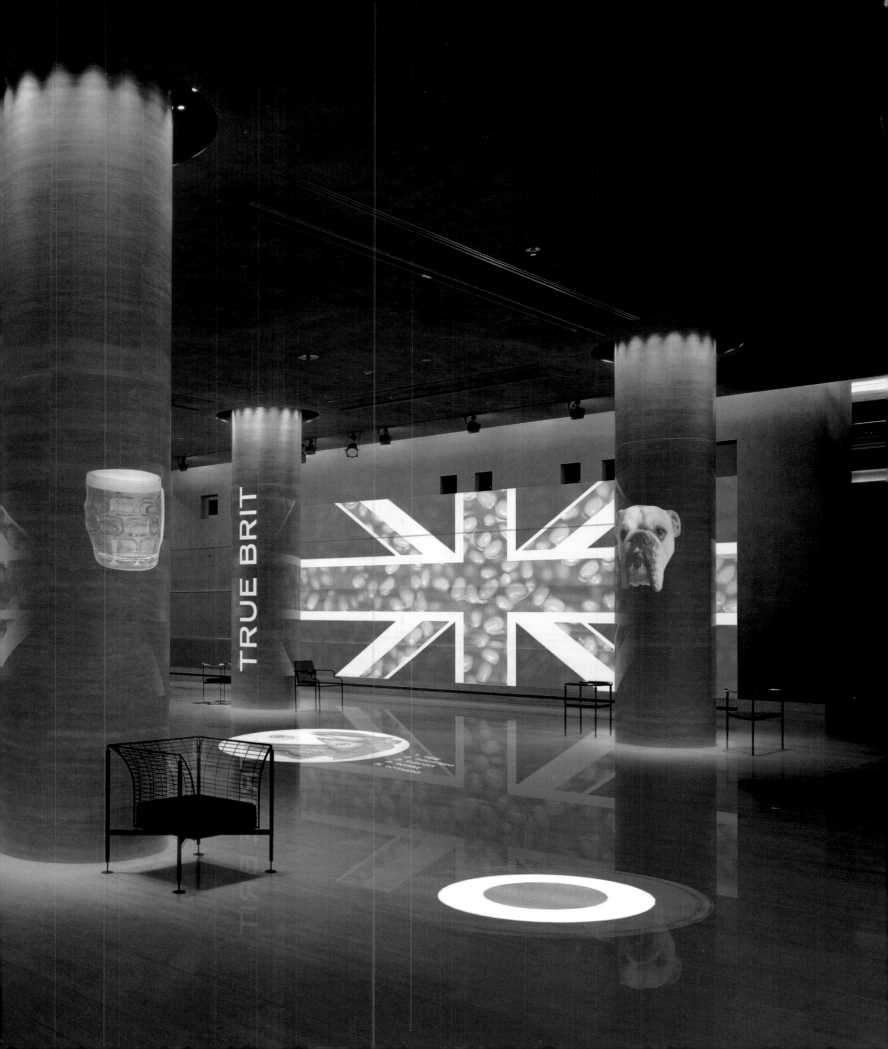

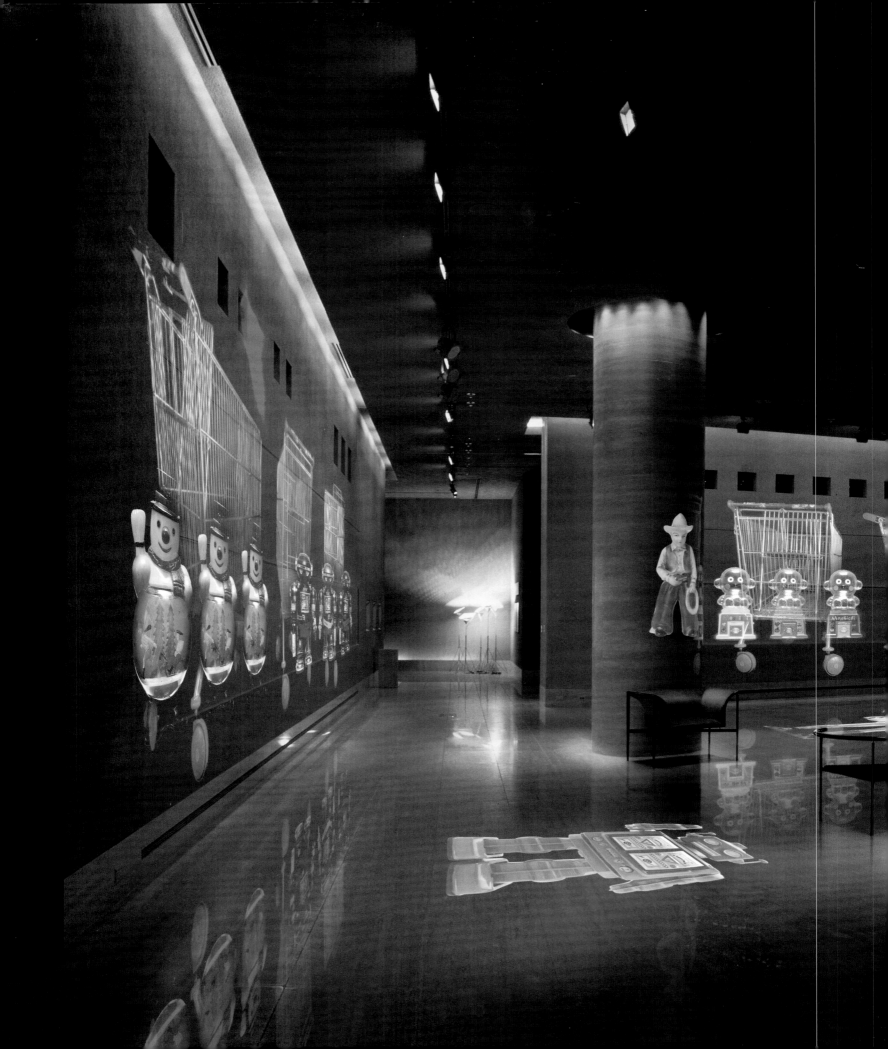

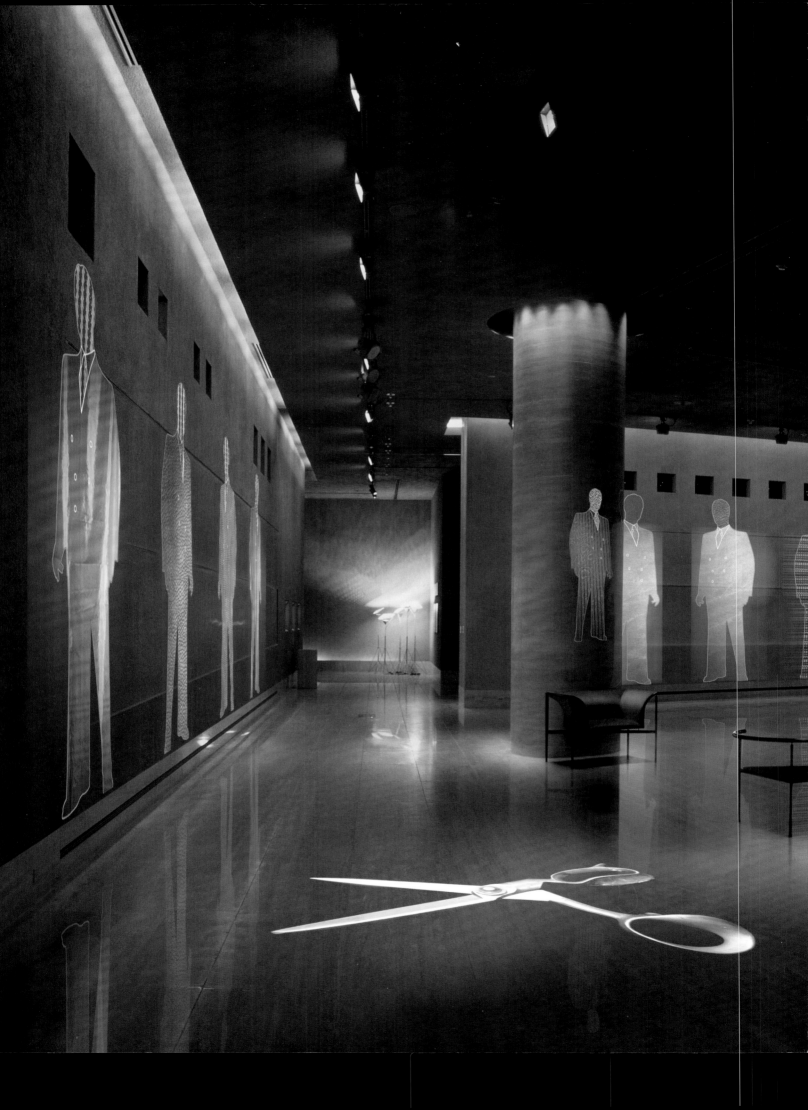

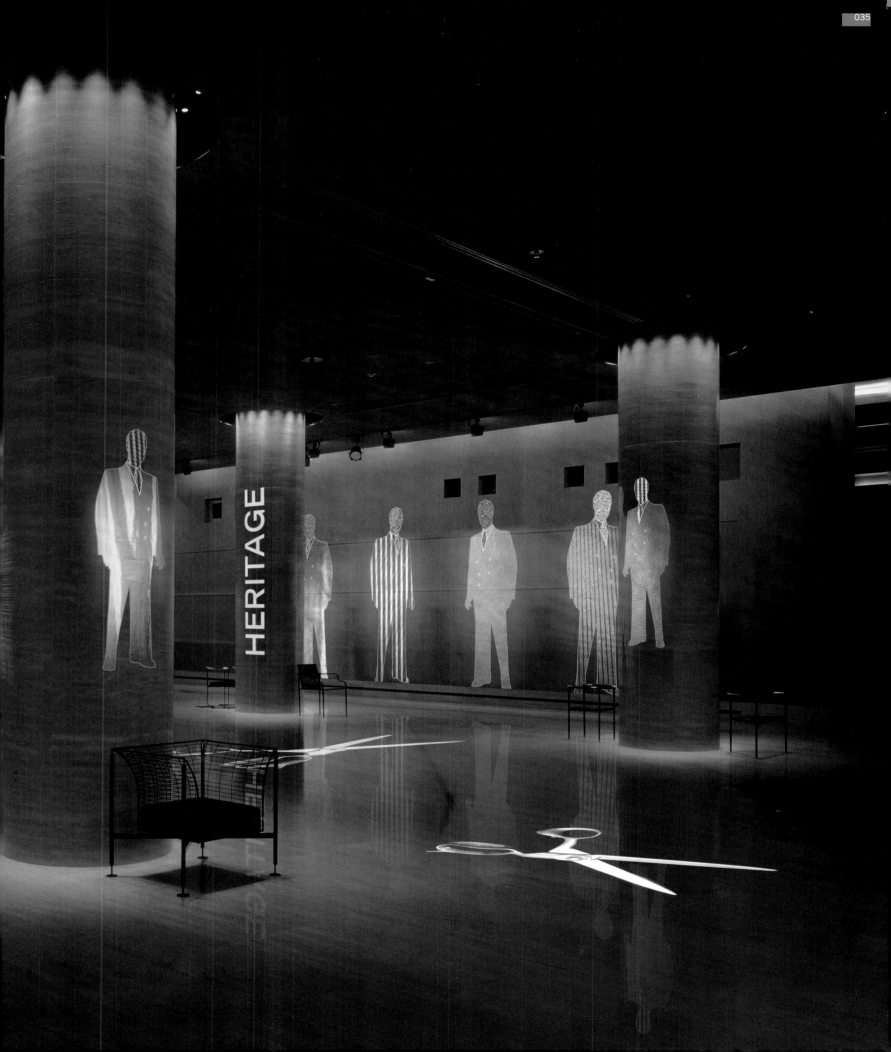

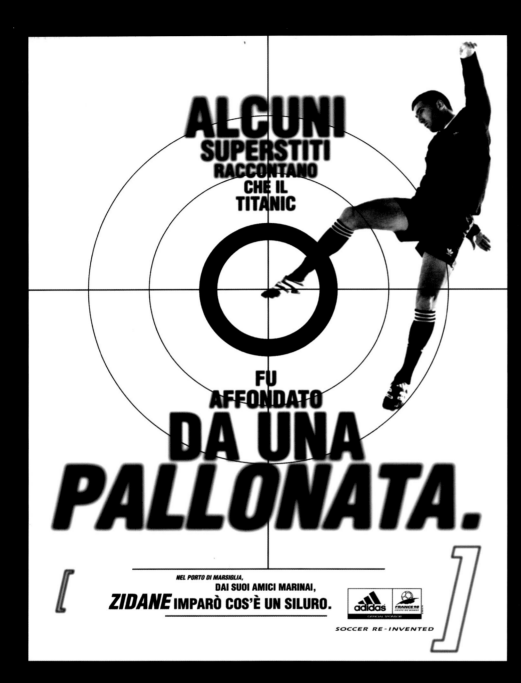

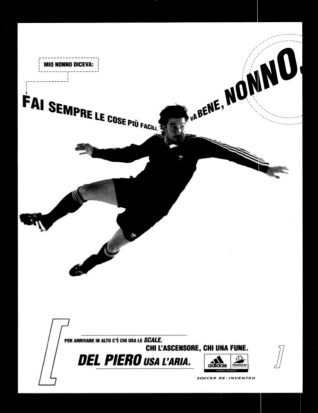

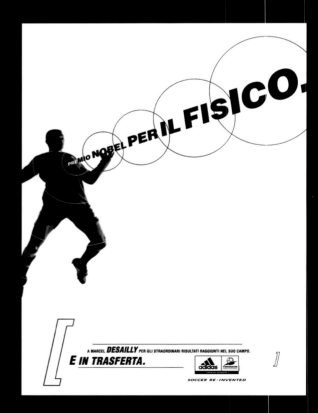

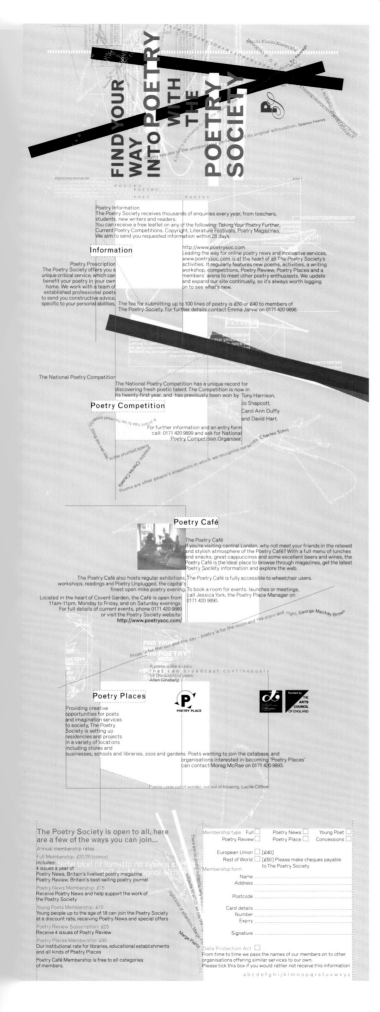
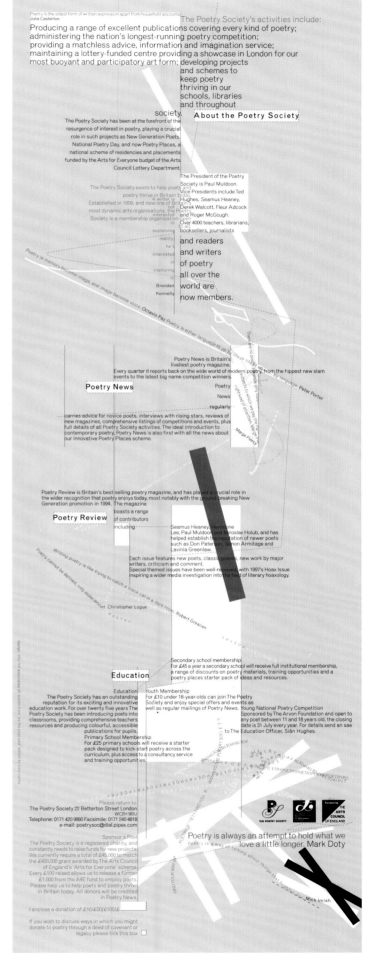

FIND YOUR WAY INTO POETRY WITH THE POETRY SOCIETY

Information

Poetry Information
The Poetry Society receives thousands of enquiries every year, from teachers, students, new writers and readers.
You can receive a free leaflet on any of the following: Taking Your Poetry Further, Current Poetry Competitions, Copyright, Literature Festivals, Poetry Magazines.
We aim to send you requested information within 28 days.

Poetry Prescription
The Poetry Society offers you a unique critical service, which can benefit your poetry in your own home. We work with a team of established professional poets to send you constructive advice, specific to your personal abilities.

The fee for submitting up to 100 lines of poetry is £50 or £40 to members of The Poetry Society. For further details contact Emma Jarvie on 0171 420 9896.

http://www.poetrysoc.com
Leading the way for online poetry news and innovative services, www.poetrysoc.com is at the heart of all The Poetry Society's activities. It regularly features new poems, activities, a writing workshop, competitions, Poetry Review, Poetry Places and a members' arena to meet other poetry enthusiasts. We update and expand our site continually, so it's always worth logging on to see what's new.

Poetry Competition

The National Poetry Competition
The National Poetry Competition has a unique record for discovering fresh poetic talent. The Competition is now in its twenty-first year, and has previously been won by Tony Harrison, Jo Shapcott, Carol Ann Duffy and David Hart.

For further information and an entry form call: 0171 420 9899 and ask for National Poetry Competition Organiser.

Poetry Café

The Poetry Café
If you're visiting central London, why not meet your friends in the relaxed and stylish atmosphere of the Poetry Café? With a full menu of lunches and snacks, great cappuccinos and some excellent beers and wines, the Poetry Café is the ideal place to browse through magazines, get the latest Poetry Society information and explore the web.

The Poetry Café also hosts regular exhibitions, workshops, readings and Poetry Unplugged, the capital's finest open mike poetry evening. The Poetry Café is fully accessible to wheelchair users.

Located in the heart of Covent Garden, the Café is open from 11am-11pm, Monday to Friday, and on Saturday evenings. For full details of current events, phone 0171 420 9880 or visit the Poetry Society website: http://www.poetrysoc.com/

To book a room for events, launches or meetings, call Jessica York, the Poetry Place Manager on 0171 420 9890.

Poetry Places

Providing creative opportunities for poets and imagination services to society, The Poetry Society is setting up residencies and projects in a variety of locations including stores and businesses, schools and libraries, zoos and gardens. Poets wanting to join the database, and organisations interested in becoming 'Poetry Places' can contact Morag McRae on 0171 420 9893.

About the Poetry Society

The Poetry Society's activities include:
Producing a range of excellent publications covering every kind of poetry; administering the nation's longest-running poetry competition; providing a matchless advice, information and imagination service; maintaining a lottery-funded centre providing a showcase in London for our most buoyant and participatory art form; developing projects and schemes to keep poetry thriving in our schools, libraries and throughout society.

The Poetry Society has been at the forefront of the resurgence of interest in poetry, playing a crucial role in such projects as New Generation Poets, National Poetry Day, and now Poetry Places, a national scheme of residencies and placements funded by the Arts for Everyone budget of the Arts Council Lottery Department.

The Poetry Society exists to help poetry thrive in Britain today. Established in 1909, and now one of Britain's most dynamic arts organisations, the Poetry Society is a membership organisation.

The President of the Poetry Society is Paul Muldoon. Vice Presidents include Ted Hughes, Seamus Heaney, Derek Walcott, Fleur Adcock and Roger McGough.

Over 4000 teachers, librarians, booksellers, journalists and readers and writers of poetry all over the world are now members.

Poetry News

Poetry News is Britain's liveliest poetry magazine. Every quarter it reports back on the wide world of modern poetry, from the hippest new slam events to the latest big name competition winners.

Poetry News regularly carries advice for novice poets, interviews with rising stars, reviews of new magazines, comprehensive listings of competitions and events, plus full details of all Poetry Society activities. The ideal introduction to contemporary poetry, Poetry News is also first with all the news about our innovative Poetry Places scheme.

Poetry Review

Poetry Review is Britain's best-selling poetry magazine, and has played a crucial role in the wider recognition that poetry enjoys today, most notably with the ground-breaking New Generation promotion in 1994. The magazine boasts a range of contributors including Seamus Heaney, Hermione Lee, Paul Muldoon and Miroslav Holub, and has helped establish the reputation of newer poets such as Don Paterson, Simon Armitage and Lavinia Greenlaw.

Each issue features new poets, classic poems, new work by major writers, criticism and comment. Special themed issues have been well-received, with 1997's Hoax Issue inspiring a wider media investigation into the field of literary hoaxology.

Education

Education
The Poetry Society has an outstanding reputation for its exciting and innovative education work. For over twenty five years The Poetry Society has been introducing poets into classrooms, providing comprehensive teachers' resources and producing colourful, accessible publications for pupils.

Primary School Membership
For £25 primary schools will receive a starter pack designed to kick-start poetry across the curriculum, plus access to a consultancy service and training opportunities.

Secondary school membership
For £45 a year a secondary school will receive full institutional membership, a range of discounts on poetry materials, training opportunities and a poetry places starter pack of ideas and resources.

Youth Membership
For £10 under 18-year-olds can join The Poetry Society and enjoy special offers and events as well as regular mailings of Poetry News. Young National Poetry Competition Sponsored by The Arvon Foundation and open to any poet between 11 and 18 years old, the closing date is 31 July every year. For details send an sae to The Education Officer, Siân Hughes.

The Poetry Society is open to all, here are a few of the ways you can join...

Annual membership rates

Full Membership: £30/25 (concs)
Includes
4 issues a year of
Poetry News, Britain's liveliest poetry magazine
Poetry Review, Britain's best-selling poetry journal

Poetry News Membership: £15
Receive Poetry News and help support the work of the Poetry Society

Young Poets Membership: £10
Young people up to the age of 18 can join the Poetry Society at a discount rate, receiving Poetry News and special offers

Poetry Review Subscription: £23
Receive 4 issues of Poetry Review

Poetry Places Membership: £45
Our institutional rate for libraries, educational establishments and all kinds of Poetry Places

Poetry Café Membership is free to all categories of members.

Membership type Full ☐ Poetry News ☐ Young Poet ☐
Poetry Review ☐ Poetry Place ☐ Concessions ☐

European Union ☐ [£40]
Rest of World ☐ [£50] Please make cheques payable to The Poetry Society

Membership form
Name
Address

Postcode
Card details
Number
Expiry
Signature

Data Protection Act ☐
From time to time we pass the names of our members on to other organisations offering similar services to our own.
Please tick this box if you would rather not receive this information

abcdefghijklmnopqrstuvwxyz

Please return to:
The Poetry Society 22 Betterton Street London WC2H 9BU
Telephone: 0171 420 9880 Facsimile: 0171 240 4818
e-mail: poetrysoc@dial.pipex.com

Sponsor a Poet
The Poetry Society is a registered charity, and constantly needs to raise funds for new projects. We currently require a total of £45,000 to match the £460,000 grant awarded by The Arts Council of England's 'Arts for Everyone' scheme. Every £100 raised allows us to release a further £1,000 from the A4E fund to employ poets. Please help us to help poets and poetry thrive in Britain today. All donors will be credited in Poetry News.

I enclose a donation of £10/£50/£100/£

If you wish to discuss ways in which you might donate to poetry through a deed of covenant or legacy please tick this box ☐

Poetry is always an attempt to hold what we love a little longer. Mark Doty

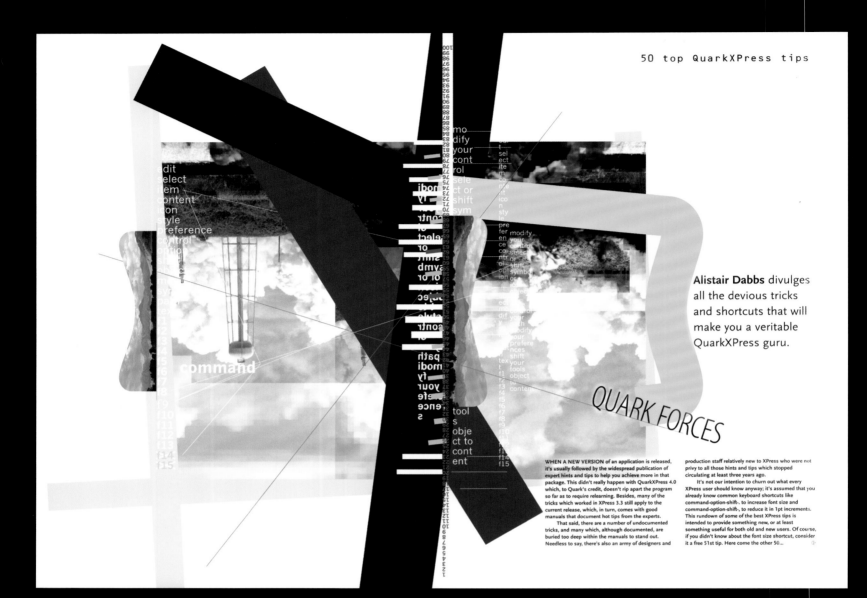

50 top QuarkXPress tips

Alistair Dabbs divulges all the devious tricks and shortcuts that will make you a veritable QuarkXPress guru.

QUARK FORCES

WHEN A NEW VERSION of an application is released, it's usually followed by the widespread publication of expert hints and tips to help you achieve more in that package. This didn't really happen with QuarkXPress 4.0 which, to Quark's credit, doesn't rip apart the program so far as to require relearning. Besides, many of the tricks which worked in XPress 3.3 still apply to the current release, which, in turn, comes with good manuals that document hot tips from the experts.

That said, there are a number of undocumented tricks, and many which, although documented, are buried too deep within the manuals to stand out. Needless to say, there's also an army of designers and production staff relatively new to XPress who were not privy to all those hints and tips which stopped circulating at least three years ago.

It's not our intention to churn out what every XPress user should know anyway; it's assumed that you already know common keyboard shortcuts like command-option-shift-, to increase font size and command-option-shift-, to reduce it in 1pt increments. This rundown of some of the best XPress tips is intended to provide something new, or at least something useful for both old and new users. Of course, if you didn't know about the font size shortcut, consider it a free 51st tip. Here come the other 50...

Mac OS X Server

Apple has made its biggest departure yet from the beloved Mac OS. **Ian Wrigley** has some X-rated details.

ALTHOUGH IT still carries the 'Mac' tag, Apple's latest OS offering is a far cry from its usual system software. Mac OS X Server (the 'X' stands for 'ten') is not, inherently, a Mac OS. In fact, it's a fully-fledged Unix-based operating system with a Mac-style interface and a 'Blue Box' Mac emulator grafted on. Aimed squarely at the server market (specifically at the Web server market), it's also intended to ease the woes of the average network administrator.

So is it a replacement for AppleShare IP 6? Is it as easy to use? Is it better than a Windows NT-based Web server or file server? What about other types of Web server? *MacUser* has had a copy of the software for about a month, and in that time we've configured and used the server, examining it from the perspective of both a Mac user and a system administrator familiar with Unix.

Setting up Although you can buy the server software as a standalone product, most users will get hold of it as

part of a G3 server bundle – especially since the software requires a G3 Mac to run. Apple admits the software will run on certain older Power Macs for now, but make sure it will work with your machine before you buy – OSes are rather more picky about hardware than applications.

We ran OS X Server on a well-configured Apple G3 server with two 9Gb SCSI hard disks, 128Mb of RAM and a decent video card (although, for a server, the video card is pretty irrelevant). The machine was also fitted with a four-port PCI Ethernet card, and a built-in 10/100Base-T network connection.

Installation should take under half an hour. Anyone who's worked with Unix systems will be amazed at the ease of configuration – but then Apple knows exactly what sort of hardware is going to be present. A step-by-step process, aided by the installation manual (the only printed manual included with Mac OS X Server), means it's hard to get it wrong.

The hard disk or partition you'll be using as your startup volume needs to be reformatted, and for the sake of security and

reviews

www.macuser.co.uk/reviews.html

Hardware

INKJET PRINTERS
25 **Canon S9000**

TV TUNERS
33 **Eskape Labs MyTV2Go**

DIGITAL CAMERAS
28 **Kodak EasyShare DX4900 Zoom**

SOFTWARE RIP
26 **PowerRIP 2000 Professional 6.0**

Software

GRAPHICS
31 **Expression 2.4.1**

WEB DESIGN
21 **Freeway 3.5**

WEB DESIGN
32 **GoLive 6.0**

FIREWALLS
24 **Impasse 1.1**

ASSET MANAGEMENT
29 **Portfolio 6.0**

AUDIO
24 **VoiceMachine**

Freeway 3.5

RATING 🐭🐭🐭🐭🐭

PROS Makes serious, creative Web design easy + Logical design-led approach to production + Actions help programmers be more efficient + Good technical support
CONS HTML import is weak
PRICE £165 (£193.88 inc VAT), download **£150** (£176.25 inc VAT), free upgrade from version 3
MAKER SoftPress Systems
NEEDS Mac OS 9, Power Mac, 10Mb free RAM
HELP Unlimited telephone and email
MAC OS X Native
CALL SoftPress 01993 882588
URL www.softpress.com

WORDS Keith Martin
IMAGE why not associates
www.whynotassociates.com

first UK REVIEW

FREEWAY 3.5 from Softpress could be the hottest Web site software in 2002. While Dreamweaver and GoLive fight for the position of best Web site programming tool, Freeway has won over some creatives as an excellent design-focused Web site tool.

The latest version, Freeway 3.5, runs natively in Mac OS X, is a free update for Freeway 3 users and adds useful new features. It has also lost the reliance on the old GX Graphics extension, which worried potential users. OS X support is a key part of the upgrade, and the Carbonized version handles well. Mac OS 9 users aren't left out, though, as there are exciting feature enhancements. Those with OS 8 must use Freeway 3.1, but at least that version is included on the CD

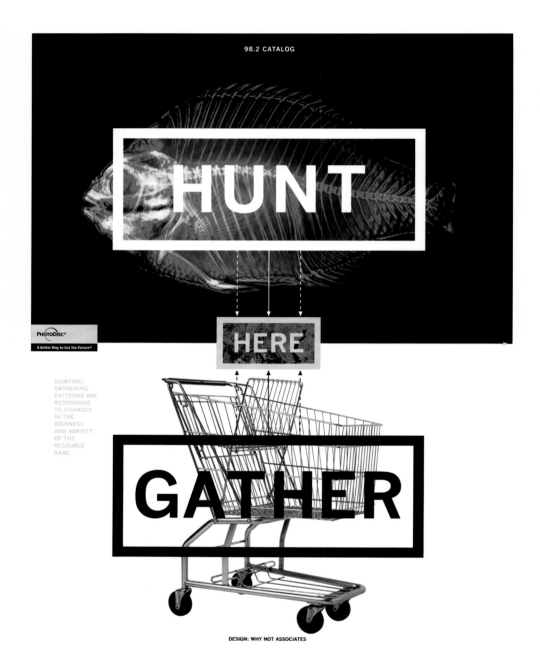

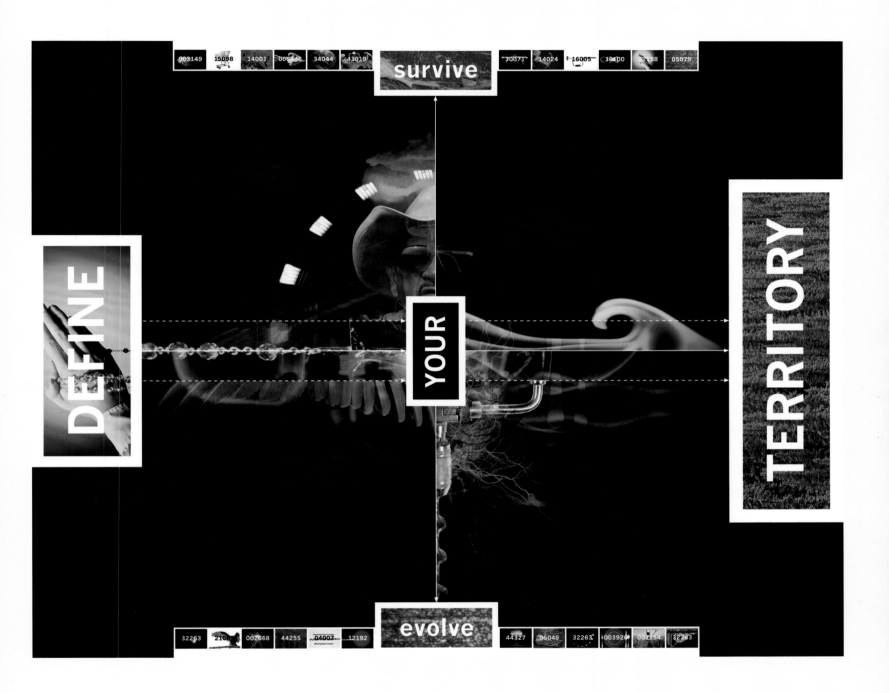

1999

The exhibition 'Voyages of Discovery' charted five significant sea voyages and their consequent discoveries. Through the use of paintings, illustrations, maps and ephemera from the museum's extensive archive, the project traces how these discoveries challenged established views of the natural world.

A mammoth task, this project – to design and apply imagery and information to over one hundred 2.5-x-1.5-metre panels and banners – lasted six months. The exhibition needed to be visually striking to draw people into what could be viewed as a dry subject. A balance was achieved between the historic content and the 'entertainment' angle through the bold use of archive material, resulting in a show that was both engaging and informative. We worked hand in hand with architects Apicella Associates (who joined Pentagram halfway through the project) to create a layered, multifaceted space with angled panels, transparent walls and themed areas. Our deliberate use of transparency and layered images and typography allowed the exhibition itself to become like a voyage through time. The entire exhibition also had to be easy to dismantle and pack into compact travel boxes to ship to museums around the world.

The project offered us the opportunity to go behind the scenes at the Natural History Museum: to see the first sketches of a new land (later named Australia), to meet various insect experts (bearded enthusiasts, dressed in sandals and corduroy, just as you might expect) and to experience the surreal sight of stuffed giraffes covered in bubble wrap!

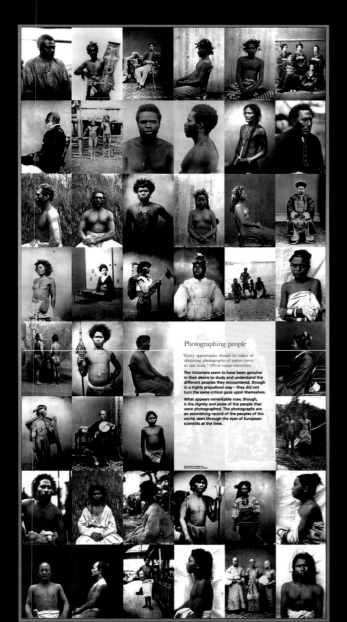

Photographing people

'Every opportunity should be taken of
obtaining photographs of native races
to one scale.' Official voyage instructions

The Victorians seem to have been genuine
in their desire to study and understand the
different peoples they encountered, though
in a highly prejudiced way – they did not
turn the same critical gaze upon themselves.

What appears remarkable now, though,
is the dignity and poise of the people that
were photographed. The photographs are
an astonishing record of the peoples of the
world, seen through the eyes of European
scientists at the time.

Sir Hans Sloane
1660 ~ 1753

Sloane was employed in Jamaica as the
colonial governor's doctor. But he spent
much of his spare time collecting natural
history objects, keeping a meticulous journal
and also employing a local artist to make
accurate visual records.

Sloane's activities were firmly grounded in the
tradition of a 'Cabinet of Curiosities', cases of
natural and man-made objects, in which unusual
and beautiful items were highly prized. However,
this fashionable society pursuit meant more to
Sloane. He wanted to understand his objects,
and believed that careful studies of them would
reveal nature's mysteries.

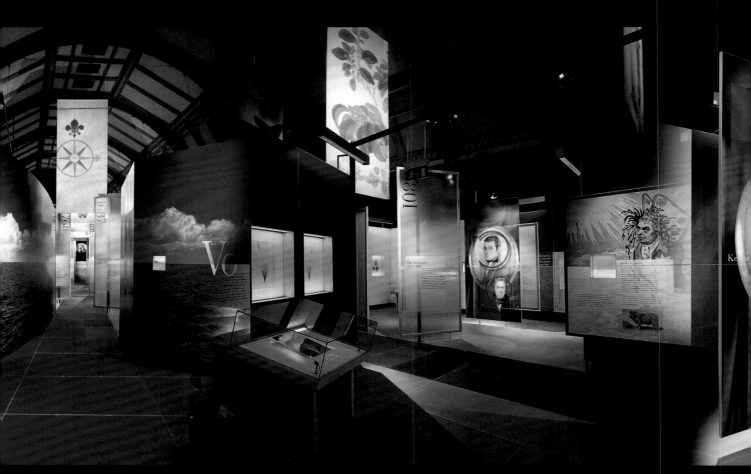

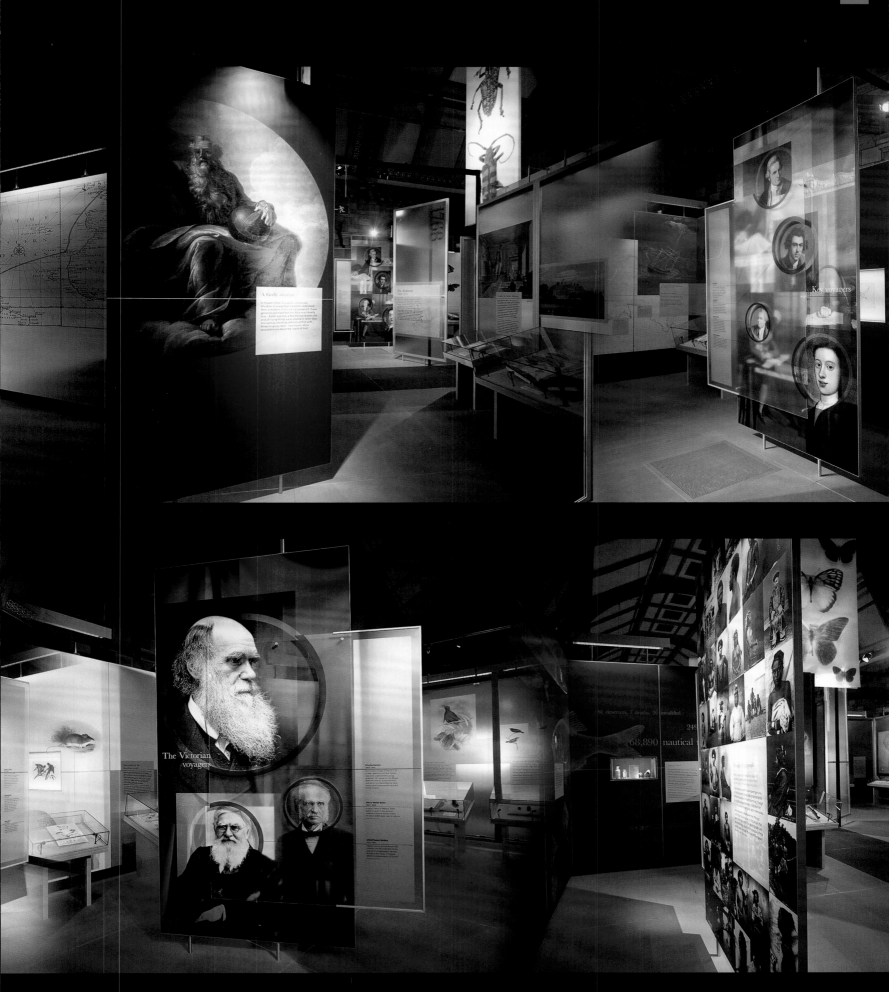

Advertising and brand-building agency Strawberry Frog in Amsterdam asked Why Not to work on the rebranding of one of the most innovative financial institutions in the world: OM. In the company's own words, 'OM is the world's leading provider of transaction technology, offering integrated and cost-efficient IT solutions to markets around the world.'

Many fact-finding seminars and workshops were held with OM, and a picture was established of a forward-thinking, passionate and courageous company. We used this as a springboard to produce an identity system that was uniquely changeable, always developing and very non-corporate. A simple lettering style was created to work with a myriad of icons reflecting the diversity and rebellious nature of OM. Ultimately, and despite our assurances otherwise, the system was deemed too complicated to implement compared with having a single logo. We also suspect that it was too bold and crazy for even a brave company to run with.

Various interesting facts came to light during the market research that precluded the use of certain images as OM icons; for example, in India a picture of raw beef is regarded distastefully as being unclean, the image of an open hand is strongly associated with the Gandhi dynasty and political party and fire often symbolizes right-wing political extremists. For the Chinese, a pear icon would be alarming because the fruit is a pictorial reference to divorce.

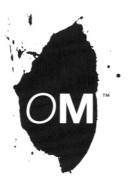

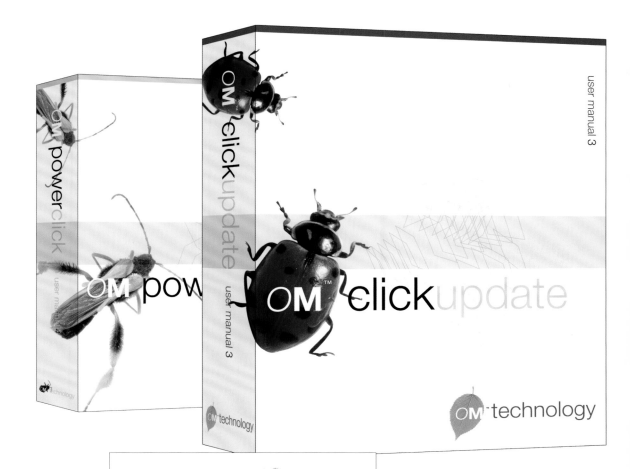

Thomas Ellis
Chairman of the Board

om group

Norrlandsgatan 31 SE–105 78 Stockholm Sweden
tel +46 8 405 66 12 fax +46 8 405 60 01 direct +46 8 405 66 12
http://www.omgroup.com e-mail: t.ellis@omgroup.com

American arts magazine *Plazm* asked Why Not to design a double-sided poster for an issue on identity. From genetics to tribute bands, many aspects of the term were explored. Cloning and the moral issues this raises were very much in the news at the time, so we found inspiration in the text of the original genetics horror story, Mary Shelley's *Frankenstein.*

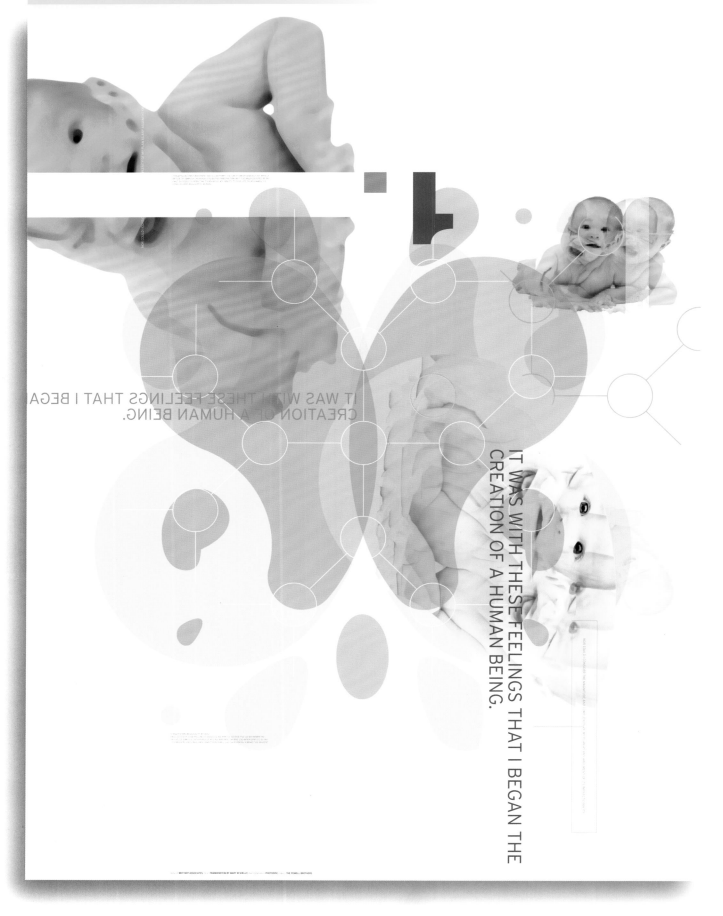

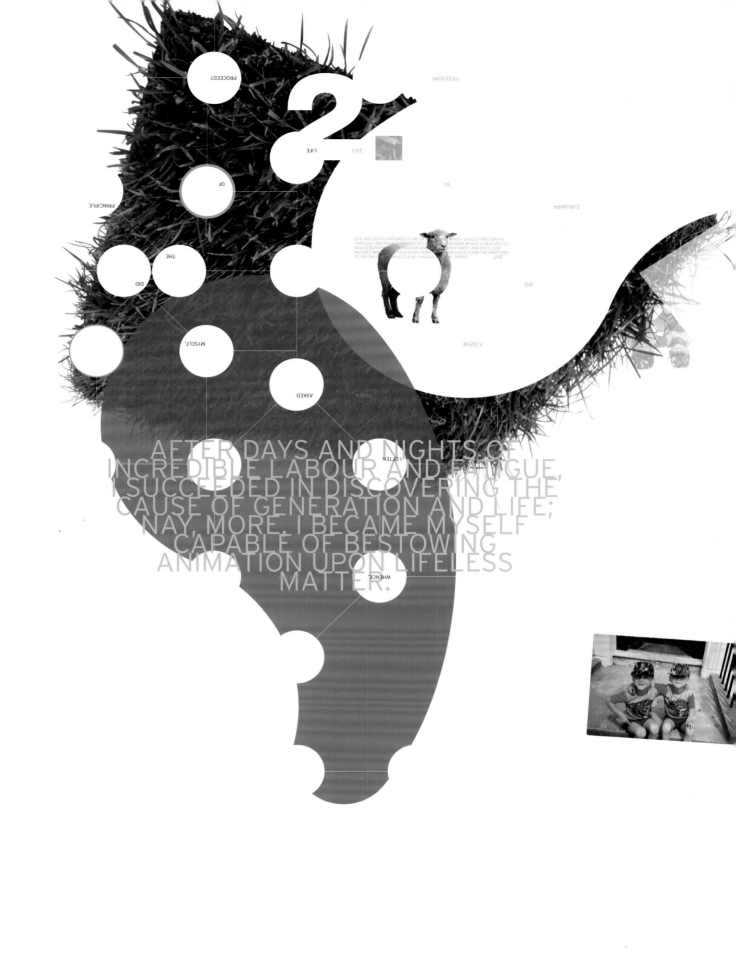

AFTER DAYS AND NIGHTS OF INCREDIBLE LABOUR AND FATIGUE, I SUCCEEDED IN DISCOVERING THE CAUSE OF GENERATION AND LIFE; NAY, MORE, I BECAME MYSELF CAPABLE OF BESTOWING ANIMATION UPON LIFELESS MATTER.

LIFE AND DEATH APPEARED TO ME IDEAL BOUNDS, WHICH I SHOULD FIRST BREAK THROUGH, AND POUR A TORRENT OF LIGHT INTO OUR DARK WORLD. A NEW SPECIES WOULD BLESS ME AS ITS CREATOR AND SOURCE; MANY HAPPY AND EXCELLENT NATURES WOULD OWE THEIR BEING TO ME. NO FATHER COULD CLAIM THE GRATITUDE OF HIS CHILD SO COMPLETELY AS I SHOULD DESERVE THEIRS.

At Gordon Young's request, we became involved in a series of projects that ran along a ten-mile section of the South West Coastal Path, passing through Plymouth on the Devon coast. Gordon's brief was not only to create public art and signage to guide people along the walk but also to inform and intrigue them, while improving the environment.

Code Words (see pp. 52–53). Gordon was inspired by the book *The Nautical Telegraph Code and Postal Guide* by Captain D. H. Bernard, which he found in a local second-hand book shop. When it was published in 1907, one of the few ways to communicate from a boat to the mainland was by telegram, but the longer the message, the more expensive it was. So, Bernard developed the nautical telegraph code, in which a single word conveyed a sentence; for example, 'scrawler' meant 'have today sent cheque payable to father'. It was only possible to decode the words, however, if you had access to the book, which was widely sold in Britain's ports.

We took twenty-four of these words and their meanings and sandblasted them into granite, installing them at various points along the walkway.

Sherlock Holmes (see pp. 54–55). The character of Sherlock Holmes was created by Sir Arthur Conan Doyle, who for a while lived in Durnford Street, Plymouth. The walkway runs down this street, and we decided to cast in bronze various quotes from Sherlock Holmes novels and set them into the existing limestone pavement.

Poem Wall (see p. 56). A local writers' group, Waterfront Writers, and several local poets wrote specifically about the walkway. We used their work to create a wall of poetry by fixing laser-cut steel text to an existing wall.

Millbay Docks Railings (see p. 57). Local hero Admiral John Hawkins (1532–95) served in the British Navy under Sir Francis Drake and frequently sailed out of Plymouth Harbour. In 1564, whilst anchored off Ferrol in north Spain en route to the Gulf of Guinea, he addressed his men thus, 'Serve God daily, love one another, preserve your victuals, beware of fire, and keep good company'. His statement was squeezed onto tubular metal railings that ran along part of the coastal path near Millbay Docks.

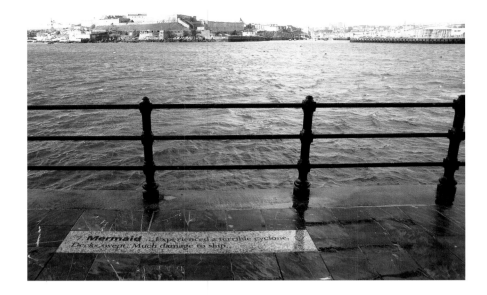

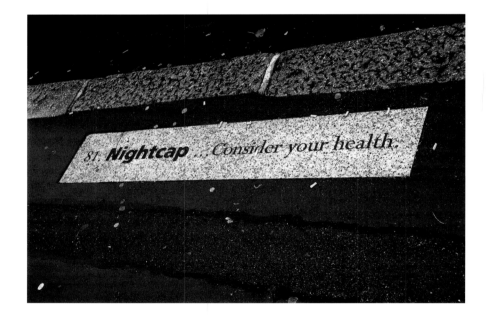

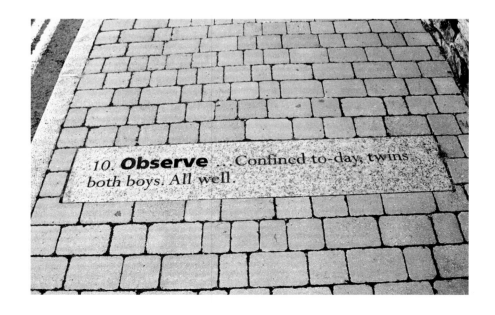

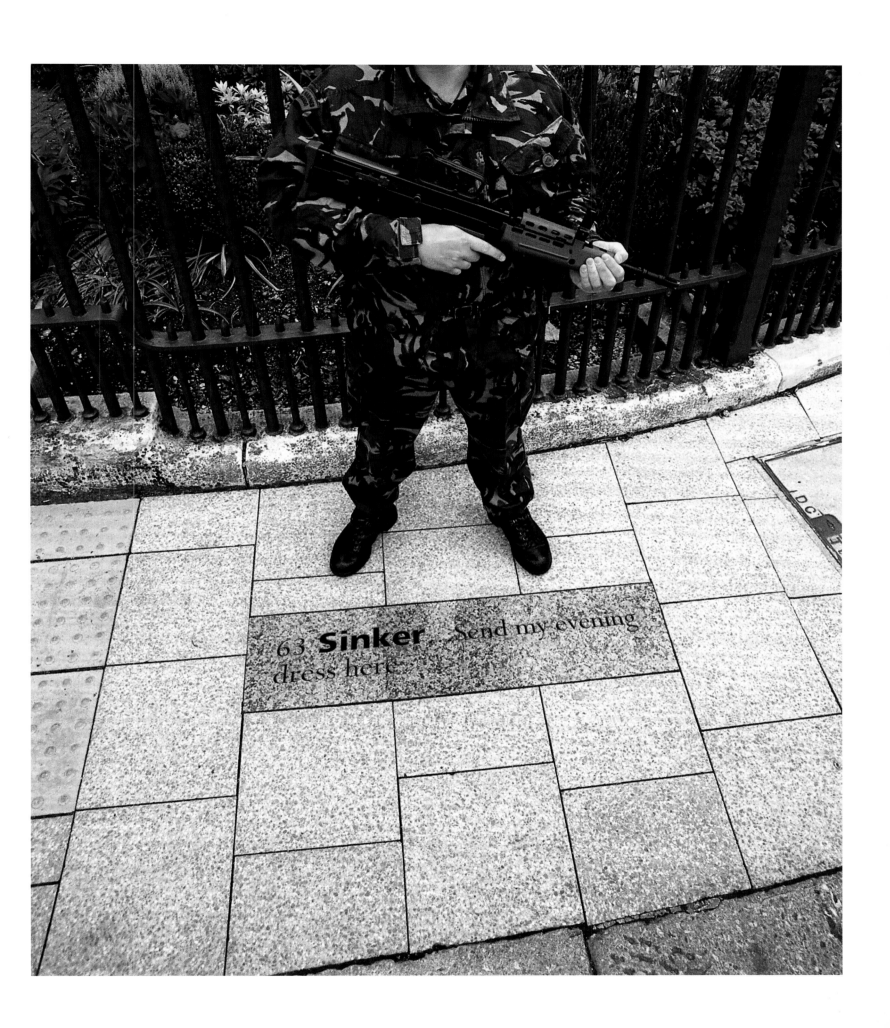

Always look at the hands first, Watson. Then the cuffs, trouser-knees, and boots.

Interesting, though elementary

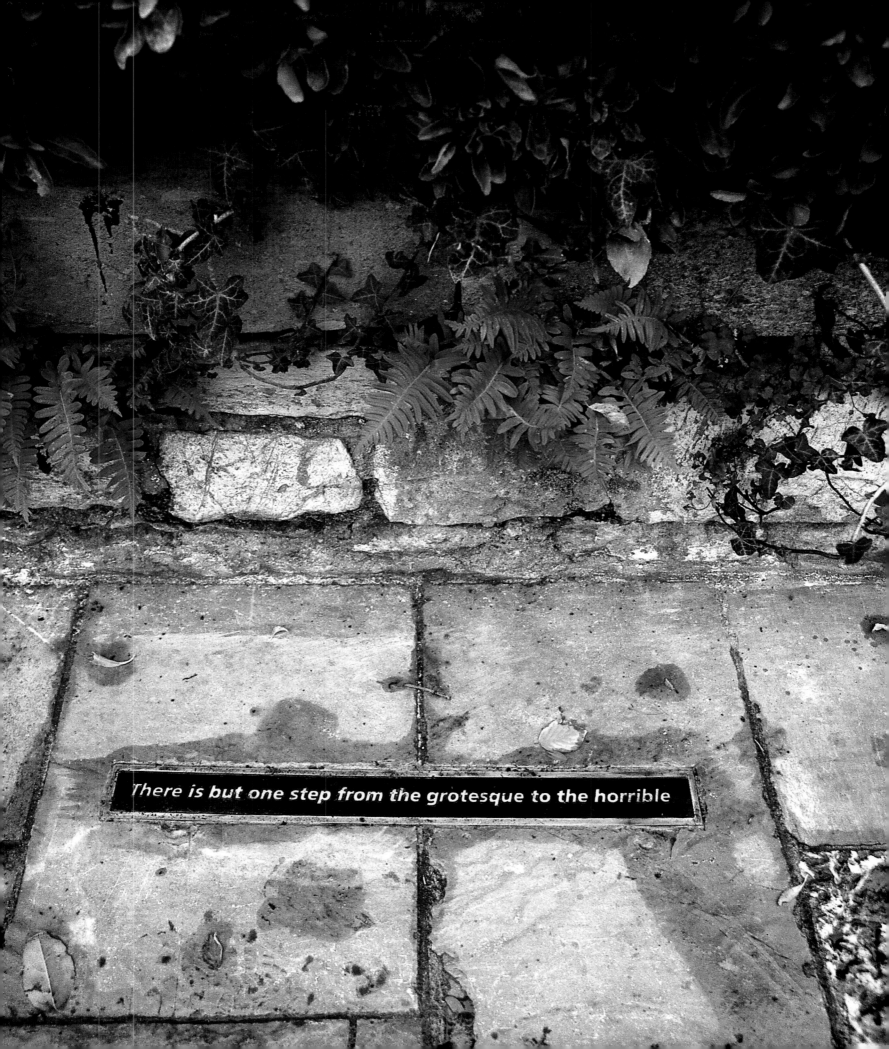

THE WATER LAPS OVER YOUR BARE FEET

SCRAWL
This scrawl on a wall
may enliven your crawl
around a ten mile haul
a literary trawl
to delight and enthral
it's a wayside bookstall

In 1999, the Rosemary Butcher Dance Company premiered a performance called 'Scan'. Our brief was to create a poster and invitation that stood out from typical dance-promotion material. We took as our starting point the performance's theme of light dissecting the human body, using x-ray photography to create something textural and engaging. We went on to print the invitation on transparent plastic to further the impression of a miniature x-ray.

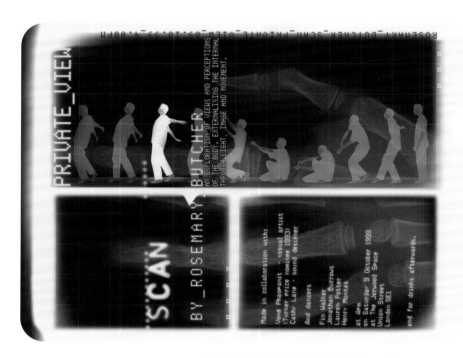

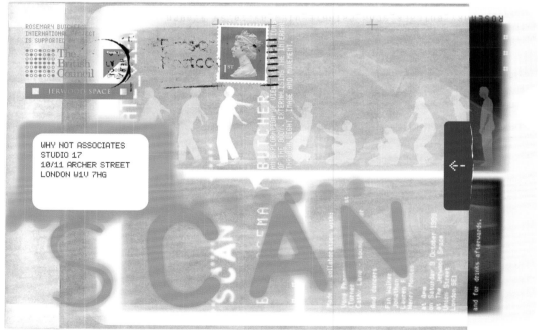

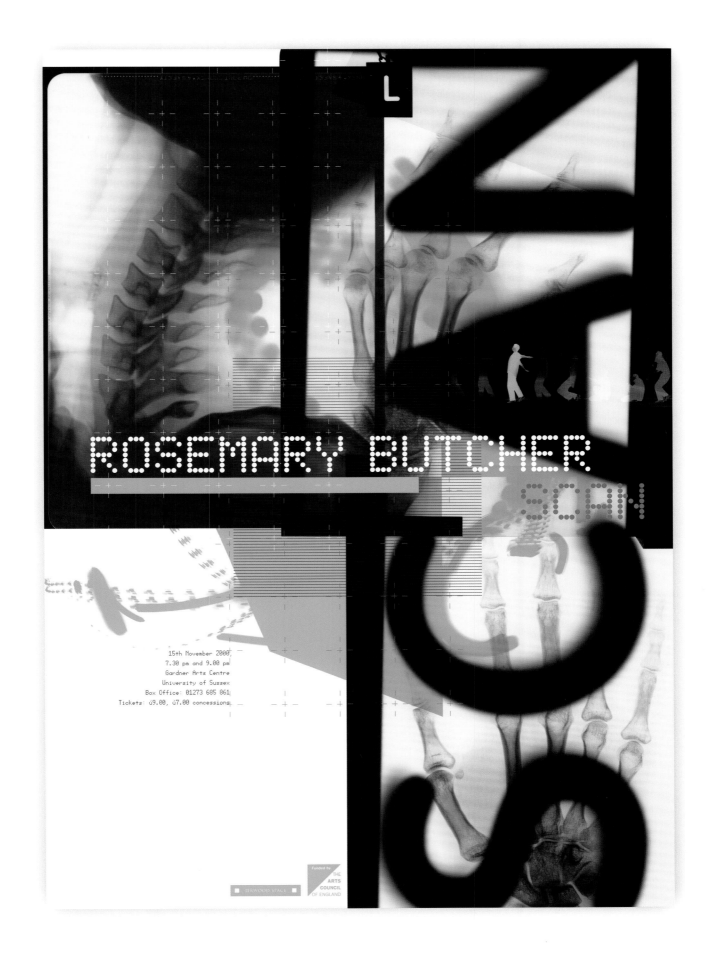

ROSEMARY BUTCHER

SCAN

15th November 2000,
7.30 pm and 9.00 pm
Gardner Arts Centre
University of Sussex
Box Office: 01273 685 861
Tickets: £9.00, £7.00 concessions

Funded by
THE
ARTS
COUNCIL
OF ENGLAND

JERWOOD SPACE

Every year, Virgin (like most record companies) hosts a lavish conference at which they present a new product to their world markets, for example, a new band or a new album, and they also give an overview of how well certain bands and areas of the company are doing. Producer Caroline True, had seen the work we did for *Shots* magazine (see *Why Not*, pp. 196–201), and commissioned us to produce a thirty-minute film presentation. We animated texts from unscripted interviews with such Virgin artists as George Michael, David Bowie and The Smashing Pumpkins and overlaid them on unlikely yet mesmerizing time-lapse footage. The titles are shown here.

george michael

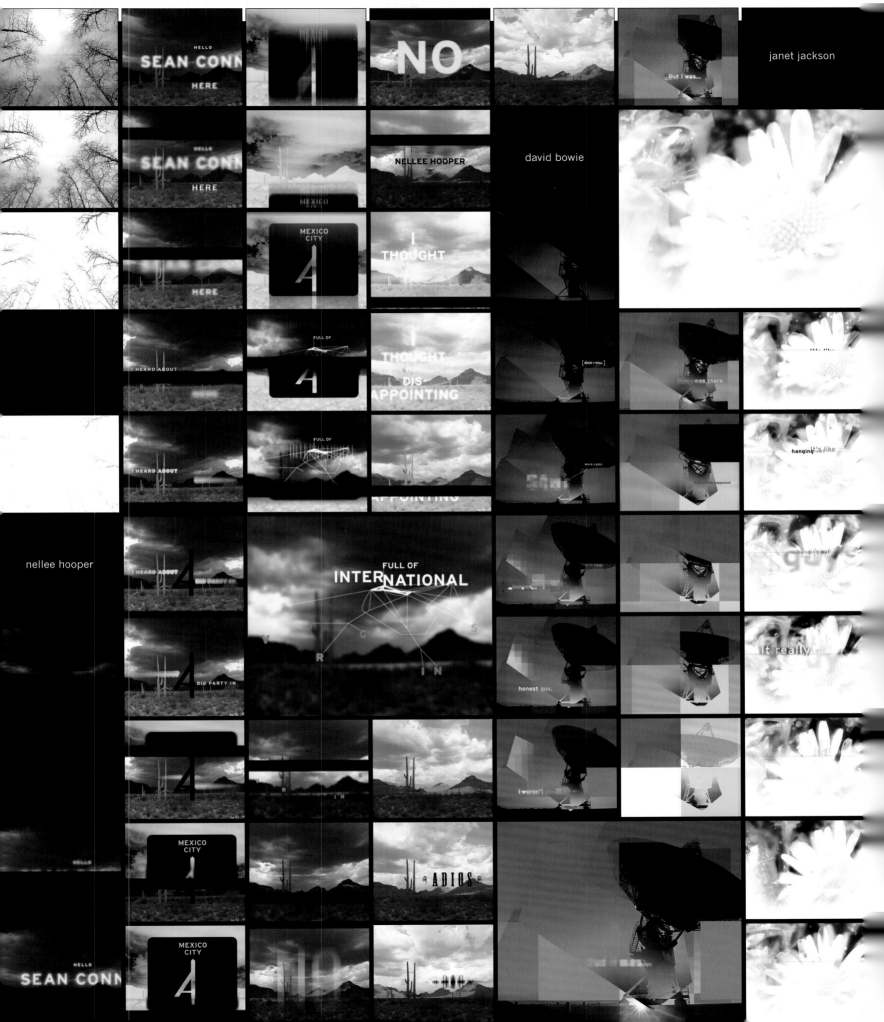

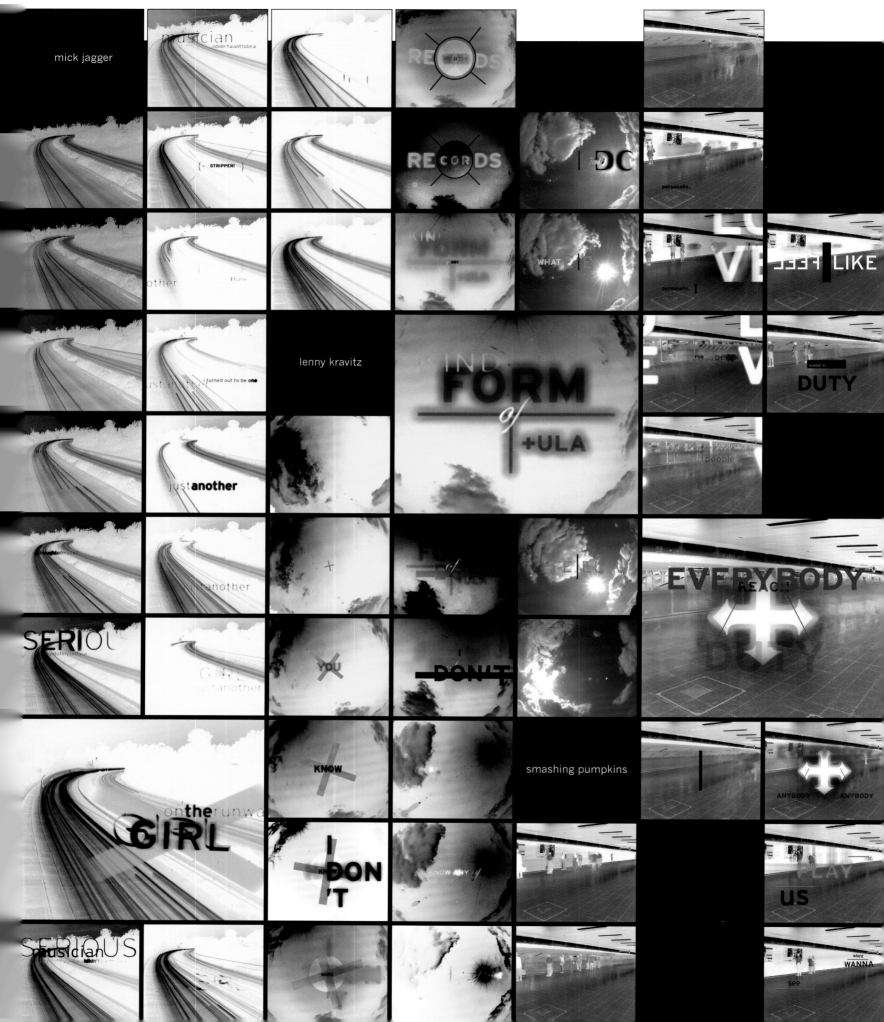

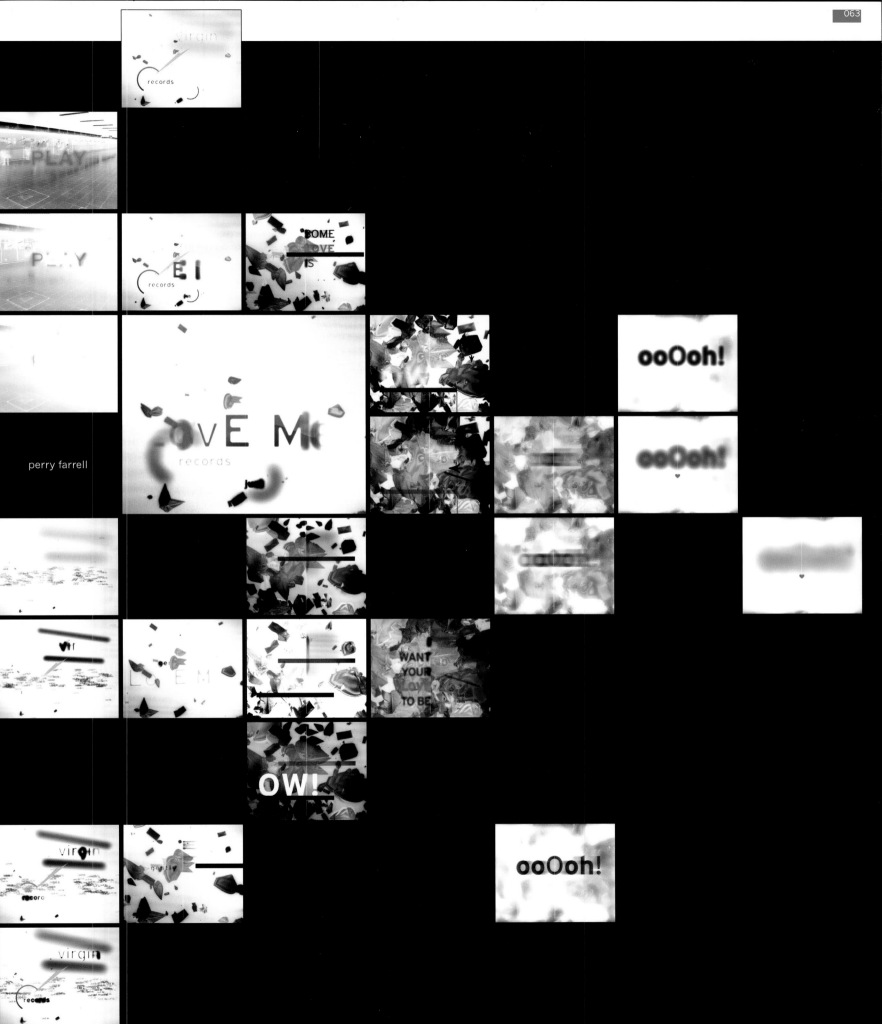

perry farrell

It was early in their partnership that John Eric Bartholomew and Ernest Wiseman adopted the names Morecambe and Wise, Morecambe being a small seaside town on the northwest coast of England where Bartholomew was born. Eric Morecambe and Ernie Wise are probably Britain's best-loved comedy double act and worked together for over forty years, refining their act in music halls and film and on radio and television. They reached audiences of over twenty-eight million in the late 1970s, and Eric Morecambe became one of the country's most popular figures of the twentieth century.

As part of the Tern project, an arts-led regeneration of Morecambe, Why Not and lead artist Gordon Young worked on the Eric Morecambe Memorial, researching the text and designing the typographic layout of the area. The statue of the local hero was executed by sculptor Graham Ibbeson and placed at the top of a set of polished granite steps on which were sandblasted the lyrics to their famous closing theme tune 'Bring Me Sunshine'.

Set into the floor elsewhere are memorable jokes or catch phrases (how do you spell 'Wh-h-hey!'?), plus the names of all the celebrities who clamoured to appear on their television shows. This information, however, will only make sense if you are British and old enough to remember their television work!

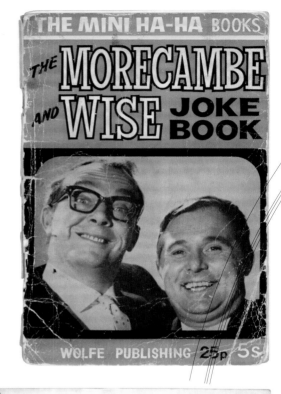

"bring me sunshine in your smile, bring me laughter all the the while. In this world where we live there should be more happiness So much joy you can give to each brand new bright tomorrow Make me happy through the years never bring me any tears Let your arms be as warm as the sun from up above bring me fun bring me sun bring me love."

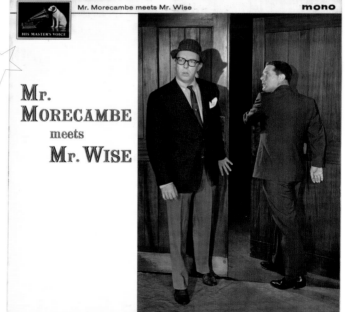

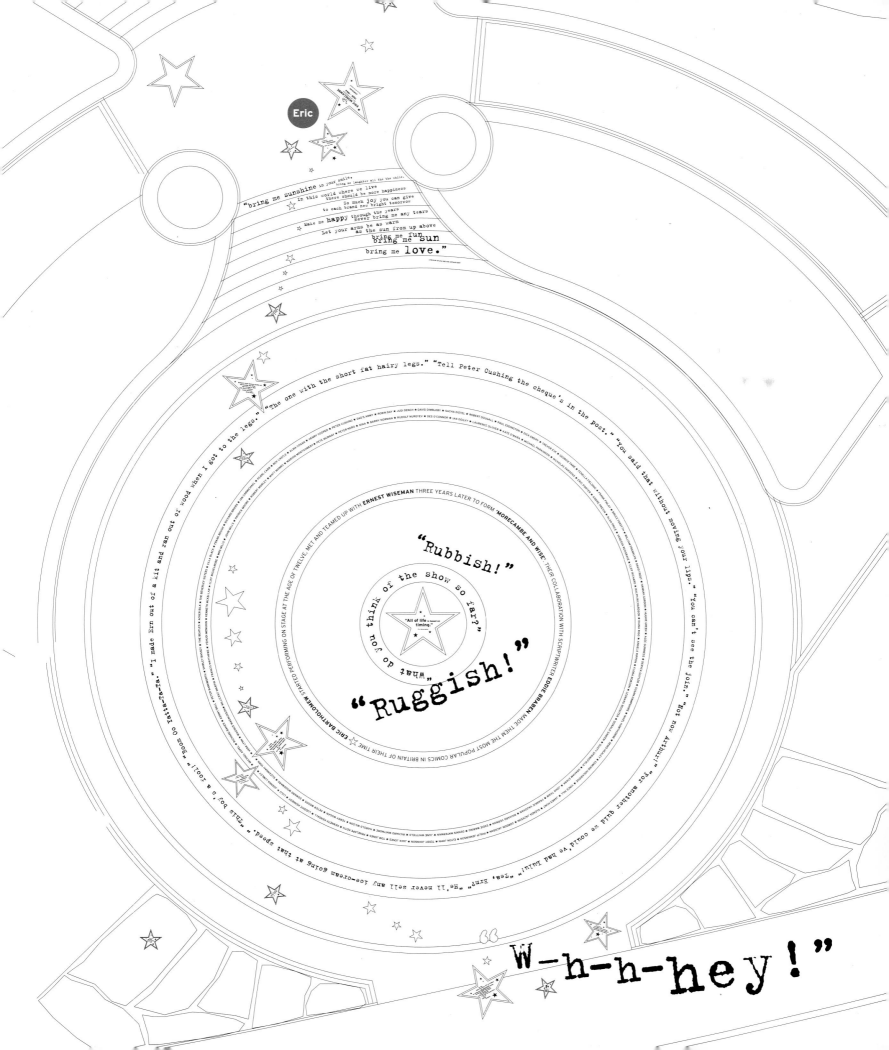

Eric

"bring me sunshine in your smile,
bring me laughter all the while.
In this world where we live
there should be more happiness
So much joy you can give
to each brand new bright tomorrow
Make me happy through the years
never bring me any tears
Let your arms be as warm
as the sun from up above
bring me fun
bring me sun
bring me love."

"The one with the short fat hairy legs." "Tell Peter Cushing the cheque's in the post." "You said that without moving your lips." "You can't see the join." "Not now Arthur."

"Rubbish!"

"Ruggish!"

"What do you think of the show so far?"

"All of life is based on timing."

ERNEST WISEMAN THREE YEARS LATER TO FORM 'MORECAMBE AND WISE'. THEIR COLLABORATION WITH SCRIPTWRITER EDDIE BRABEN MADE THEM THE MOST POPULAR COMICS IN BRITAIN OF THEIR TIME. ERIC BARTHOLOMEW STARTED PERFORMING ON STAGE AT THE AGE OF TWELVE, MET AND TEAMED UP WITH

"I made Ern out of a kit and ran out of wood when I got to the legs." "Yatta-Ta-Ta." "Boom Oo Yatta-Ta-Ta." "this boy's a fool!" "That speed." "He'll never sell any ice-cream going at that speed." "Tea, Ern?" "For another quid we could've had Raful."

W-h-h-hey!"

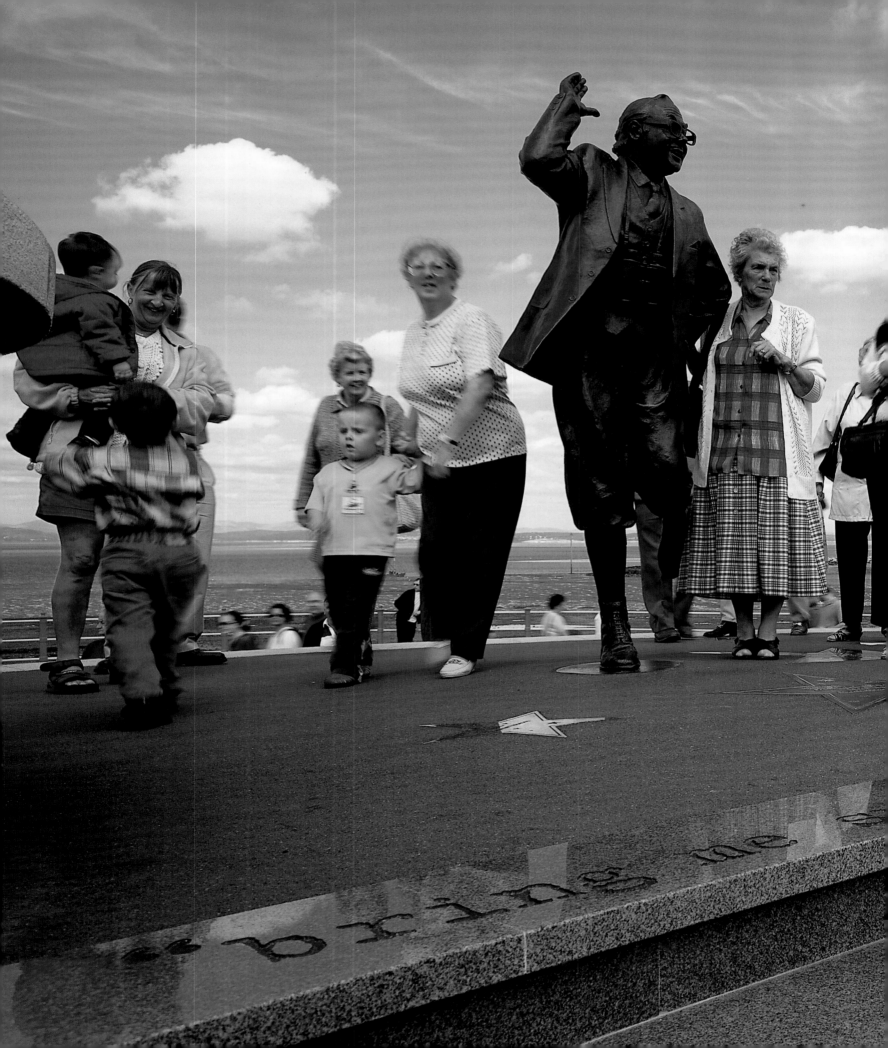

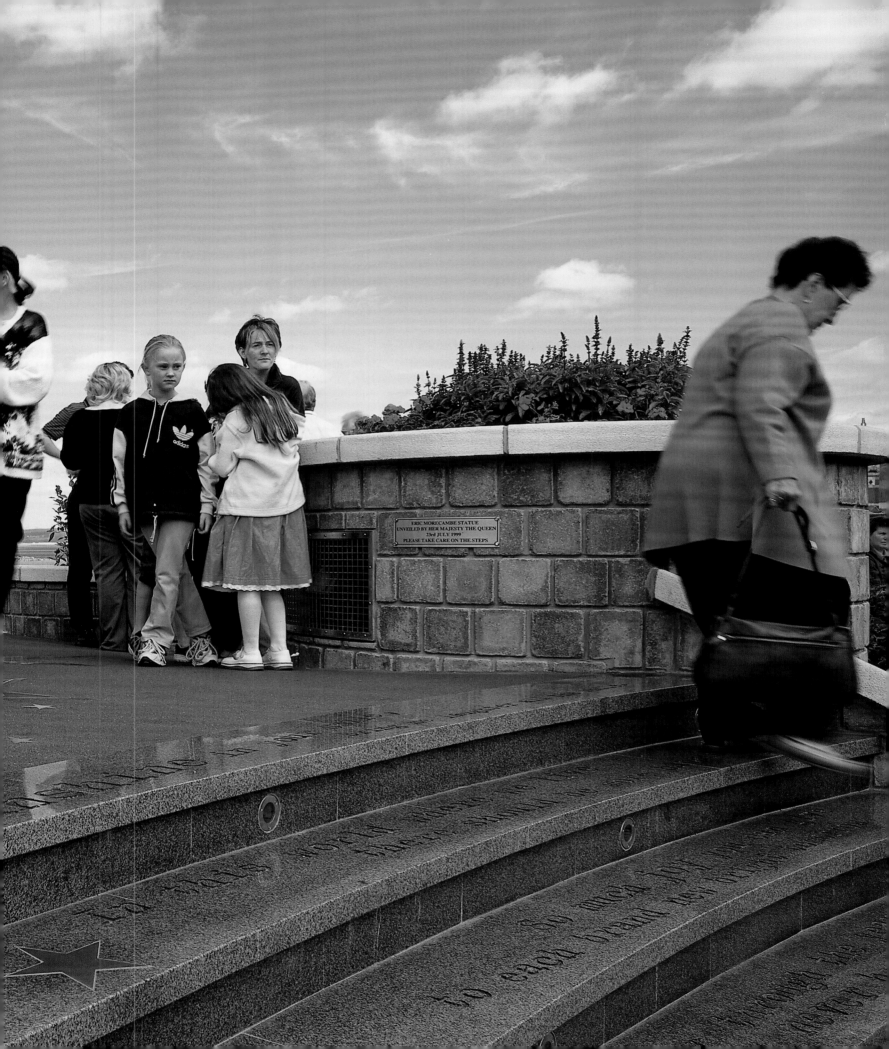

ERIC MORECAMBE STATUE
UNVEILED BY HER MAJESTY THE QUEEN
23rd JULY 1999
PLEASE TAKE CARE ON THE STEPS

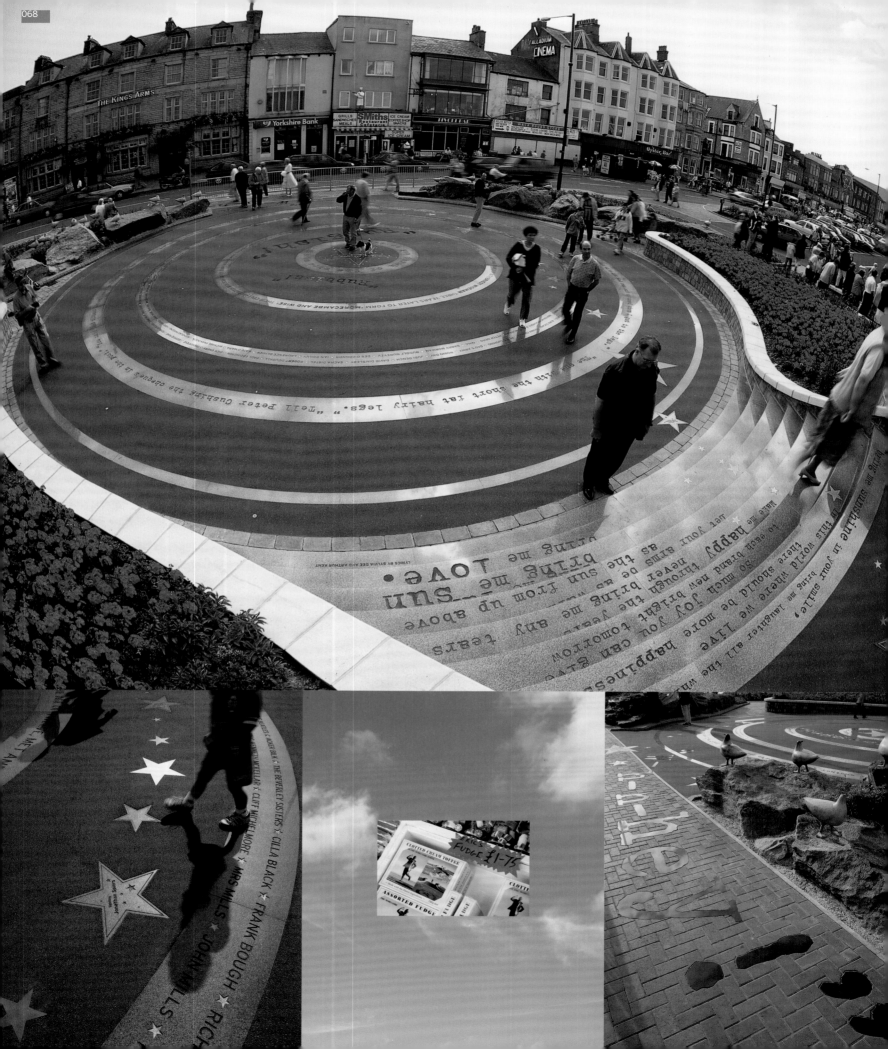

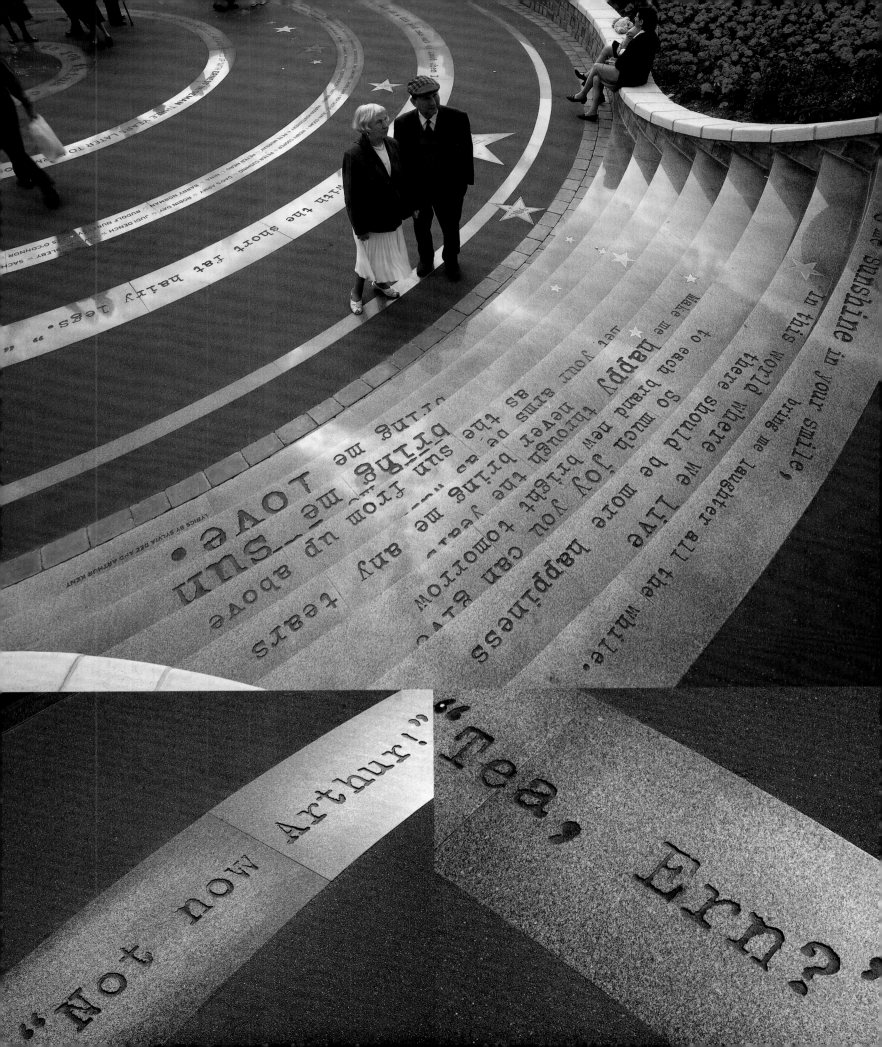

WATERCOLOURS & OTHER WORKS ON PAPER

Kandinsky

ROYAL ACADEMY OF ARTS

14 APRIL – 4 JULY 1999 SUPPORTED BY THE RA EXHIBITION PATRONS GROUP

Open daily from 10am until 6pm and Fridays in
April/May then Sundays in June/July until 8.30pm

£6 full price, £4.80 concessions, £4 full time students
£2.50 12–18 years, £1.50 8–11 years

Royal Academy of Arts, Piccadilly, London W1

Friends visit free, ring 0171 300 5664 for details

Vasily Kandinsky, Untitled 1921, watercolour, Indian ink and pencil on paper, 38.4 x 24.4 cm. Öffentliche Kunstsammlung Basel, Kupferstichkabinett. Vermächtnis Dr. Richard Doetsch-Benziger, Basel. Photo Öffentliche Kunstsammlung Basel photo Martin Bühler © ADAGP, Paris and DACS, London 1999. Design: why not associates

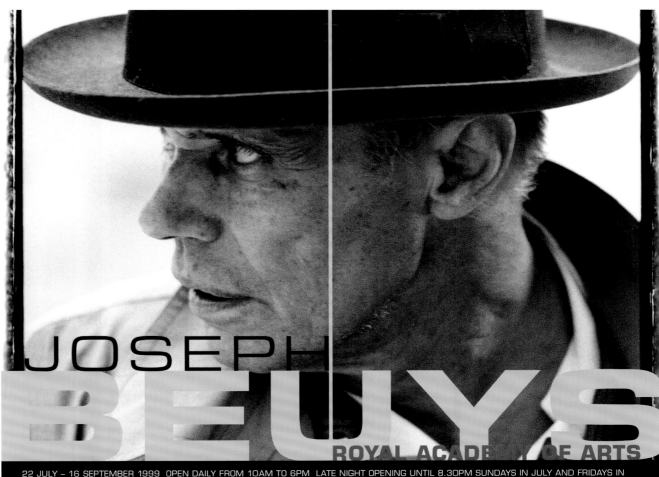

JOSEPH BEUYS

ROYAL ACADEMY OF ARTS

22 JULY – 16 SEPTEMBER 1999 OPEN DAILY FROM 10AM TO 6PM LATE NIGHT OPENING UNTIL 8.30PM SUNDAYS IN JULY AND FRIDAYS IN AUGUST AND SEPTEMBER £6 FULL PRICE, £4.80 CONCESSIONS, £4 FULL TIME STUDENTS, £2.50 12–18 YEARS, £1.50 8–11 YEARS. CALL 0171 413 1717 / WWW.TICKETMASTER.CO.UK

FRIENDS VISIT FREE RING 0171 300 5664 FOR DETAILS ROYAL ACADEMY OF ARTS, PICCADILLY, LONDON W1

DRAWINGS THE SECRET BLOCK FOR A SECRET PERSON IN IRELAND

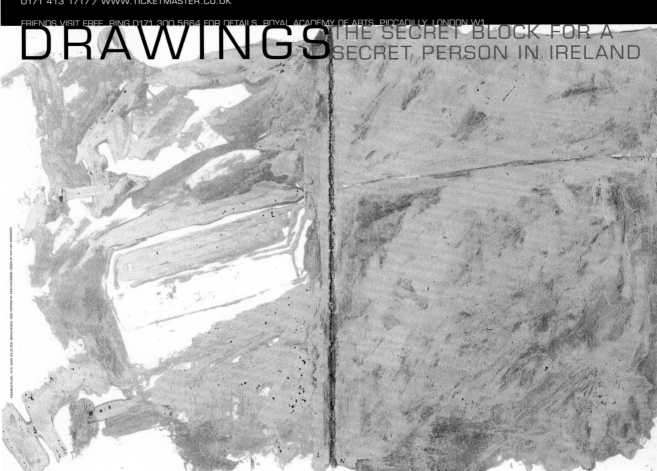

...d work of punk entrepreneur Malcolm McLaren were celebrated in an exhibition
...naak|on Taste' at the Bonnefanten Museum, Maastricht, the Netherlands and the
...re for Art and Media, Karlsruhe, Germany. Typically eccentric, the project entailed
...ic design of four fruit machines, which were linked to an audiovisual display of
...and films related to Malcolm. When someone won at a machine, the display
...to show new footage and the winner received either a limited-edition T-shirt
...(see pp. 74–75).

Malcolm spent considerable time at our office during the project
talking passionately about the exhibition and drifting around in h...
tweedy suits. As design fees were minimal, we quietly referred to...
project as 'the great graphic-design swindle'.

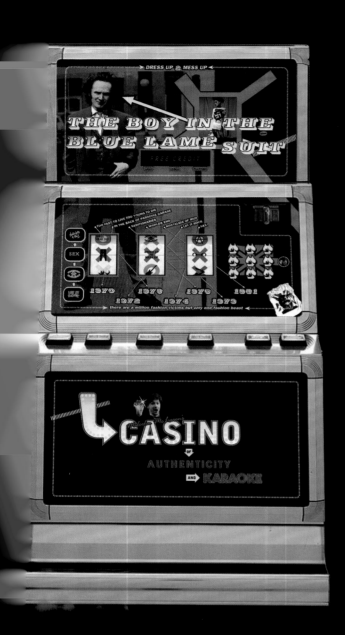
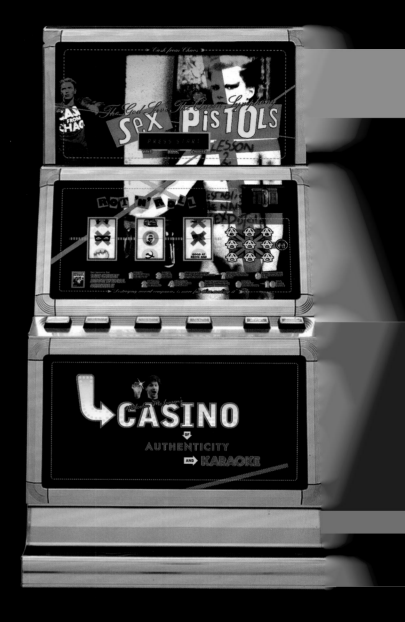

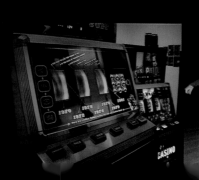

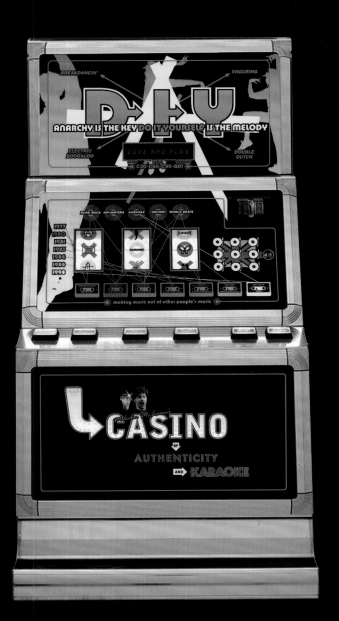

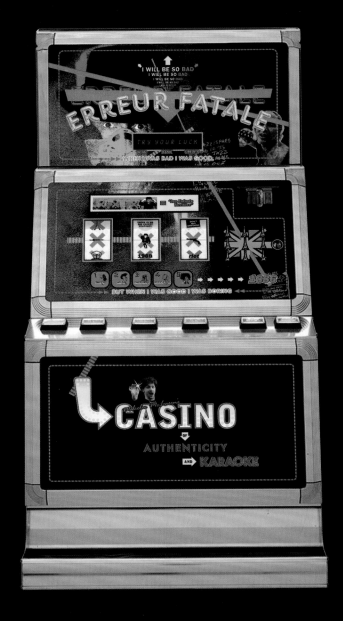

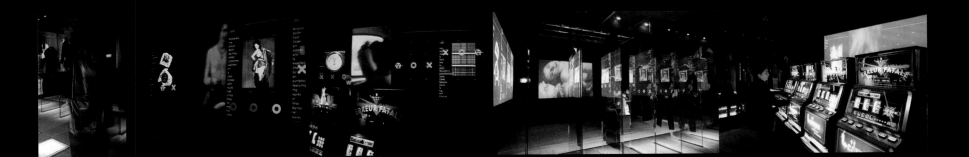

The T-shirt and poster designs pay homage to some of Punk's practices; for instance, we borrowed a technique that Malcolm used whilst designing clothes with Vivienne Westwood at their shop, Sex. They used to import second-hand college T-shirts from America and overprint them with slogans, which is the method we employed in our T-shirt design. For the poster, we created a type treatment that was overprinted on any surplus running sheets we found at the printer's, from sombre reports and account pages to nappy and food packaging.

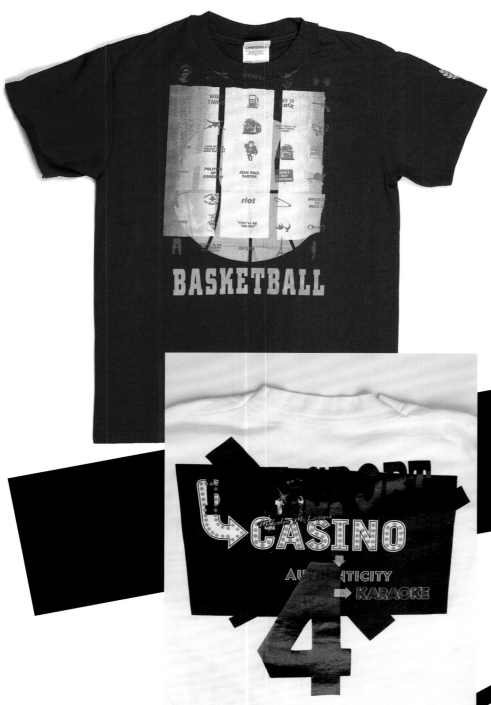

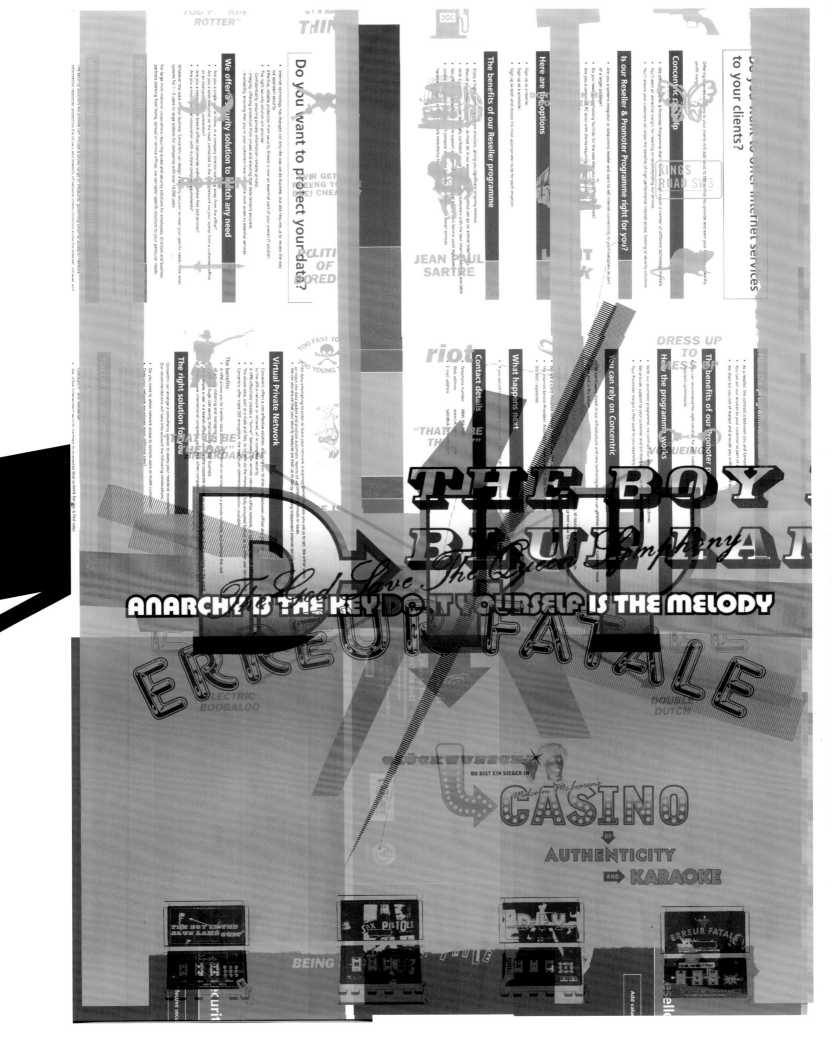

We were commissioned to design a quarterly review for TBWA, one of London's top advertising agencies. Illustrating and commenting on some of their most innovative work, *Quarter* was based on a circle that folded down into a quarter to fit into a specially shaped envelope.

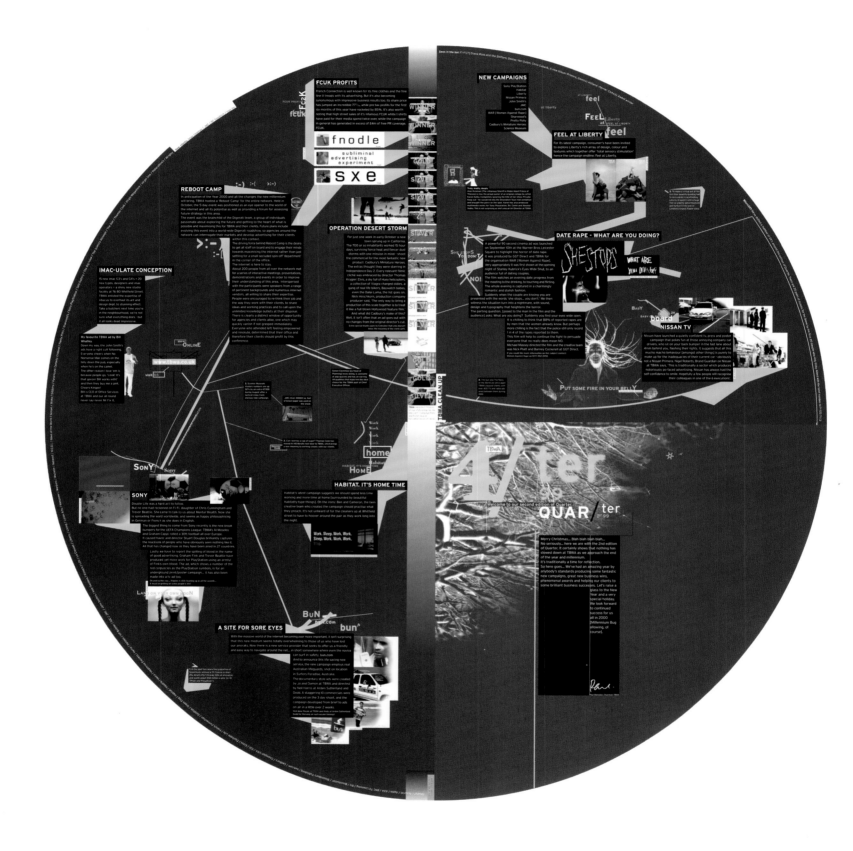

THE FOLLOWING IS AN EXTRACT FROM AN INTERVIEW GIVEN BY THE NATWEST LOGO ON THE PARKINSON SHOW IN JULY 1999.

CONQUERED WORLDS

DAFT VADER

GOLD & DELICIOUS

On the 3rd day the great god Gates... "Let there be light..." no diff/delete that... let there be light beige" And so it was in the virtual garden of computers, until some young upstarts in the Apple Design Group (let's call them Adam and Eve for arguments sake) different and promptly made all their computers cool colours like blueberry, grape, tangerine and lime.

This is merely scratching the scratch resistant surface of the revolution that is Apple iMac. It scooped the only Gold pencil at the 1999 Design & Art Direction awards, which represents the pinnacle of creative achievement, and is richly deserved for redefining our understanding of a given medium.

In short the iMac changed the rules.

Far from being an ivory tower with this mould breaking design, it's the fastest selling computer in Apple's history. During its first 139 days, 800,000 were sold: that's one every 15 seconds of every minute of every hour of every day of every week...

Of course it's only fair that we claim some small part in this phenomenal success –after all we did produce the advertising!

TANK GIRL

CANNES GRAND PRIX

one
One design company
One advertising agency
& One government

gold silver silver silver silver silver bronze bronze tv award gold bronze winner winner winner gold silver silver silver silver silver silver gold silver hon silver hon

'D&AD NIGHT SIGNALS ARRIVAL OF TBWA AS A MAJOR CREATIVE FORCE'

LIFE IMITATING ADVERTISING

f
c
u
k

IT'S THE WAY THEY MAKE YOU FEEL

It was always going to be an explosive combination. A new range of bras, scantily clad girls, the directing guru Frank Budgen and the great uptight British public. You could read the headlines before a single frame had been filmed. And the journos [as self appointed, mouthpiece for the masses] didn't disappoint. No sooner had the playful piece gone out... than the outraged column inches started to mount up. Disgusting. Sexist. Immoral.

But guess what? The girls loved it. And sales (as well as bosoms) were uplifted by over 400% in a matter of weeks.

TBWA

Welcome to our first edition of Quarter.

/ 99

It's a quarterly review of life at TBWA. So it will feature stories about our people, our clients and our ads. That's not to say that we might stray off the brief because our editorial policy will be to make it up as we go along.

The purpose of Quarter is to keep everyone who has something to do with TBWA up to date with all our goings on. If you don't have anything to do with TBWA, it's to show you what you're missing. We couldn't have picked a better time to start as the last few months have been non-stop in terms of our new business and awards. Read on to find out why our nipples were on everyones lips at Cannes.

CLEVER FCUKERS

Why Not contributed a piece to an exhibition on the theme of Ultraman, the hugely popular Japanese comic hero. The exhibition was in support of the rehabilitation of the city of Kobe after a major earthquake. 'Get Well Soon' was a large, single lenticular panel on which the image and message changed between three designs as the viewer moved past. We had found the children's sticking plasters in a shop on a previous visit to Kobe.

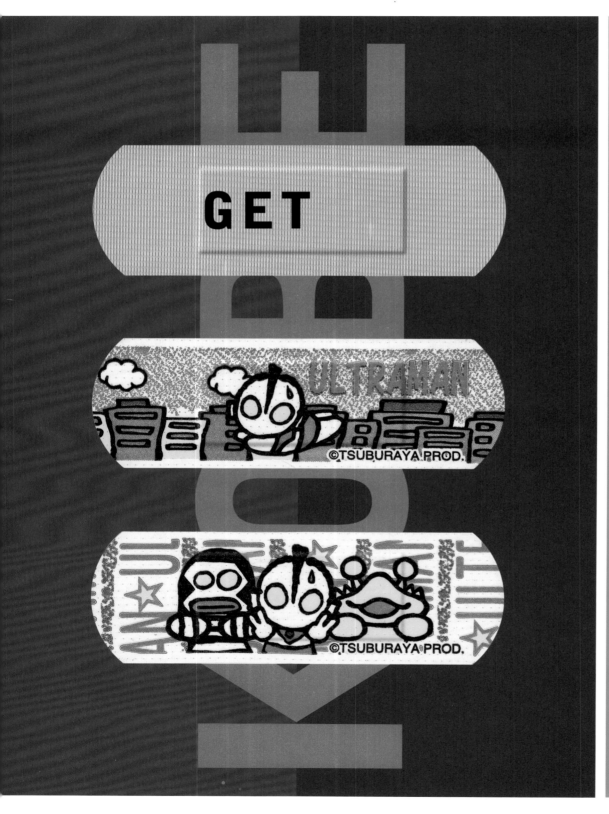

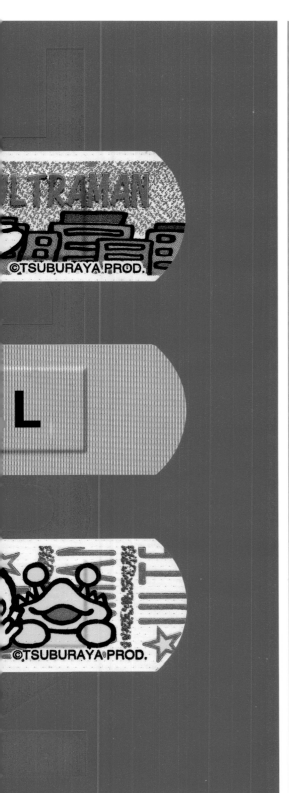

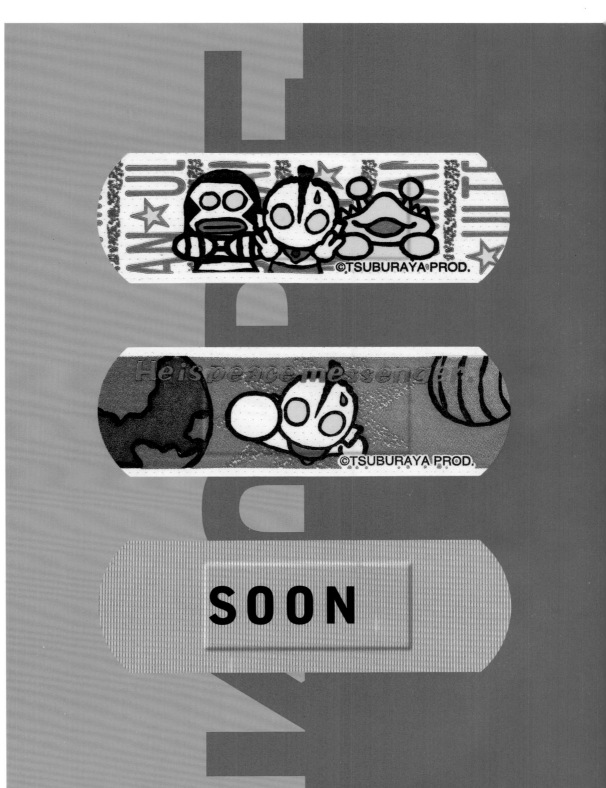

Osaka's DDD Gallery and Tokyo's Ginza Graphic Gallery mounted an exhibition of Why Not's work, and ever since we have submitted pieces to their one-off exhibitions. This particular show carried an ecological message and we chose to highlight the much-overlooked fact that recycling is not nearly as green as washing and re-using: don't buy milk in cartons, instead, have the milkman deliver bottles that he will collect when empty and re-use.

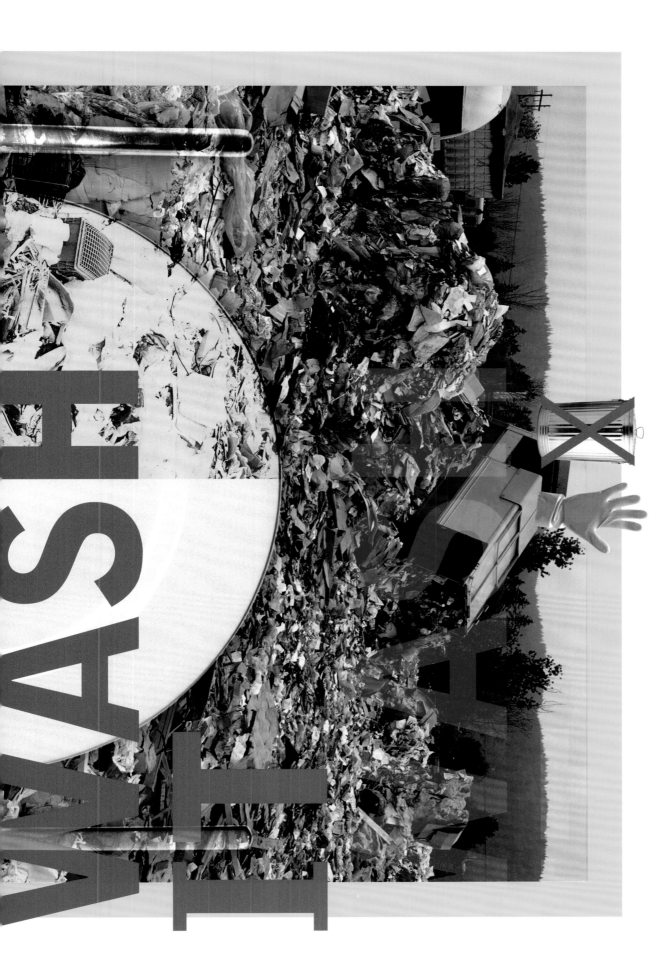

Job Name: BD-TORANCE-B3-POSTER Fold No.3 Bottom flat
出力日時 : 1999年10月21日 (木) 10時45分56秒 JST
Screen : CR-SGR000 Ruling/Resolution: 175-400

A television documentary charting the progress of a group of world travellers, keeping in contact over the Internet by email, photographs and video clips, provided us with one of our first opportunities to attempt the in-house post production of the title sequences, using the software After Effects. These pages show stills from the title sequences.

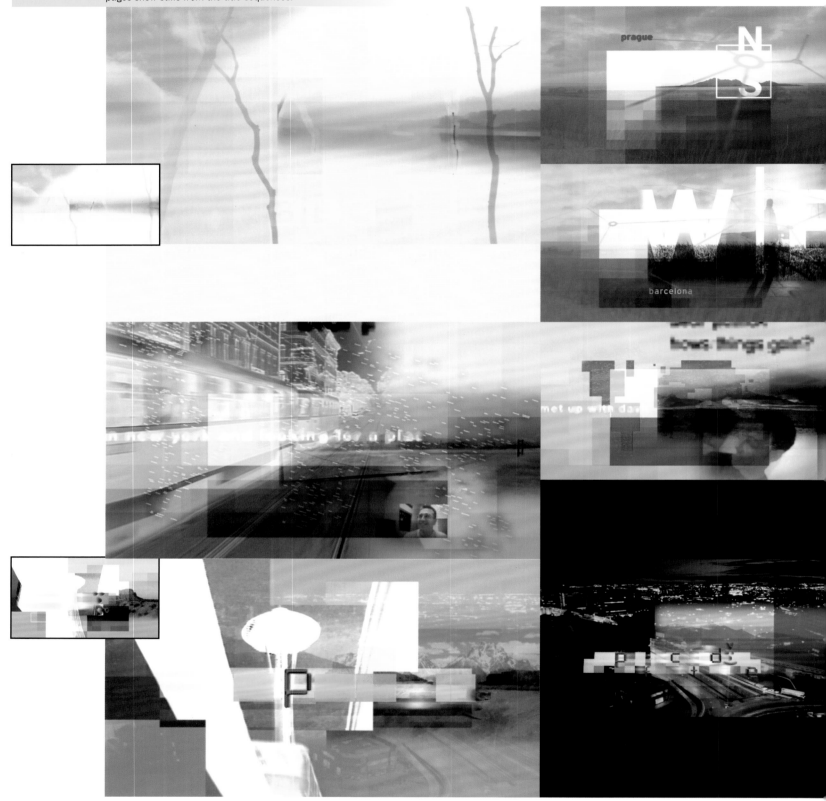

A television documentary charting the progress of a group of world travellers, keeping in contact over the Internet by email, photographs and video clips, provided us with one of our first opportunities to attempt the in-house post production of the title sequences, using the software After Effects. These pages show stills from the title sequences.

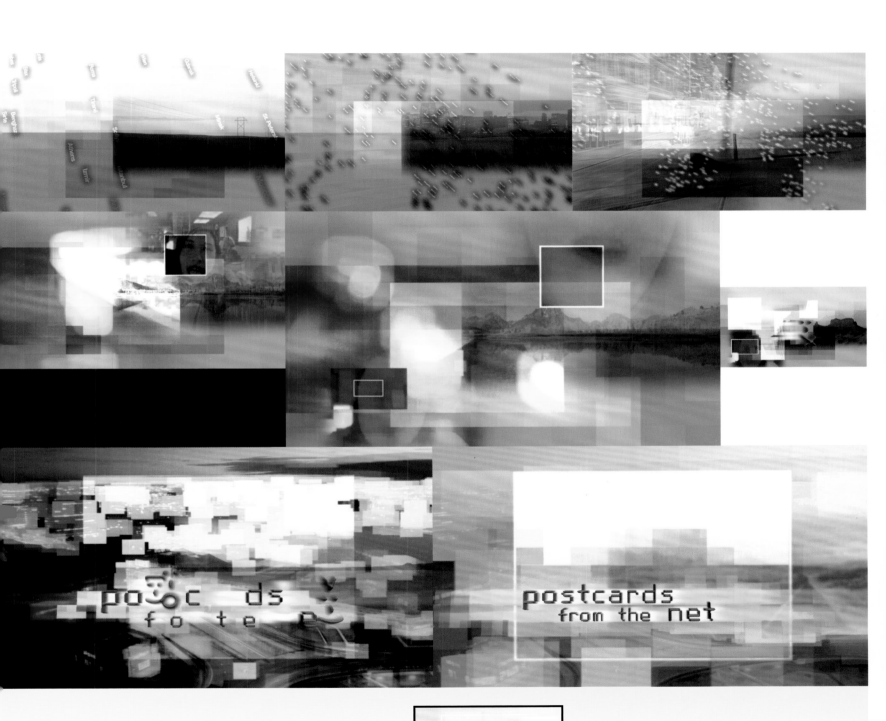

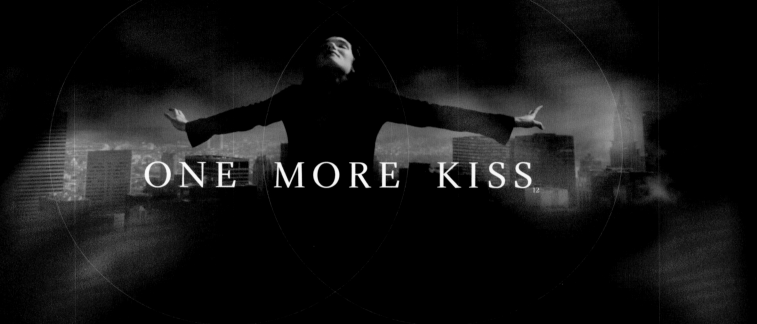

"SINCERE AND MOVING. ONE MORE KISS SHOULD INSPIRE ALL THOSE WHO SEE IT."
EMPIRE ★★★★

"AN AMBITIOUS, STRIKINGLY SHOT LOVE STORY. AN ODE TO LIFE."
VARIETY

ONE MORE KISS

DIRECTED BY VADIM JEAN

GERARD BUTLER JAMES COSMO VALERIE EDMOND VALERIE GOGAN

MOB FILMS PRESENTS IN ASSOCIATION WITH J&M PICTURES AND FREEWHEEL INTERNATIONAL. GERARD BUTLER. JAMES COSMO. VALERIE EDMOND. VALERIE GOGAN. ONE MORE KISS. DANNY NUSSBAUM CASTING GARL PROCTOR AND CO-DESIGNER LINDA BROOKER MAKE-UP AND HAIR DESIGN COLETTE KING PRODUCTION DESIGNER SIMON HICKS EDITOR JOE McNALLY DIRECTOR OF PHOTOGRAPHY MIKE FOX SOUND MIKE LAX. TOMMY HAIR. IAN WILSON MUSIC JOHN MURPHY & DAVID A HUGHES LINE PRODUCER IAN SHARPLES EXECUTIVE PRODUCERS DEREK ROY & SARA GILES CO-PRODUCERS MICHAEL BRAHAM & JANE WALMSLEY PRODUCED BY VADIM JEAN & PAUL BROOKS SCREENPLAY BY SUZIE HALEWOOD DIRECTED BY VADIM JEAN

www.onemorekiss.inuk.com

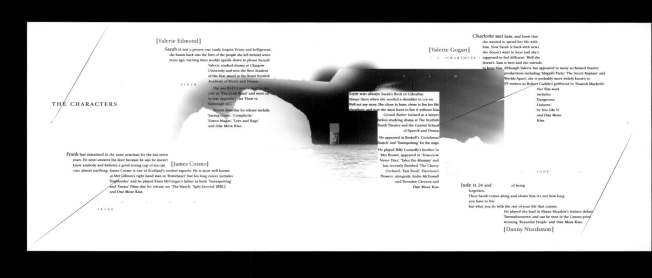

THE CHARACTERS

[Valerie Edmond]

Sarah is not a person one easily forgets. Feisty and belligerent, she bursts back into the lives of the people she left behind seven years ago, turning their worlds upside-down to please herself.

Valerie studied drama at Glasgow University and won the Best Student of the Year award at the Royal Scottish Academy of Music and Drama.

She was BAFTA nominated for her role in 'The Crow Road' and went on to star opposite John Thaw in 'Kavanagh QC'.

Recent films due for release include 'Saving Grace', 'Complicity', 'Simon Magus', 'Love and Rage' and One More Kiss.

[Valerie Gogan]

Charlotte met Sam, and knew that she wanted to spend her life with him. Now Sarah is back with news she doesn't want to hear and she's supposed to feel different. Well she doesn't. Sam is hers and she intends to keep him. Although Valerie has appeared in many acclaimed theatre productions including 'Abigail's Party', 'The Secret Rapture' and 'Worlds Apart', she is probably more widely known to TV viewers as Robert Carlyle's girlfriend in 'Hamish Macbeth'. Her film work includes 'Dangerous Liaisons', 'As You Like It' and One More Kiss.

Sam was always Sarah's Rock of Gibraltar. Always there when she needed a shoulder to cry on. Well not any more. She chose to leave, chose to live her life elsewhere, and now she must learn to live it without him.

Gerard Butler trained as a lawyer before studying drama at The Scottish Youth Theatre and the Central School of Speech and Drama.

He appeared in Berkoff's 'Coriolanus', 'Snatch' and 'Trainspotting' for the stage.

He played Billy Connolly's brother in 'Mrs Brown', appeared in 'Tomorrow Never Dies', 'Tales the Mummy' and has recently finished 'The Cherry Orchard', 'Fast Food', 'Harrison's Flowers' alongside Andie McDowall and Brendan Gleeson and One More Kiss.

Frank has remained in the same armchair for the last seven years. He never answers the door because he says he doesn't know anybody and believes a good strong cup of tea can cure almost anything. James Cosmo is one of Scotland's coolest exports. He is most well known as Mel Gibson's right hand man in 'Braveheart' but his long career includes 'Highlander' and he played Ewan McGregor's father in both 'Trainspotting' and 'Emma'. Films due for release are 'The Match', 'Split Second' [BBC] and One More Kiss.

[James Cosmo]

Jude is 24 and of being forgotten.

Then Sarah comes along and shows him it's not how long you have to live but what you do with the rest of your life that counts.

He played the lead in Shane Meadow's feature debut 'Twentyfourseven' and can be seen in the Cannes prize winning 'Beautiful People' and One More Kiss.

[Danny Nussbaum]

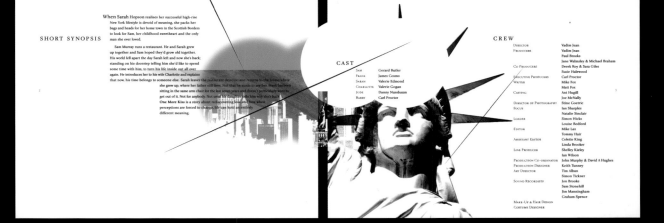

SHORT SYNOPSIS

When Sarah Hopson realises her successful high-rise New York lifestyle is devoid of meaning, she packs her bags and heads for her home town in the Scottish Borders to look for Sam, her childhood sweetheart and the only man she ever loved.

Sam Murray runs a restaurant. He and Sarah grew up together and Sam hoped they'd grow old together. His world fell apart the day Sarah left and now she's back; standing on his doorstep telling him she'd like to spend some time with him, to turn his life inside out all over again. He introduces her to his wife Charlotte and explains that now, his time belongs to someone else. Sarah leaves the restaurant dejected and returns to the house where she grew up, where her father still lives. Not that he wants to see her. Frank has been sitting in the same chair for the last seven years and doesn't particularly want to get out of it. Not for anybody. Not until his daughter tells him why she's back.

One More Kiss is a story about rediscovering love and how when perceptions are forced to change, life can hold an entirely different meaning.

CAST

Sam	Gerard Butler
Frank	James Cosmo
Sarah	Valerie Edmond
Charlotte	Valerie Gogan
Jude	Danny Nussbaum
Barry	Carl Proctor

CREW

Director	Vadim Jean
Producers	Vadim Jean
	Paul Brooks
	Jane Walmsley & Michael Braham
Co Producers	Derek Roy & Sara Giles
	Suzie Halewood
Executive Producers	Carl Proctor
	Mike Fox
Writer	Matt Fox
Casting	Ant Hugill
	Joe McNally
Director of Photography	Stine Goetric
Focus	Ian Sharples
	Natalie Sinclair
Loader	Simon Hicks
	Louise Bedford
Editor	Mike Lax
	Tommy Hair
Assistant Editor	Colette King
	Linda Brooker
Line Producer	Shelley Kieley
	Ian Wilson
Production Co-ordinator	John Murphy & David A Hughes
Production Designer	Keith Tunney
Art Director	Tim Alban
	Simon Tickner
Sound Recordists	Jon Brooke
	Sam Stonehill
	Jim Manningham
	Graham Spence
Make-Up & Hair Design	
Costume Designer	

'...HE WHO RETURNS HAS NEVER LEFT.' Pablo Neruda

NEW YORK CITY

PHOTOGRAPHS BY. VADIM ~ PHOTONIC
DESIGN BY. WHY NOT ASSOCIATES
SCOTLAND

Technical specifications

Running Time	102 minutes
Format	35 mm film
Number of Reels	6 reels
Sound	Dolby Digital
Ratio	2:35:1 [anamorphic]
Footage	9,180ft / 2,798 m

Contractual credit block

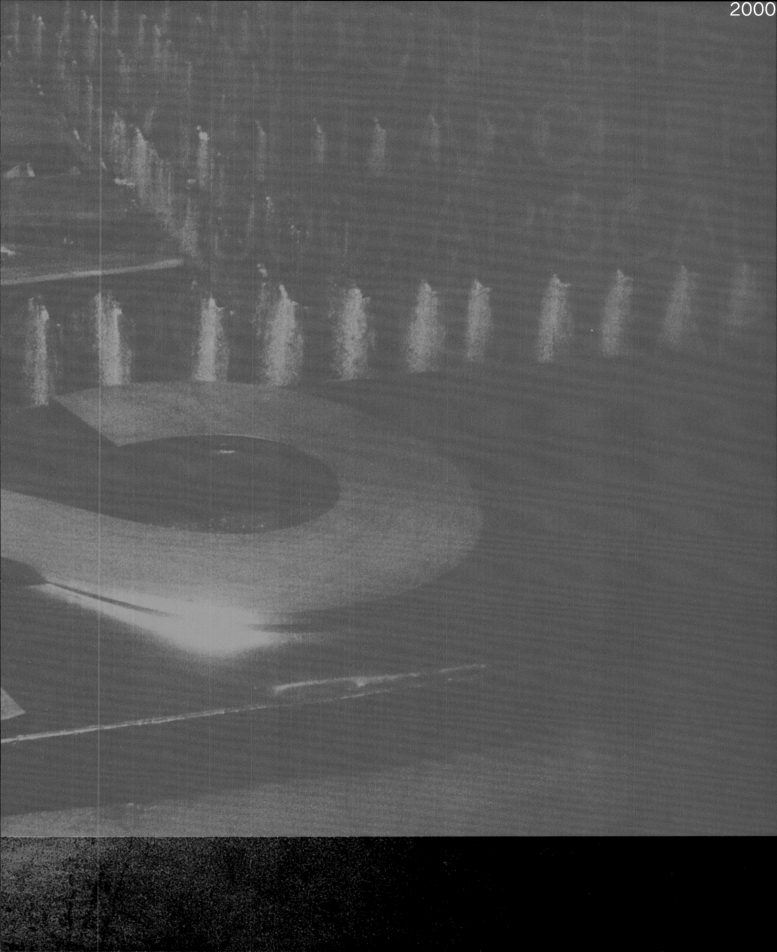

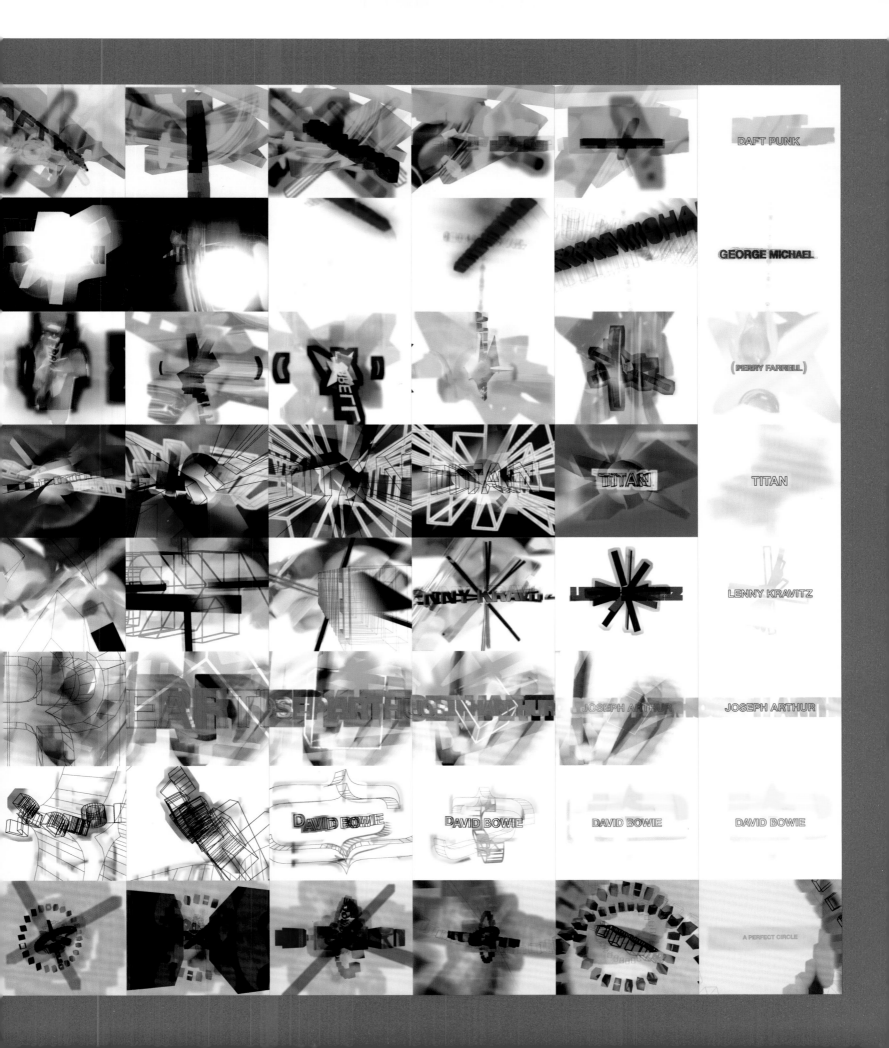

London Arts, now part of the Arts Council England, was the regional arts board for the capital, covering its thirty-two boroughs and the corporation of the City of London. When redesigning their corporate identity, we wanted to establish a mark that was easily recognizable, one that was friendlier, brighter, more open and more colourful than its predecessor.

The symbol had to be clearly identifiable even when used very small as a footnote on all kinds of documents and websites. London Arts gave different amounts of funding to various organizations and we made reference to this in the size of the dots, which represent pools of funding and help give the logo its unique character.

We selected a clean simple typeface – Interstate – to ensure legibility and encouraged the board to change the colours of the identity on each application to retain its friendly, non-corporate appearance.

Pages 94 and 95 show the introductory pages and covers for two of the board's reports and accounts.

LONDON ARTS

LONDON ARTS 2 Pear Tree Court London EC1R ODS
tel +44 (0)20 7608 6100 fax +44 (0)20 7608 4100
textphone 020 7608 4101 www.arts.org.uk/londonarts

with compliments

Statement by London Arts on Cultural Diversity

1 We recognise the right of all Londoners to **preserve**, **develop** and **share** their artistic and cultural heritage.

2 We recognise and commit ourselves to promote the understanding that **cultural diversity is fundamental to the identity of London** and a vital resource in the shaping of the capital's future.

3 We promote the right of people and communities of all origins to take a full part in the artistic and creative life of London and commit ourselves to help to eliminate barriers to participation.

4 We promote the understanding and creativity that arises from the interaction between individuals and communities of different origins.

5 We encourage the social, cultural, economic and political institutions of London to **appreciate and support artistic work that reflects the city's ethnic diversity.**

6 We commit ourselves to ensure that individuals and groups of all origins **receive equal treatment** from this organisation, while respecting and valuing their differences.

7 **We commit ourselves to collect data in order to monitor our own activities and to develop policies, programmes and practices that** are sensitive and responsive to the ethnic diversity of London.

The London Arts statement of policy is based on a declaration in the Canadian Multiculturalism Act, which was adopted by the Commission on the Future of Multi-Ethnic Britain as a model.

7

LADY HOLLICK
Chair
tel +44 (0)20 7608 6157
fax +44 (0)20 7340 1083
lady.hollick@lonab.co.uk

LONDON ARTS
2 Pear Tree Court
London EC1R ODS
tel +44 (0)20 7608 6100
www.arts.org.uk/londonarts

LONDON ARTS

LONDON ARTS

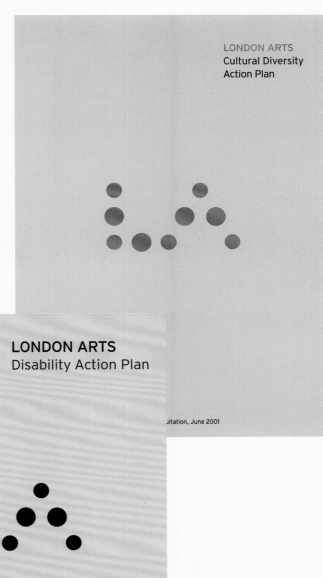

LONDON ARTS
Cultural Diversity
Action Plan

...ultation, June 2001

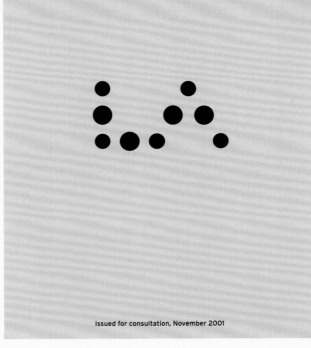

LONDON ARTS
Disability Action Plan

Issued for consultation, November 2001

LONDON ARTS 2 Pear Tree Court London EC1R 0DS
tel +44 (0)20 7608 6100 fax +44 (0)20 7608 4100
textphone 020 7608 4101 www.arts.org.uk/londonarts
Chair **Lady Hollick** Chief Executive **Sue Robertson**
Registered Charity no. 1010905 Company Registration no. 2704751

London Views
LONDON ARTS
ANNUAL REPORT
1999/2000

• LONDON
ARTS

Arts & Learning / Worlds of possibility

Creative and cultural activities have a powerful role to play in education and training. Children involved in arts-based programmes, for instance, can learn complex teamwork and problem-solving skills. Older people, meanwhile, acquire skills that improve employment and career prospects, and that enhance their quality of life. The arts and learning are a great fit.

London Arts is committed to the principle of lifelong learning and to fostering the role of the arts in education. By developing a learning-based economy, the capital will offer greater opportunities for individuals to increase their confidence and creativity and for businesses to develop and grow.

48 Hours

A lot can happen in 48 hours and, at the Tabernacle Centre's Tablet Gallery in October 1999, it did. Jessica Voorsanger's video and performance piece, Karate Heroes, involved the students and instructor of a karate class, while 741 mph, an audio-visual installation by Huf — a collaborative art and architecture practice, was created with the Centre's sound engineer. Other pieces involved games of 48-hour patience (by Tomoko Takahashi and Elia Gibbs), the production of an artist's book (by Jaqueline Donachie) and the decoration of the Good Cook café (by Mary Evans).

"I asked the artists to work with different groups of people here, from transient users to employees," says Melanie Keen, curator of 48 Hours. "Activities was broadcast live on the web [see www.48hours.org.uk] and audiences and participants gained an insight into artists' practice."

Big Splash

When your school looks like an outsize commercial laundry, you know something's going on. And that's just what happened to hundreds of students with profound and multiple learning disabilities, when they arrived for performances of Big Splash by the Oily Cart [www.oilycart.org.uk], a project supported by London Arts' Theatre for Young People fund.

"We'd researched the possible benefits of a theatrical production for students in hydro-therapy pools," says artistic director Tim Webb, "and got very positive results. So we used spray, lights, bubbles, music and puppets to add to the traditional sights and sounds and created a journey for the kids as they travelled around the 'laundry' in search of a lost sock. It was a very effective, very moving production."

Creativity in Education

London Arts is a strong advocate and supporter of the arts in education. In 1999 London Education Arts Partnership (LEAP - www.londonartsed.org.uk) was transformed from a funding programme into an independent limited company offering advocacy, fund-raising, training, professional development and research services. In 2000 the London Youth Arts Network (LYAN) was set up.

In November 1999, London Arts organised an arts education conference All Our Futures - Making It Happen. From this event sprang the Creativity in Education programme. The results have been significant: a new Certificate in Professional Practice in Youth Arts Development; a comprehensive information file detailing London's arts education organisations; a series of eight short training sessions on topical issues; the launch of Artscape [www.artscape.org.uk], a database of artists working with young people; and the development of a series of Teacher Training/Arts Organisation Partnerships.

Backing Talent / Shock of the new

The future of the arts depends, more than anything, on developing artists. Artists can bring new perspectives to existing art forms and explore the possibilities that give rise to new ones. At the beginning of a new Millennium innovation is, more than ever, the lifeblood of the arts. But promising young artists can be lost to the arts of the future unless they are supported in the crucial early years of their career.

Support, experience or funding - or all three - help them to find and develop fully their artistic voices. London Arts works to promote innovation and to give fresh talent the chance to develop and grow.

Carnival at the Dome

London Arts is a long-time supporter of and investor in Carnival arts in the capital. Its interest led to the commissioning of 11 Carnival groups for the Millennium Eve celebrations at the Dome.

"It's a huge space," says coordinator Catherine Ugwu, "and Carnival artists are the only ones with the experience necessary to create structures and costumes on that scale. And what an opportunity for them. They could create costumes for indoor, rather than outdoor, display. They could collaborate with artists from different disciplines, and they were performing for millions, maybe tens of millions, of people around the world. On the night they were amazing!"

"Carnival artists are the only ones with the experience necessary to create structures and costumes on that scale... On the night they were amazing!"
Catherine Ugwu, coordinator of Millennium Eve celebrations at the Dome

Icarus Falling

Primitive Science is an experimental theatre company whose inspiration, says producer Roz Temple Morris, "does not come from traditional theatrical texts, but from non-theatre sources, such as a painting, a poem, or a short story, and also from the performance space itself. The spark for Icarus Falling was Peter Breughel's Landscape with Icarus, and the resulting piece explored the myth through the eyes of the son who, supposedly, flew too close to the sun."

The London Arts funded piece was performed in an open space on the top floor of The Museum of on the South Bank and won the Time Out Award for the Best Off-West End Show of 1999. For more Primitive Science, see www.primitivescience.com.

Douglas Gordon and Steve McQueen

FEATURE FILM is 1996 Turner Prizewinner Douglas Gordon's latest big screen installation. Commissioned by London Arts-funded organisation Artangel, Douglas took the musical score to Alfred Hitchcock's Vertigo and set it alongside a close-up film of the hands and face of James Conlon, Chef d'un-hestre at the Paris Opéra, as he conducts the orchestra performing the score.

The final ingredient to the piece, though, was its setting in the vast Atlantis Gallery (the former Truman brewery) in Brick Lane. "It was set at the top of the building," says Artangel's Melanie Smith. "You had to mount six flights of stairs to a dizzying height and there it was - Vertigo."

At the ICA, meanwhile, Steve McQueen - a British artist who has recently gained a powerful international reputation - held his first solo show, including a range of work employing sound, light and architectural and sculptural techniques. "McQueen's work is both film and art of a very high order ... it goes back to the beginning, when the medium was alive, filled with enigma and infinite possibilities," said Adrian Searle in The Guardian.

Project 4

When was the last time you enjoyed the show on a bus? Well, if you ride the London Central Bus Company's number 12 or number 36 buses, the chances are it was quite recently. "Route 1236 was a series of commissions to the South London Gallery," says arts consultant Jane Bilton, who coordinated the work.

Project 4 by Faisal Abdu'Allah was the third of the three projects. Abdu'Allah first placed enigmatic posters in the bus ad spaces, tempting passengers to view his website, where they viewed images of bus drivers and conductors and were asked to select the best. The most popular images were then displayed, gallery style, on the buses.

"More than 5,000 people visited the website," says Bilton. "It was a very popular project with passengers, with the bus company and with the drivers and conductors."

The Circus Space

For London Arts it funded The Circus Space, the approach of the new Millennium was a turning point. "We were commissioned to train '90 aerial performers for the show at the Dome," says Chief Executive Teo Greenstreet. "It was the biggest circus project and the highest-quality training ever provided in the UK."

Not only has the show been the high point of most visitors' trips to Greenwich, but The Circus Space itself has gone from strength to strength, and developing more specialised training facilities and establishing the UK's first accredited degree programme in circus with the Central School of Speech and Drama.

"Now the challenge is to build on this year's success," explains Greenstreet. "Some of the performer's have been auditioned by circuses from abroad, some will come back to complete the degree. We will assist others in creating new work and will be establishing a production company to ensure this country makes the most of this incredible talent."

Residency at HMP Brixton

It is often said that art frees the spirit. What better, then, than for London Arts to join the Arts Council of England and the Writers in Prison Network to fund a writer in residence at Brixton Prison?

Writer Hugh Stoddart began the one-year residency last year but it has proved so successful that he is to stay on for a second full year. Projects so far have included the production of OIL, an anthology of prisoners' work, and workshops with prisoners working in the community in preparation for their release.

Artslink

Funded by London Arts in conjunction with the London Tourist Board, Artslink has begun a Millennium project that investigates how user-friendly disabled people find the information and buildings of more than 300 venues. "It's a joint project between Artslink, which focuses on access, the London Tourist Board for events and Global Vision for IT expertise," says Artslink's Roger Robinson. "We're covering a huge range of arts and entertainment venues putting on events for the Millennium year. We'll complete the database by the end of 2000 and the information will be the basis of a new database we'll launch, which will replace our existing guides."

London Arts' investment in the project has enabled Artslink to do in just 6 months, work that would otherwise have taken many years. To see for yourself, visit www.londontown.com.

Journeys

Camden Arts Centre, an organisation in receipt of London Arts funding, received an Arts for Everyone award to run the North London Live Project. This series of public art works made with and for new audiences included Journeys.

"It's a twin screen projection," says North London Live coordinator Peter Cross. "On one side was the video story itself, made by a deaf producer, and on the other was the producer him or herself explaining it in British Sign Language. To access the narrative those who don't understand sign language have to listen to a voice-over on headphones. Journeys reverses the usual patterns of access that seek to include disabled people in public spaces."

Inspired by the real and imaginary travels of eight individuals, the video work - produced by members of the deaf community, and artists Anthony O'Flaherty, Claudia Kappenberg, Esther Sayers - Journeys was installed in Swiss Cottage Library in December 1999. The exhibition coincided with the launch of Swiss Cottage Library's new service for the deaf community.

Take Me to the River

Take Me to the River was a riverboat trip with a difference. Twice daily over two weekends, says Helen Smart, general manager of Greenwich Dance Agency, "Take Me to the River began with a community dance show at the Royal Naval College's Painted Hall, then the audience was transported down the Thames to Canary Wharf, where a professional dance piece was performed, then up the river again to the South Bank and a third dance performance, this time on the roof of the Queen Elizabeth Hall. It was a sell-out."

The event was organised by Canary Wharf Arts & Events and backed by an award from London Arts' London Calling fund. While two of the performances involved professional dancers, the Royal Naval College piece called on several dance students, local schoolchildren, several older non-dancers and two senior citizens. And the sun shone throughout.

Sitting in my cell with nothing to do
I picked up a mag called *OIL 2*
On one of its pages, I was pleased to see . . .
A very short poem written by me.
Brixton Prison Inmate

vivacity still celebrating the new

The show must go on and it did. Heralded with fireworks, parties and parades, the first year of the new Millennium continued with a non-stop extravaganza of the arts and of artists right across London. The Millennium Festival, funded by the National Lottery, broke all the rules by happening everywhere all the time – well into the summer of 2001. And last century's year-by-year focus on different artforms culminated in our new century with the *Year of the Artist*, which brought living artists together with a vast number of people in a wide variety of extraordinary places.

"The idea of a 'mobile' residency was intriguing for a couple of reasons. First, I repeatedly find myself telling cab drivers things I wouldn't ordinarily dream of telling a stranger. And they tell me their stories as well ... That leads to the second, more important reason: London's mini-cabs are driven largely by immigrants. And I'm an immigrant a few times over."

Ian Iqbal Rashid, writer, about his *No Back Routes* residency for the *Year of the Artist*

diversecity

capacity investing in the creative spirit

How creative can a cheque be? That question is the bottom line for any funder. In the arts – where the sky is barely the limit – it is crucial to make investments that really count, now and in the long-term. This means partnerships with other funders and policy-makers, strategic approaches to specific needs – and finding other ways to support the arts other than simply writing cheques. This year London Arts worked to achieve Lottery capital awards for many excellent projects. Detailed reviews resulted in greater support for some sectors, notably theatre, and the creation of entirely new projects, including a literature development agency for West London.

It seemed obvious to us to concentrate on the spoken word when we created a thirty-second television commercial for Radio Four's cricket coverage. We animated humorous, slightly eccentric and poignant excerpts from various commentaries and overlaid them on abstract, tightly cropped shots of cricket imagery to emphasize the entertaining power of the commentary.

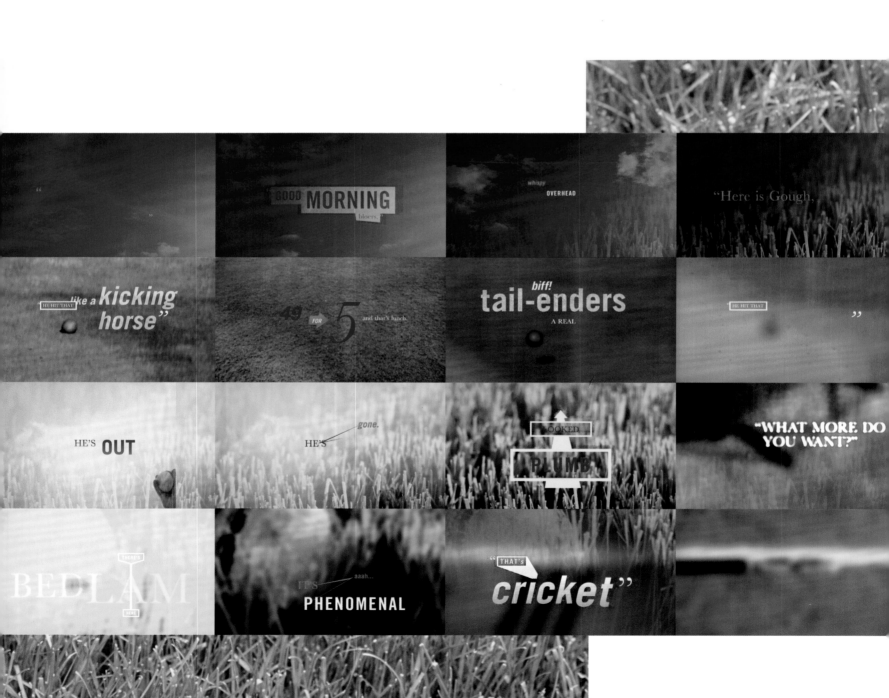

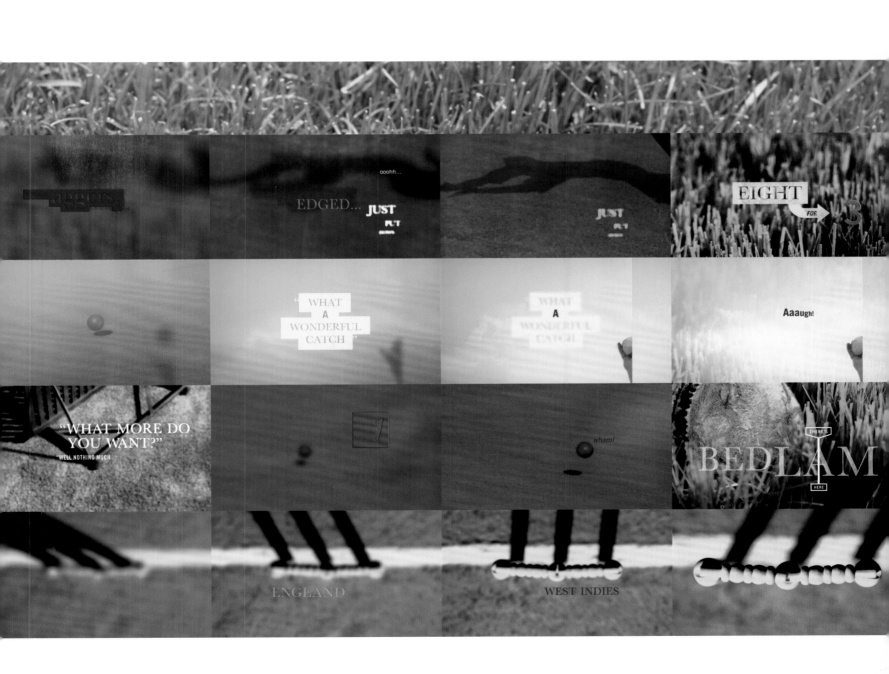

Taking our cue from the company's name and location, we produced a series of targets of different sizes and colours to define and personalize the client's identity. Such a straightforward design is surprisingly versatile and no two products look the same.

Archer Street

with compliments

Archer Street

Archer Street Limited
Studio 5, 10-11 Archer Street
London W1V 7HG
tel. +44 (0)20 7439 0540
fax. +44 (0)20 7437 1182
email. films@archerstreet.com

Directors: Andy Paterson
Frank Cottrell Boyce : Anand Tucker

Company Registered No. 3537276

Registered Address:
10 Orange Street, London WC2H 7DQ

Archer Street Ltd

Studio 5, 10-11 Archer Street
London W1V 7HG
tel. +44 (0)20 7439 0540
fax. +44 (0)20 7437 1182
email. films@archerstreet.com

Directors: Andy Paterson
Frank Cottrell Boyce : Anand Tucker

Company Registered No. 3537276

Registered Address:
10 Orange Street, London WC2H 7DQ

Archer Street

Studio 5, 10-11 Archer Street
London W1V 7HG
tel. +44 (0)20 7439 0540
fax. +44 (0)20 7437 1182
email. films@archerstreet.com

Andy Paterson

Archer Street

Studio 5, 10-11 Archer Street
London W1V 7HG
tel. +44 (0)20 7439 0540
fax. +44 (0)20 7437 1182
email. andy@archerstreet.com

Anand Tucker

Archer Street

Studio 5, 10-11 Archer Street
London W1V 7HG
tel. +44 (0)20 7439 0540
fax. +44 (0)20 7437 1182
email. anand@archerstreet.com

Frank Cottrell Boyce

Archer Street

Studio 5, 10-11 Archer Street
London W1V 7HG
tel. +44 (0)20 7439 0540
fax. +44 (0)20 7437 1182
email. frank@archerstreet.com

 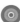

Archer Street

Studio 5, 10-11 Archer Street
London W1V 7HG
tel. +44 (0)20 7439 0540
fax. +44 (0)20 7437 1182
email. films@archerstreet.com

When asked to direct the 2000 conference film for Virgin, we decided to make neon signs of all the band and artists' names and then photograph them in the most unlikely places. Weeks later, we had turned a simple set of conference titles into an exercise that involved dragging a film crew, a crane, a generator and a van of neon signs around the UK. Locations ranged from the beach on the southeast coast to a tunnel under the Thames, with an elderly gentleman's front room, a forest, a graveyard, an elevator and a train station in between.

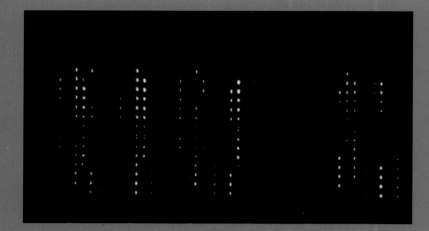
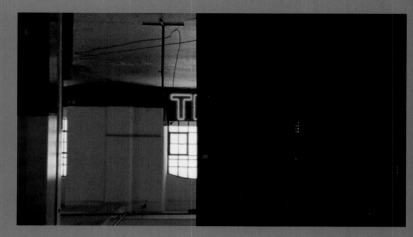

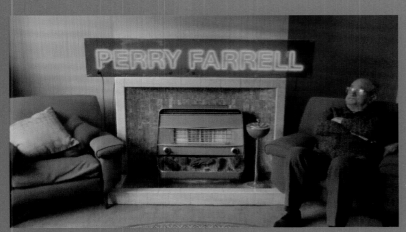

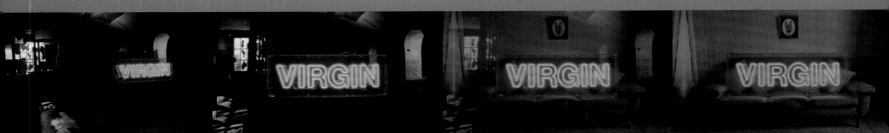

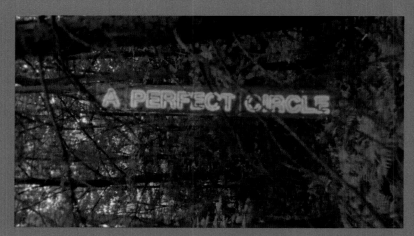

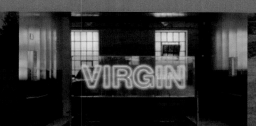

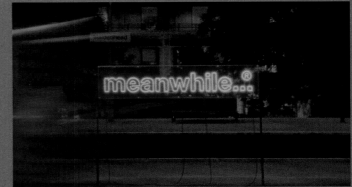
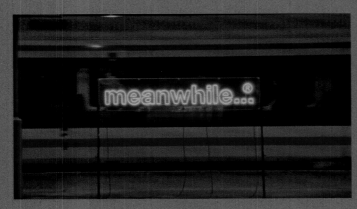
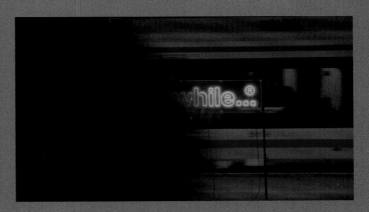

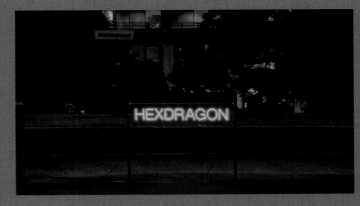

'Apocalypse: Beauty and Horror in Contemporary Art' was
conceived as part of the Royal Academy's own millennium
project. The RA is not known for its presentation of radical art
of the moment, but 'Apocalypse' was a follow-up exhibition to the
very successful and controversial 1987 'Sensation: Young British
Artists from the Saatchi Collection' for which Why Not designed
the poster and advertising material (see Why Not, pp. 202–03).

In 'Apocalypse', thirteen contemporary artists were each given
a gallery space in which to present work that addressed the
powerful and dramatic issues of the time. Artists included Jeff
Koons, Jake and Dinos Chapman, Mariko Mori and Chris
Cunningham, and the exhibition was curated by Norman
Rosenthal and Max Wigram. As with 'Sensation , 'ʌ'.ʲ Not were
asked to produce an original icon to represent the exhibition
rather than taking the more traditional approach of using an
image or detail from one of the featured works.

We were given a copy of the book of Revelation to read for
inspiration, and, armed with that and the exhibition title, we
began to design around the obvious images of doom and gloom:
fire, death, volcanic eruptions, holocausts, and so on. In tandem
with this, we bastardized the font Trade Gothic so all the counters
were filled in black. It was immediately apparent that the word
'apocalypse' was very bold in this font and when juxtaposed
against positive images, the overall effect was incredibly striking,
making the viewer question the meaning of the piece.

We presented our preferred combination for use on the London
Underground – the swimmers embracing in the water – which the
Royal Academy liked, but they also asked to see alternatives and
dutifully we suggested many (see opposite)! In the end, we
returned to our favourite.

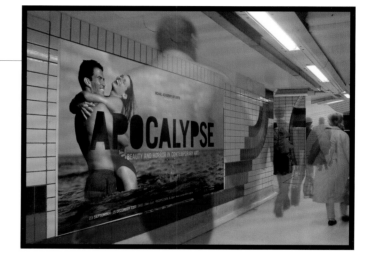

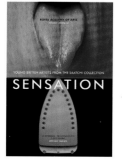

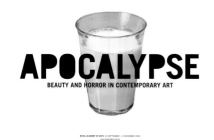
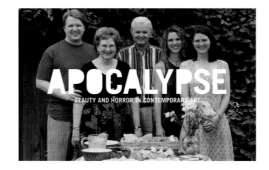
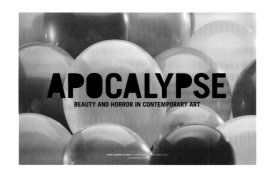
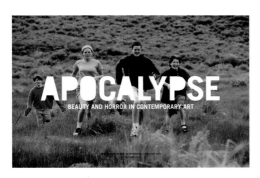
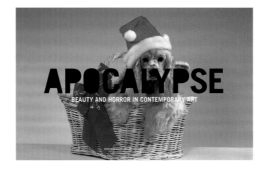
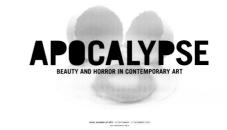
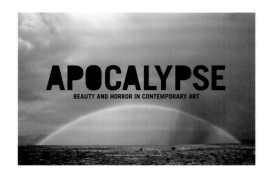
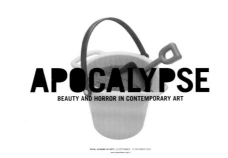
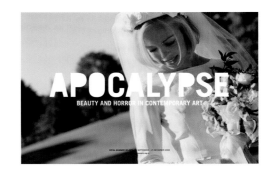
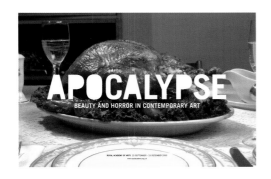
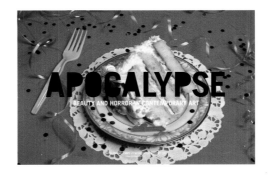
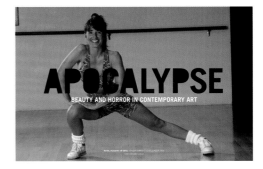
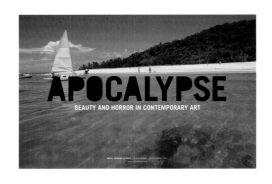
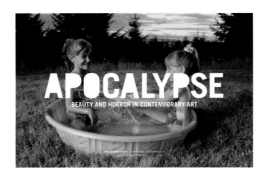
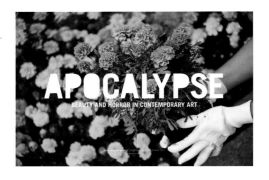

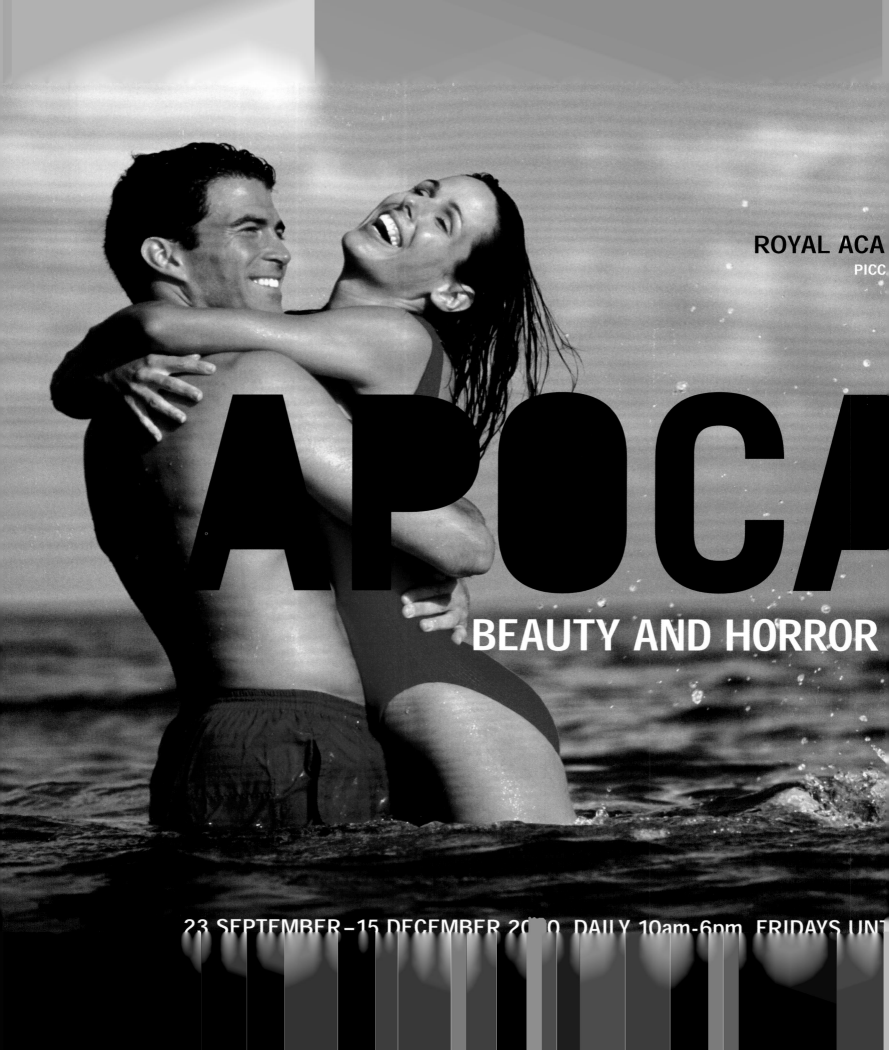

ROYAL ACA

PICC

APOCA

BEAUTY AND HORROR

23 SEPTEMBER – 15 DECEMBER 20 0 DAILY 10am–6pm FRIDAYS UN

MY OF ARTS
LY W1

LYPSE

CONTEMPORARY ART

CONTENTS

JAKE AND DINOS CHAPMAN
Photo: Norbert Schoerner

APOCALYPSE
BEAUTY AND HORROR IN CONTEMPORARY ART

NORMAN ROSENTHAL

DUMMY, UNEDITED TEXT ON JOSEPH BEUYS, THE SECRET BLOCK FOR A SECRET PERSON IN IRELAND: WE ARE ALL STANDING AT A PECULIAR MOMENT IN HUMAN HISTORY: BOTH AT THE ONSET OF A NEW MILLENNIUM AND, MORE SIGNIFICANTLY, AT THE END OF THE TWENTIETH CENTURY. THESE PAST HUNDRED YEARS HAVE SEEN SO MUCH APPALLING AND EXTREME VIOLENCE, MUCH OF IT, BUT BY NO MEANS ALL, HAVING ITS IDEOLOGICAL ROOTS IN CENTRAL EUROPE.

MARIKO MORI
THE EVE OF THE FUTURE

NATHAN KERNAN

MARIKO MORI IS A VISIONARY ARTIST WHO MAKES FULL USE OF, AND EXPANDS, THE CAPABILITIES OF ELECTRONIC IMAGING AND OTHER TECHNOLOGIES TO CREATE WORKS OF FUTURISTIC BEAUTY AND HISTORICAL RESONANCE. IN HER FIRST VIDEO, INSTALLATION AND PHOTOGRAPHIC WORKS FROM THE MID-1990S, MORI, A FORMER FASHION MODEL AND DESIGNER, TRANSFORMED HERSELF INTO AN IRONIC TWENTY-FIRST-CENTURY VERSION OF A COMPLIANT FEMALE CYBORG, REVISITING AS A WOMAN ARTIST A PERENNIAL FIGURE OF MALE SCIENCE-FICTION FANTASY. IN THE LAST FEW YEARS, AS THE SPIRITUAL AND PHILOSOPHICAL UNDERPINNINGS OF HER WORK HAVE BECOME MORE APPARENT, MORI'S PROJECTS HAVE STEADILY BECOME MORE AMBITIOUS IN SCALE AND TECHNICAL EXPERTISE. MORI'S AMBITION ON A TECHNICAL LEVEL SEEMS TO BE NO LESS THAN TO 'RIVAL OR SURPASS THE FORCES MOBILISED BY THE CONTEMPORARY IMAGE STREAM OF POPULAR CONSUMER-DRIVEN CULTURE, AS NORMAN BRYSON HAS WRITTEN,' WHILE HER IDEALISM AND SEARCHING INTELLIGENCE HAVE LED HER TO LOOK INWARD, EXPLORING THE NATURE OF CONSCIOUSNESS AND TIME.

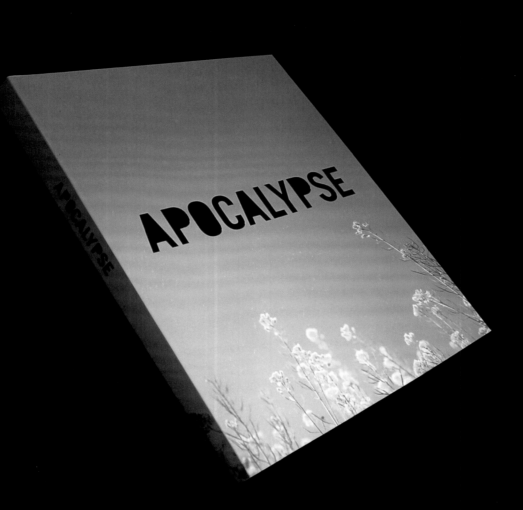

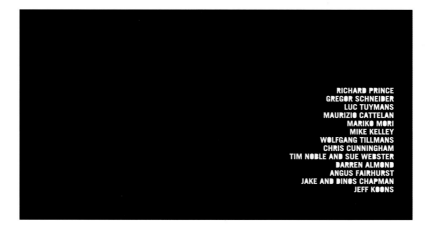

RICHARD PRINCE
GREGOR SCHNEIDER
LUC TUYMANS
MAURIZIO CATTELAN
MARIKO MORI
MIKE KELLEY
WOLFGANG TILLMANS
CHRIS CUNNINGHAM
TIM NOBLE AND SUE WEBSTER
DARREN ALMOND
ANGUS FAIRHURST
JAKE AND DINOS CHAPMAN
JEFF KOONS

CHRIS CUNNINGHAM

MAN, MACHINE AND MUSIC

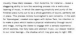

Nike Europe commissioned a series of films to be shown on giant plasma screens within specially built ball-shaped buildings for the Euro 2000 Football Championships. The clips were linked to the main Nike advertising campaign in which each player is presented as an agent with a specific skill. We shot the boots using motion control and combined the various elements and typography in-house using After Effects.

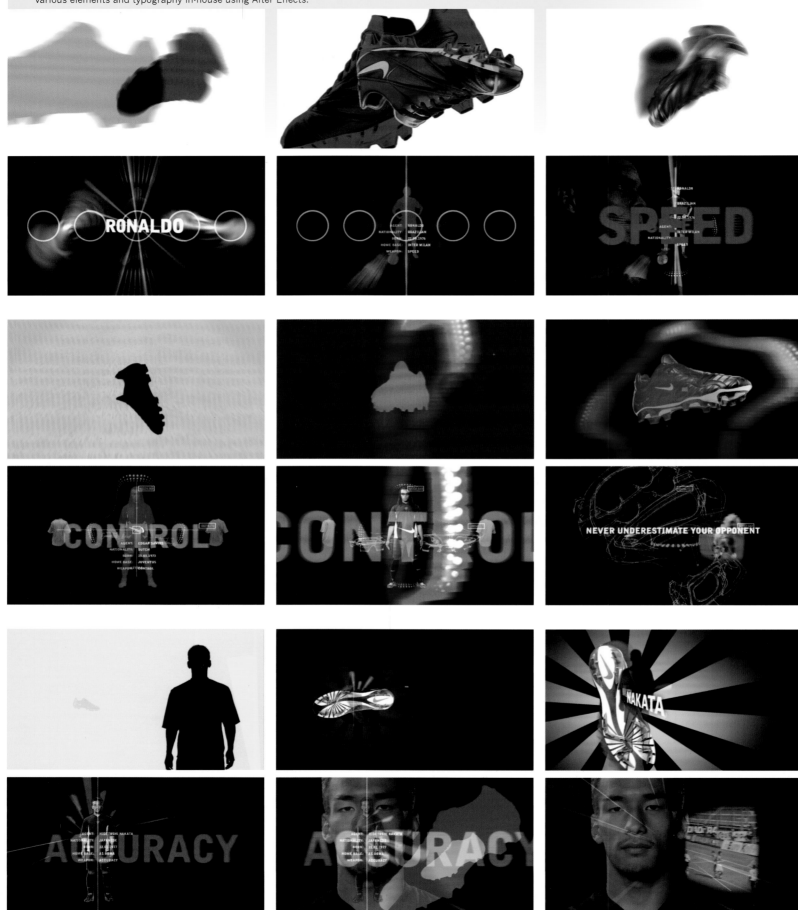

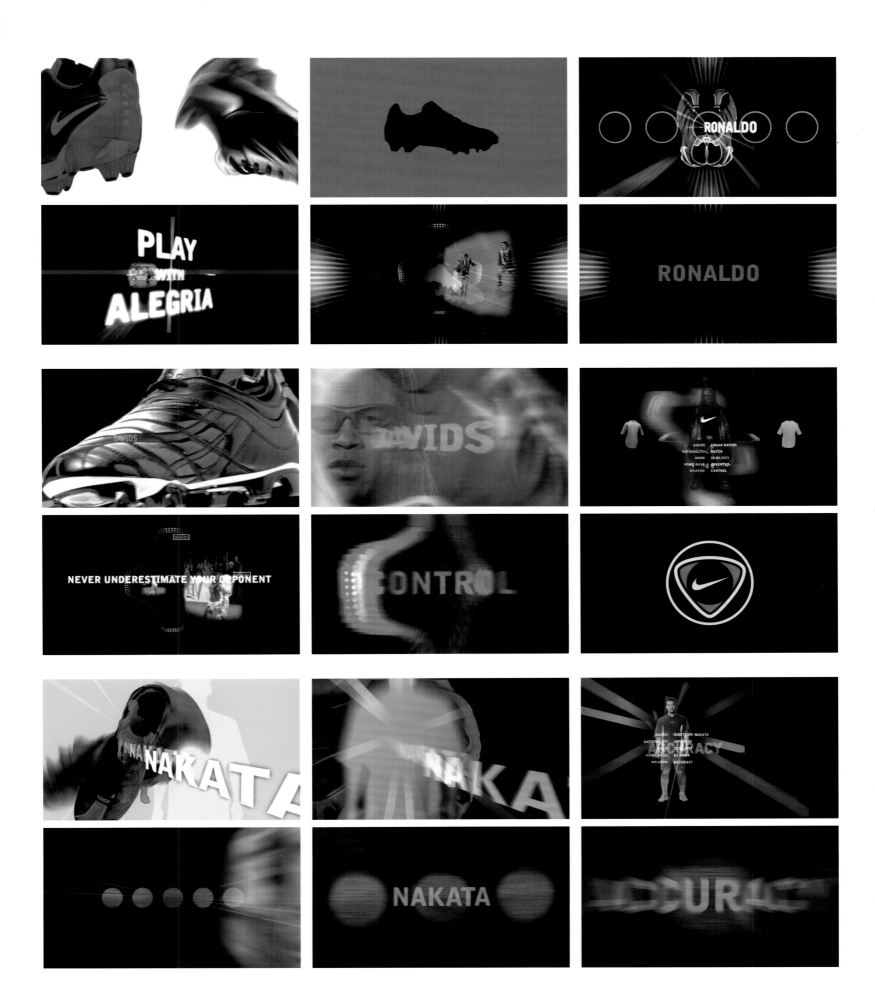

BITE is a yearly season of international theatre events held at the Barbican Centre in London. We created the original identity for the festival and went on to design the website and all the publicity and advertising material. Each year's poster has to be unspecific in its imagery but still needs to convey the energy, diversity and dynamism of the event.

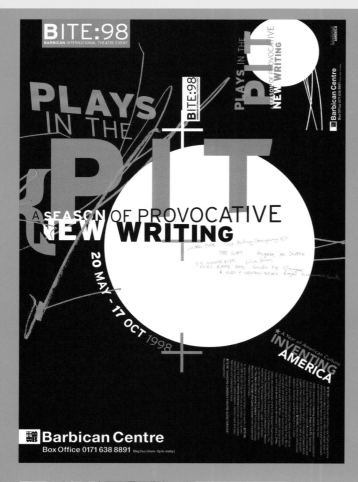

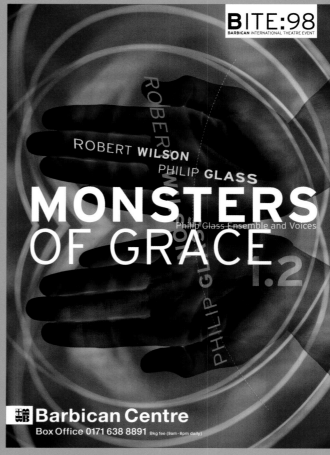

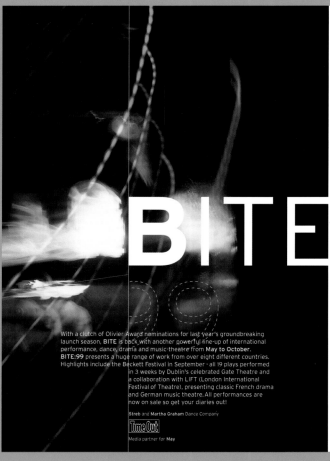

With a clutch of Olivier Award nominations for last year's groundbreaking launch season, **BITE** is back with another powerful line-up of international performance, dance, drama and music-theatre from **May to October**. **BITE:99** presents a huge range of work from over eight different countries. Highlights include the Beckett Festival in September - all 19 plays performed in 3 weeks by Dublin's celebrated Gate Theatre and a collaboration with LIFT (London International Festival of Theatre), presenting classic French drama and German music theatre. All performances are now on sale so get your diaries out!

Streb and Martha Graham Dance Company

Time Out

Media partner for **May**

BARBICAN THEATRE		
	2	**STREB**
	4	**MARTHA GRAHAM** DANCE COMPANY
	5	**CITY**-ODESSA STORIES
	6	**PLATONOV**
	7	THE GAME OF **LOVE** AND **CHANCE**
	8	**DIABELLI** - TWYLA THARP
	9	**BLACK** ON **WHITE**
	10	**SHAZAM!**
	11	**JESSYE NORMAN**
	12	**WIZADORA** - THE MAGIC ADVENTURE
	13-19	THE **BECKETT** FESTIVAL
	20	LIFE IS A **DREAM**
THE PIT	21	**YEMAYÁ**
	22	**ELAINE FEINSTEIN** AND ST.PETERSBURG LEGACY
	23	**VICTORY** OVER THE SUN
	24	**TINKA'S** NEW DRESS
	25	**SCENES** FROM AN **EXECUTION**
	26	PRE AND POST SHOW TALKS AND PRODUCTION CREDITS
	27	BOOKING AND YOUR JOURNEY TO THE BARBICAN
	28-30	**CALENDAR**
	31	**BOOKING FORM**
	32	**PRICES AND DISCOUNTS**
	33	**SEATING AND DISABILITY INFORMATION**

BITE:99
BARBICAN INTERNATIONAL THEATRE EVENT

MAY | OCTOBER THEATRE DANCE MUSIC

BITE
BARBICAN INTERNATIONAL THEATRE EVENT
99

Barbican Centre
Box Office 0171 638 8891 Bkg fee (9am-8pm daily)

www.barbican.org.uk design: why not associates photography: rocco redondo

The Barbican Centre is owned, funded and managed by the Corporation of London.

"INNOVATION, INVENTION AND UNBEATABLE QUALITY · OUR THIRD BITE PROMISES A KALEIDOSCOPE OF THEATRICAL SURPRISES FROM SOME OF THE WORLD'S GREATEST ARTISTS AND COMPANIES."
GRAHAM SHEFFIELD ARTISTIC DIRECTOR, BARBICAN CENTRE

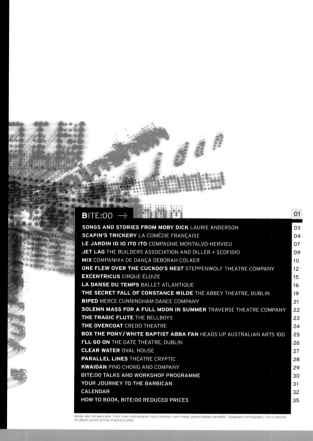

BITE:00 → 01

design: why not associates front cover photography: rocco redondo, mark molloy, blijvert/debbie daniel/RIC typographic photographs: rocco redondo
All details correct at time of going to press

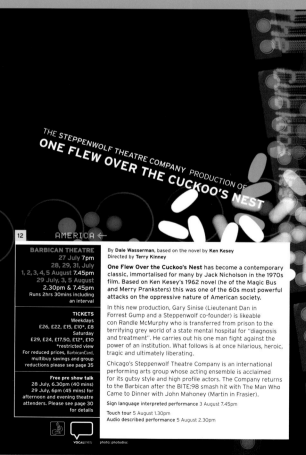

THE STEPPENWOLF THEATRE COMPANY PRODUCTION OF
ONE FLEW OVER THE CUCKOO'S NEST

12 AMERICA ←

BARBICAN THEATRE
27 July **7pm**
28, 29, 31, July
1, 2, 3, 4, 5 August **7.45pm**
29 July, 3, 5 August
2.30pm & 7.45pm
Runs 2hrs 30mins including
an interval

TICKETS
Weekdays
£26, £22, £15, £10*, £8
Saturday
£29, £24, £17.50, £12*, £10
*restricted view
For reduced prices, BarbicanCard,
multibuy savings and group
reductions please see page 35

Free pre show talk
28 July, 6.30pm (40 mins)
29 July, 6pm (45 mins) for
afternoon and evening theatre
attenders. Please see page 30
for details

By **Dale Wasserman**, based on the novel by **Ken Kesey**
Directed by **Terry Kinney**

One Flew Over the Cuckoo's Nest has become a contemporary classic, immortalised for many by Jack Nicholson in the 1970s film. Based on Ken Kesey's 1962 novel (he of the Magic Bus and Merry Pranksters) this was one of the 60s most powerful attacks on the oppressive nature of American society.

In this new production, Gary Sinise (Lieutenant Dan in Forrest Gump and a Steppenwolf co-founder) is likeable con Randle McMurphy who is transferred from prison to the terrifying grey world of a state mental hospital for "diagnosis and treatment". He carries out his one man fight against the power of an institution. What follows is at once hilarious, heroic, tragic and ultimately liberating.

Chicago's Steppenwolf Theatre Company is an international performing arts group whose acting ensemble is acclaimed for its gutsy style and high profile actors. The Company returns to the Barbican after the BITE:98 smash hit with The Man Who Came to Dinner with John Mahoney (Martin in Frasier).

Sign language interpreted performance 3 August 7.45pm

Touch tour 5 August 1.30pm
Audio described performance 5 August 2.30pm

VOCALEYES photo: photodisc

"THE BEST KIND OF AMERICAN ACTING – GRITTY AND GNARLED" THE SUNDAY TIMES

"ONE OF THE MOST INTENSE AND HONORED THEATER COMPANIES IN THE UNITED STATES" US MAGAZINE

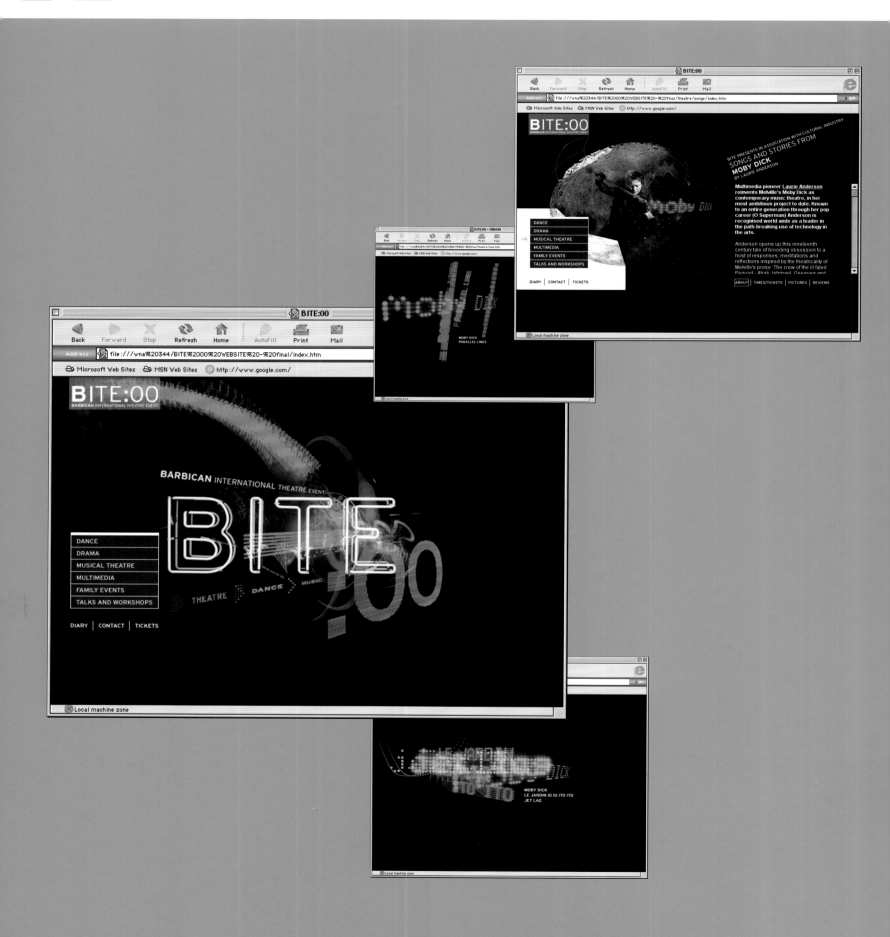

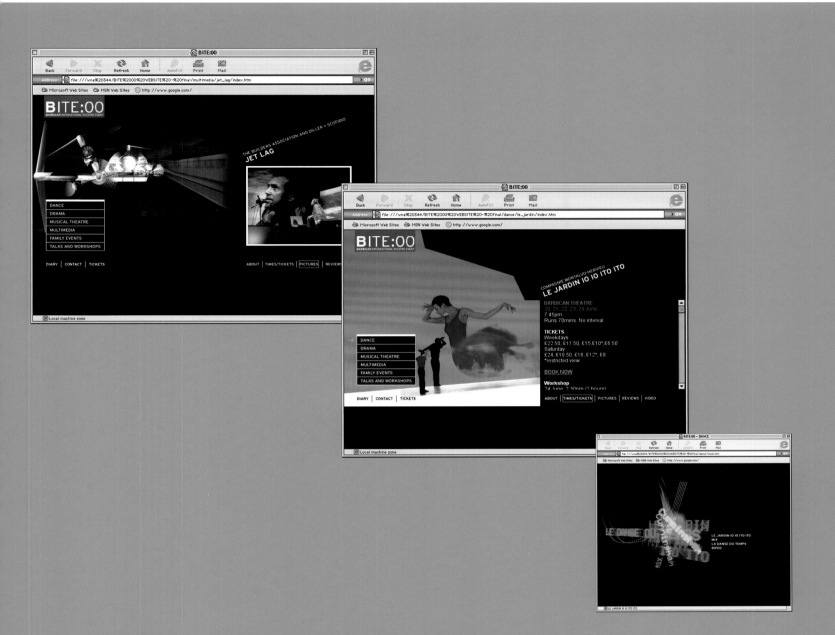
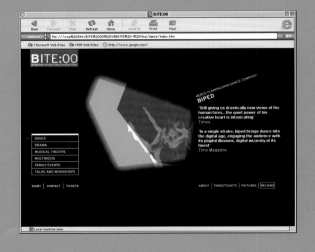

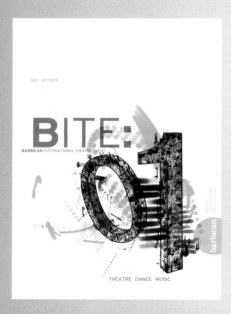

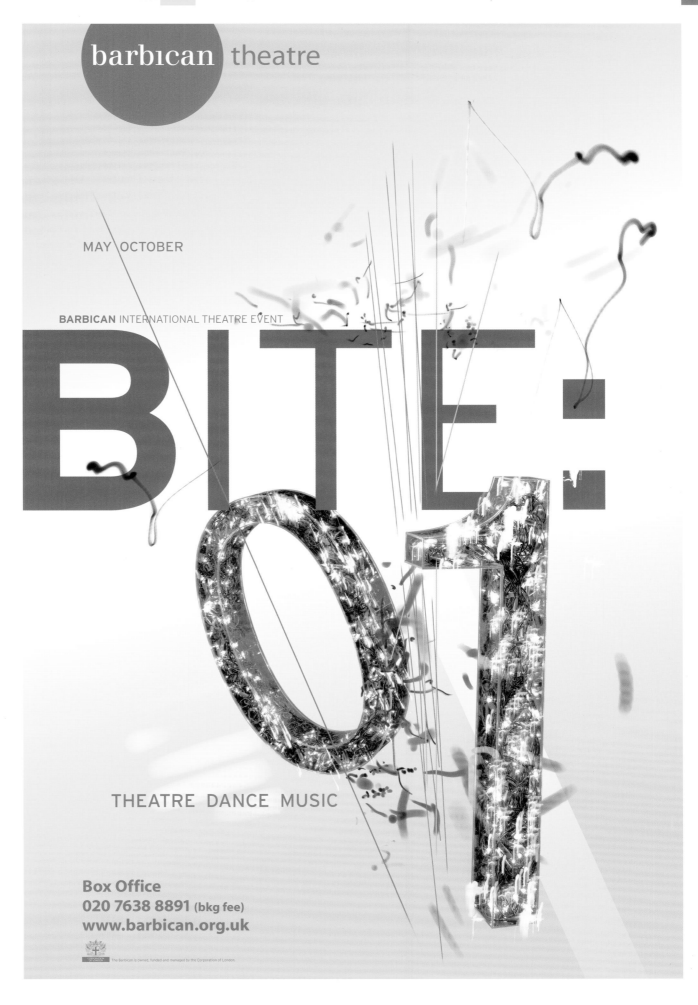

Canadian consultancy Sebastian asked Why Not to work on the promotional material for the new company Leap Batteries. The project consisted of directing two television commercials in London and going on location in Canada. We also designed an 800-x-480mm broadsheet that was inserted in the national press. Working with the tag line 'the evolution of power', we used images of nature to convey a sense of motion, energy and power.

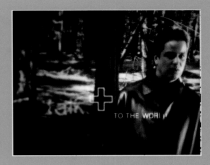

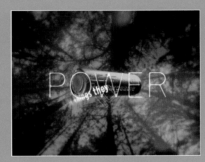

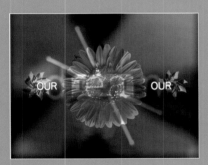
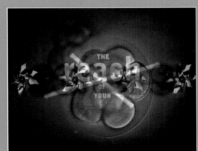

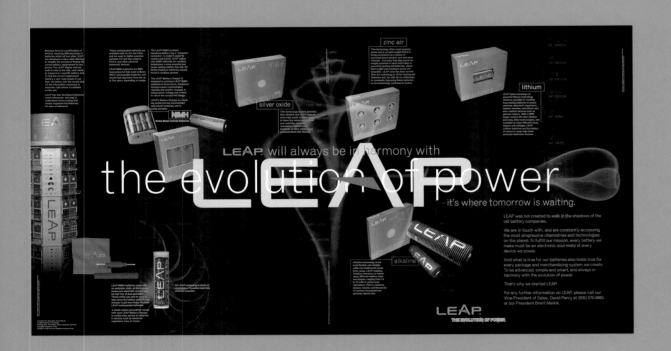

extend the reach

of all your senses

We exist to

to find out more about LEAP and our
products e-mail: info@leapbatteries.com

LEAP.

The wireless world is really about

no boundaries,

only infinite possibilities,

a kind of total electronic freedom

Our inspiration for LEAP was to be as

beautiful, simple and advanced

as the products we power

One day we received a phone call from Steve Thompson, executive producer at Nike Europe, wanting us to create a series of films for Niketown. Some films were to advertise specific products, others were less explicit in their purpose and the material was accompanied with the note 'can you do something cool with this?'. It is rare to find a client with such an approach, but perhaps that is why Nike consistently produces innovative work.

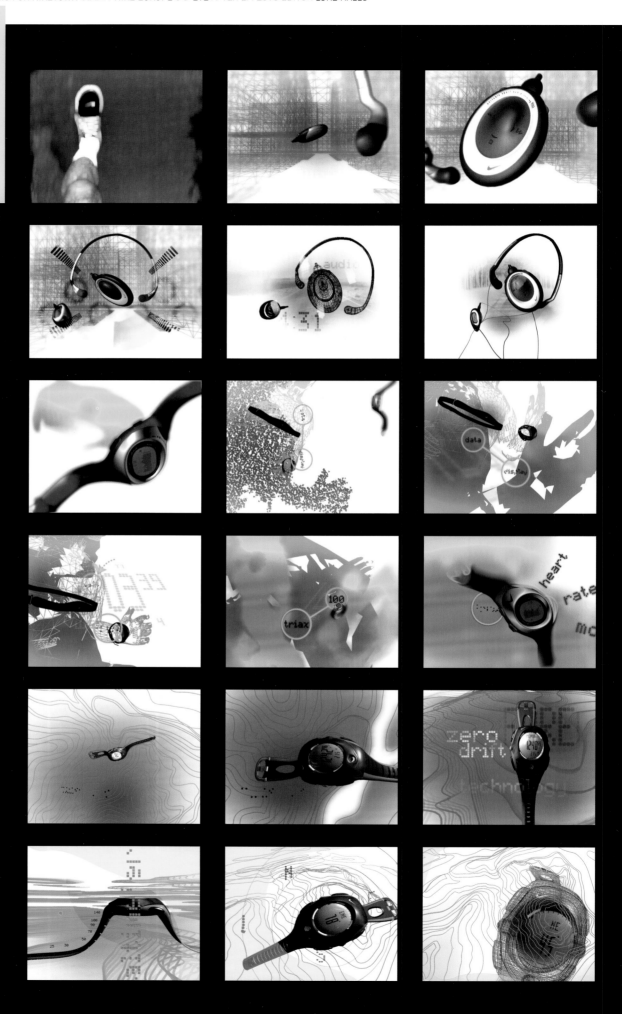

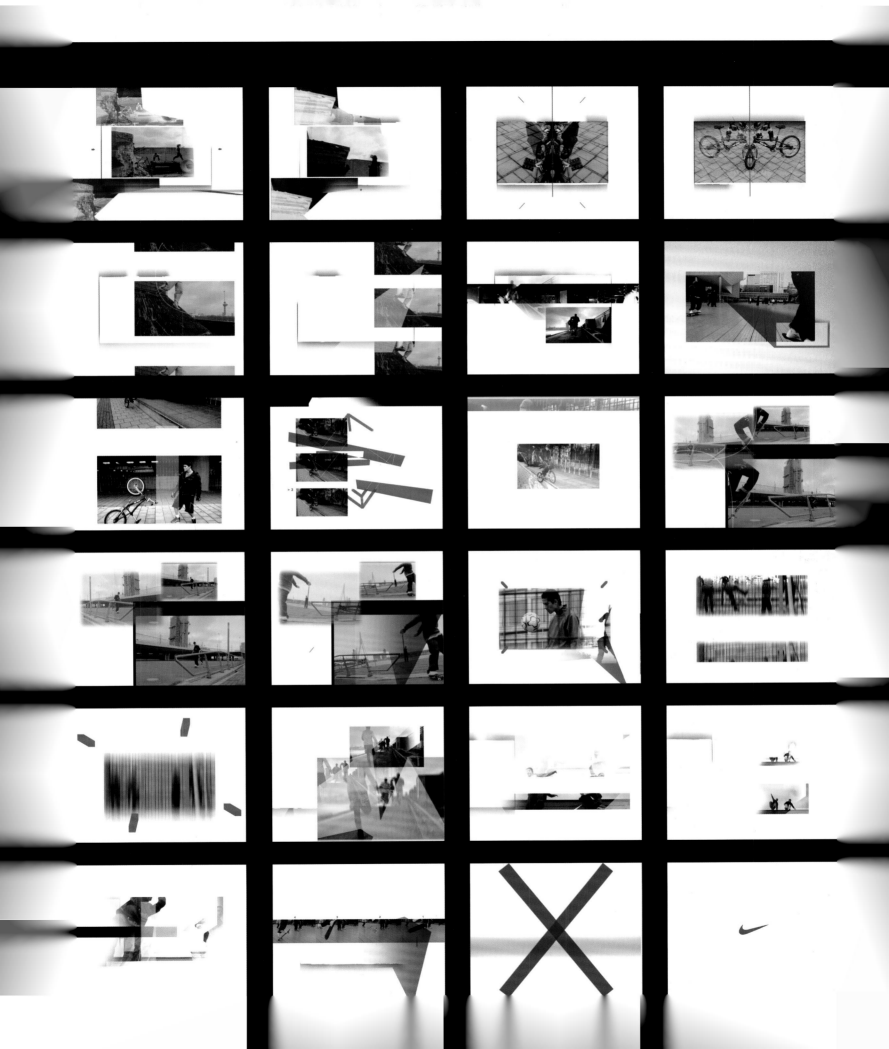

2001

In 1525, the Archbishop of Glasgow, Gavin Dunbar, put the colourfully worded 'Mother of all Curses' on the Reivers, English and Scottish sheep rustlers and robbers who terrorized the border lands between the two countries. Priests read the curse to their congregations in every parish of the area – what is now Cumbria, Northumberland, the Borders and Dumfries and Galloway – in an attempt by the Catholic Church to stop cross-border violence and increase tax revenues by preventing smuggling. Despite these efforts, border reiving continued for another two hundred years.

Finding this monition inspired Carlisle-born artist Gordon Young to create the *Cursing Stone and Reiver Pavement* as part of his contribution to the city's millennium project. Young found the boulder for the project in Scotland: originally weighing fourteen tons, it took over twenty days to be carved and polished before the text was finally sandblasted onto its surface. The stone sits on an eighty-metre granite walkway that has surnames of Reiver families repeatedly sandblasted onto the surface.

Even before it was installed, there was an outcry from various members of the church, who saw the stone as 'a shrine for devil worship', and it eventually became blamed for the foot and mouth crisis! We think the project proves that you can only create really powerful graphics if you have strong content.

"Words can affect reality for good or ill and become even more powerful when they are written down,"
Reverend Kevin Davies

"As for the future of the stone and the curse it brings, they need to be broken, both literally and spiritually, for all time."
Reverend Kevin Davies

"...I curse
thair face,
thair ene,
thair mouth,
thair neise,
thair toung,
thair teith,
thair crag,
thair schulderis,
thair breist,
thair hert,
thair stomok,
thair bak,
thair wame,
thair armes,
thair leggis,
thair handis,
thair feit,
and everilk part of thair body,
frae the top of thair heid
to the soill of thair feit,
befoir and behind,
within and without..."

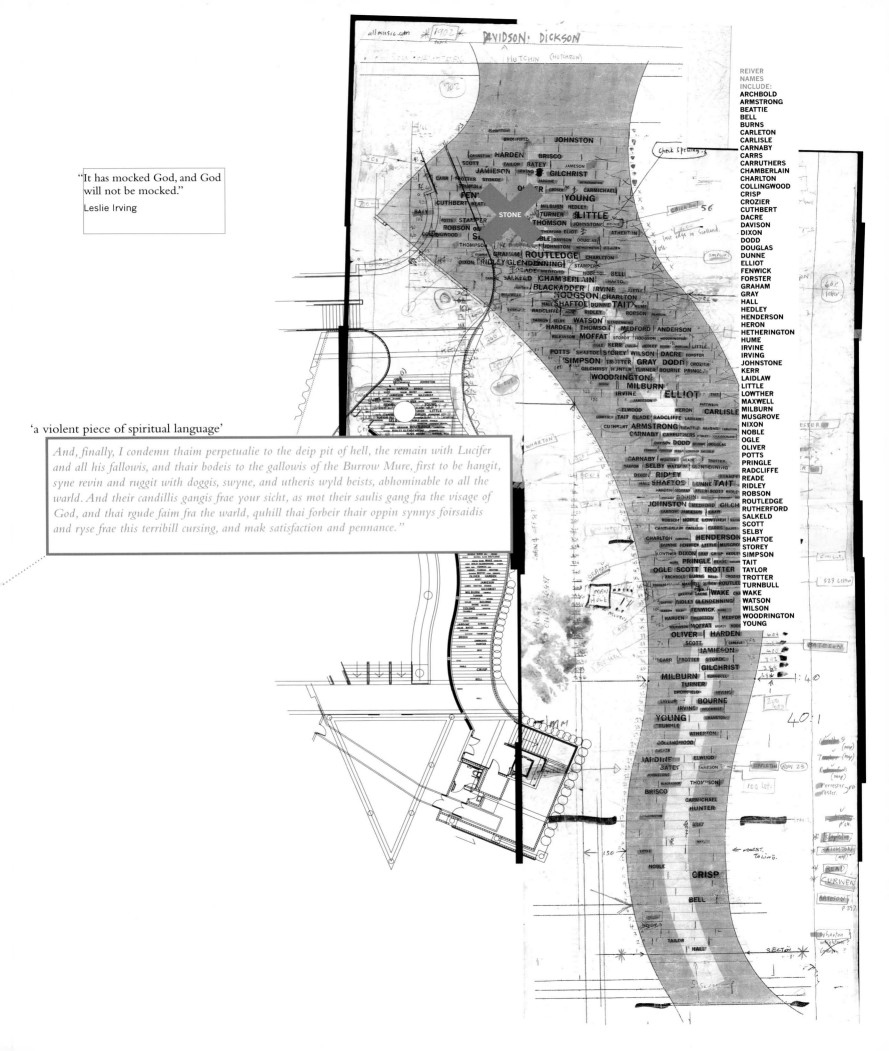

"It has mocked God, and God will not be mocked."

Leslie Irving

'a violent piece of spiritual language'

And, finally, I condemn thaim perpetualie to the deip pit of hell, the remain with Lucifer and all his fallowis, and thair bodeis to the gallowis of the Burrow Mure, first to be hangit, syne revin and ruggit with doggis, swyne, and utheris wyld beists, abhominable to all the warld. And their candillis gangis frae your sicht, as mot their saulis gang fra the visage of God, and thai rgude faim fra the warld, quhill thai forbeir thair oppin synnys foirsaidis and ryse frae this terribill cursing, and mak satisfaction and pennance."

REIVER
NAMES
INCLUDE:
ARCHBOLD
ARMSTRONG
BEATTIE
BELL
BURNS
CARLETON
CARLISLE
CARNABY
CARRS
CARRUTHERS
CHAMBERLAIN
CHARLTON
COLLINGWOOD
CRISP
CROZIER
CUTHBERT
DACRE
DAVISON
DIXON
DODD
DOUGLAS
DUNNE
ELLIOT
FENWICK
FORSTER
GRAHAM
GRAY
HALL
HEDLEY
HENDERSON
HERON
HETHERINGTON
HUME
IRVINE
IRVING
JOHNSTONE
KERR
LAIDLAW
LITTLE
LOWTHER
MAXWELL
MILBURN
MUSGROVE
NIXON
NOBLE
OGLE
OLIVER
POTTS
PRINGLE
RADCLIFFE
READE
RIDLEY
ROBSON
ROUTLEDGE
RUTHERFORD
SALKELD
SCOTT
SELBY
SHAFTOE
STOREY
SIMPSON
TAIT
TAYLOR
TROTTER
TURNBULL
WAKE
WATSON
WILSON
WOODRINGTON
YOUNG

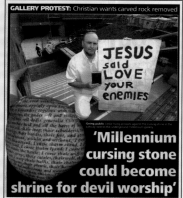
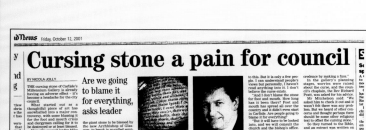

News Friday, October 12, 2001

Cursing stone a pain for council

BY NICOLA JOLLY

Are we going to blame it for everything, asks leader

THE cursing stone of Carlisle's Millennium Gallery is already having an adverse effect – it become a headache for the city council.

What started out as a thoughtful piece of art has snowballed into a major controversy, with some blaming it for the foot and mouth crisis and clergymen calling for it to be destroyed or at least blessed.

Now city council leader Mike Mitchelson has agreed to look into those demands, but admits it is a delicate situation because others have called for the curse to be ignored.

His reaction comes after the Bishop of Carlisle, the Rt Reverend Graham Dow, called for the giant stone to be blessed by the new Archbishop of Glasgow, to break its so-called spiritual power.

The stone is the centrepiece of the underground gallery beneath Castle Way. It features the words of a 14th century curse by the then Archbishop of Glasgow against the Border Reivers who were pillaging the

area. It is read by walking around it in an anti-clockwise direction, which some say is a process used in satanic rituals.

Mr Mitchelson said: "I don't expect this. No-one realised during the early stages the controversy that that part of the gallery would cause. It's peculiar how people have latched on

to this. But it is only a few people. I can understand people's views but personally, I haven't read anything into it. I don't believe the curse exists.

"And I don't blame the stone for foot and mouth. How long has it been there? Foot and mouth has spread all over the country and it didn't even start in Carlisle. Are people going to blame it for everything?

"But it will have to be looked into, and we will consult the church and the bishop's office. If he feels there should be some lifting of the curse, we shall look into it.

"It's a difficult one, a fine balance, and there are views on both sides. I've had letters from people saying we should ignore it and not give the curse any

credence by making a fuss."

In the gallery's planning stages, worries were raised about the curse, and the council's chaplain, the Rev Richard Pratt, was asked for his advice.

Mr Mitchelson said: "We asked him to check it out and it wasn't felt there was any problem. But we heard of other concerns and thought perhaps there should be some other religious text to offset the cursing stone."

So they turned to the Bible, and an extract was written on the door next to the stone.

The quote from Paul's Letter to the Philippians refers to "whatsoever is true, honourable, just, pure, lovely and gracious", ending with "and the peace of God be with you."

● **STONE ME!** 'I don't believe the curse exists,' says Mike Mitchelson

● Letters – Page 13

Page 30 NW1 Daily Mail, Tuesday, November 6, 2001

Visitors to gallery have revived a 500-year-old oath, warns church leader

Written in stone: The huge granite sphere on which the curse is carved

Bishop tries to lift curse blamed for causing foot and mouth

By Nilufer Atik

Revoking evil: The Bishop of Carlisle

IT is a curse that has sat in the history books for hundreds of years.

Written by the Catholic Archbishop of Glasgow, it was intended to condemn 16th century pillagers to the torments of hell.

But modern clergymen fear the power of the ancient curse of Cumbria has been revived after it was inscribed on a giant stone to form the centrepiece of a millennium exhibition.

Now Anglican leaders, including the Bishop of Carlisle, the Right Reverend Graham Dow are calling for the stone to be 'exorcised'.

One cleric has even suggested the oath could have contributed to the region's foot-and-mouth epidemic.

'Words have power and in as much as the curse wishes evil on people it should be revoked,' said Bishop Dow.

The oath was issued 500 years ago against the 'Border Reivers' – English and Scottish sheep rustlers. Priests in every parish of what is now Cumbria, Northumberland, the Borders, Dumfries and Galloway, read it to congregations.

Three years ago, sculptor Gordon Young carved the words into a huge granite ball for an exhibition in the new Millennium Gallery in Carlisle. Now some Christians believe the

'I can't see a problem'

power of the curse has been maintained by visitors walking around the stone in an anti-clockwise direction.

The Vicar of Scotby, Reverend Kevin Davies, blames the stone for the severe outbreak of foot-and-mouth in Cumbria and says it should be smashed to pieces.

And the Bishop of Carlisle, a friend of Tony Blair, has asked the Catholic Church in Scotland to lift the curse by blessing the stone. He said: 'I would prefer it if the stone wasn't there. If it has to stay I would prefer like a blessing to offset it.

But Rev Gavin Gilchrist, of St Herbert's Church, Carlisle, said: 'I can't see a problem with someone walking around the stone to read the inscription.'

the giant stone to be blessed by the new Archbishop of Glasgow, to break its so-called spiritual power.

The stone is the centrepiece of the underground gallery beneath Castle Way. It features the words of a 14th century curse by the then Archbishop of Glasgow against the Border Reivers who were pillaging the

and the curse it brings, they need to be broken, both literally and spiritually, for all time."

The giant stone is the centrepiece of the underground gallery, part of the city's Millennium Gateway scheme.

The text dates from the 16th century, when the Borders were in the grip of pillaging Reivers. The Archbishop of Glasgow issued the curse in the hope of instilling the fear of God into the rebels.

A council spokeswoman said: "The bishop's stone is an impressive piece of craftsmanship incorporating an important part of Border Reiver history. Placing the stone in the walkway complements the Reiver pavement and forms an

integral part of the public scheme."

This is not the first time the stone has fallen foul of local Christians. Leslie Irving, editor of the Christian magazine Bound Together, warned last month that the stone could become the focus of satanic rituals.

Mr Davies was unavailable

Bishop calls for 'powerful' Reiver curse to be lifted

BY JULIAN WHITTLE

THE Bishop of Carlisle wants to hold a ceremony to break the "spiritual power" of the cursing stone in the city's new Millennium Gallery.

The Rt Rev Graham Dow has joined a growing section of Christian opinion concerned about the malevolent influence of the stone, which is inscribed with a 14th century curse issued by the Archbishop of Glasgow.

The giant stone, the centrepiece of the underground gallery, carries the words of the 700-year-old curse against the Border Reivers who laid waste to the area at that time.

Some Carlisle Christians have even suggested it may have contributed to the foot and mouth epidemic.

Bishop Dow does not go that far, but wants the modern-day Archbishop of Glasgow to visit Carlisle to lift the curse.

He said: "I understand that it is a piece of history and it is reasonable for it to be known about, but words have power and in as much as the curse wishes evil on people it should be revoked.

"I would prefer it if the stone wasn't there. If it has to stay I would prefer a blessing to offset it. We can't treat it as just a joke.

"People have differing views about spiritual power and its capacity to do evil, but I am sure spiritual power is a real force."

Some evangelical Christians believe visitors re-invoke the curse

as they walk anti-clockwise around the stone to read it.

The Cumberland News reported last week that the vicar of Scotby, the Rev Kevin Davies, had called for the stone to be broken, "literally and spiritually", and linked the curse with foot and mouth.

He wrote in the parish magazine: "This stone, whatever the council's intent, is a lethal weapon. Its spiritual violence will act like a cancer underneath the fabric of society."

Bishop Dow said: "I share these

● 'WORDS HAVE POWER:' The Bishop of Carlisle, Graham Dow

concerns, although I don't know whether there is any direct connection [with foot and mouth]."

His predecessor, the Rt Rev Ian Harland, had approached the Roman Catholic Archbishop of Glasgow about a ceremony to lift the curse, but there was not enough support from the city churches.

"I revived the invitation but the Cardinal Archbishop of Glasgow, Thomas Winning, has since died and we are waiting for a new Archbishop," said Bishop Dow.

"There are no definite plans made but I think it would be helpful if the new Archbishop were to revoke the curse."

He said it was desirable to change the context of the cursing stone to wish good on people rather than evil, and said there were people within Carlisle City Council who were sympathetic to this view.

The bishop's comments were welcomed by Leslie Irving, editor of the Carlisle-based Christian magazine Bound Together, who has campaigned against the stone for two years, was the first to make a connection with foot and mouth and has written letters to the Queen and others.

14th century curse for concern?

EXTRACT FROM THE CURSE: ...I curse their held and all the harts on their heid, I curse their face, their ene, their mouth, their nase, their tung, their teeth, their crag, their schulderis, their breist, their hert, their stomok, their bak, their wame, their armes, their legis, their handis, their feit...I curse their wyffis, their bairnis, their servandis participand with thaim in their deides...I curey their corpis, their catale, their woll, their scheip, their hors, their nayne, their geis... their hirts (cranheth), their heryandis, their culyerdis (cubbage patches)...

● Town & Country 8&9 ● District News 10&11 ● Agenda 12 ● Letters 13 ● Business News 14
● Community 17 ● Weddings 18&19 ● Farming 22 ● Sport 23-26 ● Review 27 ● TV 28 ● What's On 29

Is Cursing Stone to blame for foot and mouth, asks the vicar

BY JULIAN WHITTLE

THE VICAR of Scotby, near Carlisle, says the Cursing Stone in the city's Millennium Gallery may be to blame for the severity of the foot and mouth outbreak.

The Rev Kevin Davies, Vicar of Scotby and Cotehill with Cumwhinton, has launched a vehement attack on the stone, which invokes a medieval curse against the Reivers.

He believes it could bring all manner of woes, and says it should be smashed to pieces to break the spiritual power of the curse.

"This stone, whatever the council's original intent, is a lethal weapon," he wrote in the parish magazine, Pow Maughan.

"Its spiritual violence will act like a cancer underneath the fabric of society. I don't think anyone in their right mind could argue that this is what Cumbria needs just now.

"Is it a coincidence that the curse was first bandied about in 1999-2000 and now, in 2001, we find that that Cumbria is the worst affected region in the entire country to the foot and mouth crisis?

"The land retains what is spoken against it and the violence acted upon it.

"As to the future of the stone

● THE REV KEVIN DAVIES: 'Astonishing complacency regarding the reality of power in the spiritual realm' ● EVIL INFLUENCE? The Cursing Stone in Carlisle's Millennium Gallery

for comment this week. He is due to return from a three-month sabbatical on Monday.

His article says: "Clearly the city council holds matters spiritual in such trivial regard that it cheerfully can commission the equivalent of a loaded gun and regard it as a tourist attraction. The ignorance of those content to have this curse

re-invoked each time it is read or spoken beggars belief.

"Without doubt the curse was effective in its original context, as we no longer suffer cross-border raids. To reinvoke it was unnecessary, inappropriate and shows astonishing complacency regarding the reality of power in the spiritual realm."

The Cumberland News Friday, October 5, 2001 LETTERS TO THE EDITOR 13

Stone superstitions hark back to days of witchcraft

Archbishop to lift 'evil' curse linked to foot and mouth

BY JONATHAN PETRE

AN "EVIL" 16th-century curse inscribed on a giant stone in Cumbria – the centrepiece of a £67 million millennium exhibition – is to be "exorcised" by an archbishop after clergy complained that it generated "spiritual violence".

The Bishop of Carlisle, Rt Rev Graham Dow, is backing local Christians who believe that the curse exerts a malevolent influence. One clergyman has even suggested that it could have contributed to the foot and mouth epidemic in Cumbria.

The colourfully worded curse was originally issued 500 years ago by the then Archbishop of Glasgow, Gavin Dunbar, against English and Scottish sheep rustlers and robbers who terrorised the border country. Priests in the pulpits of every parish in what is now Cumbria, Northumberland, the Borders, and Dumfries and Galloway read it aloud to congregations.

The words, which condemn the "reivers" to the torments of hell, were carved into a eight foot granite sphere by a sculptor three years ago, who was commissioned by Carlisle city council as part of the millennium project. An extract reads:

I curse thair heid and all the hairis of thair heid; I curse thair face, thair ene, thair mouth, thair neise thair toung, thair teith, thair crag, thair shoulderis, thair breist, thair hert, thair stomach, thair bak, thair wame, thair armes, thair leggis, thair handis, thair feit, and everilk part of thair body, frae the top of thair heid to the soill of thair feit, befoir and behind, within and without.

I condemn thaim perpetuallie to the deip pit of hell, to remain with Lucifer and all his fallowis, and thair bodeis to the gallowis of the Burrow Mure, first to be hangit, syne revin and ruggit with doggis, swyne, and utheris wyld beists, abhominable to all the warld. And thair candellis (gangand) fra your sicht, as mot their saulis gang fra the visage of God, and their gude fame fra the world, quhill thai forbeir thair oppin synnis foirsaidis and ryse frae this terribill cursing, and mak satisfaction and pennance.

Bishop Dow, a friend of the Prime Minister, Tony Blair, since he was an Oxford university chaplain in the 1970s, has dismayed councillors by disclosing that he has invited whoever succeeds the late Cardinal Thomas Winning, who died in June, as the next Roman Catholic Archbishop of Glasgow, to visit Carlisle to bless the stone and lift the curse invoked by his predecessor.

He said that while he did not believe that the curse was connected to the outbreak of foot and mouth in the region, it did contain "spiritual power" and he would prefer that it was removed altogether.

"I understand that it is a piece of history and it is reasonable for it to be known about, but words have power and in as much as the curse wishes evil on people it should be revoked," he said.

"If it has to stay I would prefer a blessing to offset it. My own heart is not just a joke. People have differing views about spiritual power and its capacity to do evil, but I am sure that it is a real force."

Bishop Dow's comments follow claims by the Rev Kevin Davies, the vicar of Scotby and Cotehill with Cumwhinton, that the stone may be to blame for the severity of the foot and mouth outbreak.

In a fierce attack on the medieval curse, Mr Davies said it would bring "all manner of woe" and should be smashed into pieces.

"Clearly, the council holds matters spiritual in such trivial regard that it can cheerfully commission the equivalent of a loaded gun and regard it as a tourist attraction," he wrote in his parish magazine.

"Its spiritual violence will act like a cancer underneath the fabric of society. I don't think anyone in their right mind could argue that this is what Cumbria needs just now."

Leslie Irving, the editor of the evangelical magazine Round Together, said that the stone, which is housed in the city's underground millennium Gallery, could become the focus of satanic rituals.

A spokesman for the council said that it took Bishop Dow's concerns seriously and senior council members were arranging to meet him in the next few weeks. "We do not regard the stone as evil. We regard it as a work of public art," she said.

Bishop Dow, a friend of the Prime Minister

Cursed stone: a clergyman has suggested that it may have contributed to the foot and mouth epidemic

Up to his mitre in mumbo-jumbo

WHAT on earth is the Bishop of Carlisle doing getting involved in a load of mumbo-jumbo about the 14th century curse on a stone in the city's new Millennium Gallery.

The stone carries the words of a 700-year-old curse against the Border Reivers. One local vicar wants it broken "literally and spiritually" and has linked it with foot and mouth.

Bishop Graham Dow says he shares these concerns and has revived an invitation to the Archbishop of Glasgow, one of whose distant predecessors apparently invoked the curse, to come and lift it.

Has the church nothing better to do with its time than become embroiled in the sort of twaddle that witch doctors in the New Guinean jungles ditched decades ago?

What next? Coming soon to a church hall near you. *Exorcist III – The Cursing*

Stone starring the local curate with special guest appearances from Bishop Dow, as himself, and the Archbishop of Glasgow, directed by Ken Russell.

with musical effects by the massed bands of Carlisle City Council.

Conspiracy theories over the outbreak of foot and mouth abound. They range from a plot by Tony Blair to stage manage the election to Osama Bin Liner and his terrorist pals wrecking the British economy.

Frankly some of the wilder, more fanciful theories hold greater water than the accursed stone and its devilish powers.

For one thing, it doesn't explain how foot and mouth also got into far removed parts of the country like Devon for example. I don't think even the most dedicated Reivers made it that far south.

I suggest that the real causes of the foot and mouth outbreak, if they are ever discovered, are likely to lie in incompetence and poor agricultural and food practices rather than some ancient lump of rock.

Rock of rages: The Bishop of Carlisle

"This stone, whatever the council's intent, is a lethal weapon. Its spiritual violence will act like a cancer underneath the fabric of society."

Reverend Kevin Davies

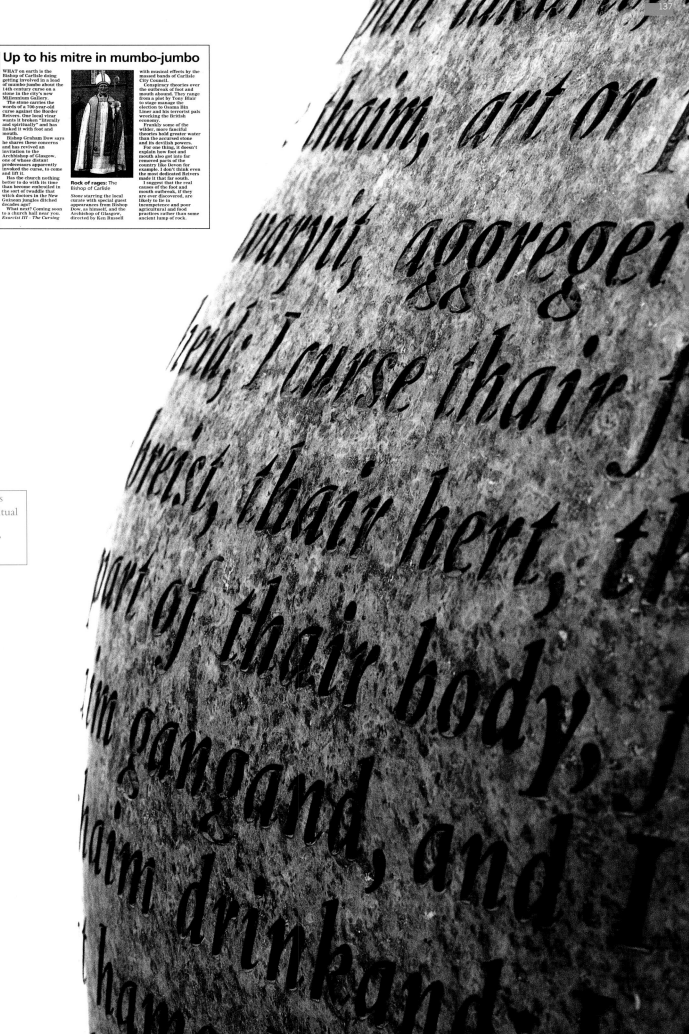

We wanted the visuals for our fourth conference film for Virgin to tell more of a story than the others had. Influenced by the number of rock artists and the fact that the majority of the delegates would be travelling around the world to attend the event, we decided on a road-movie theme. Trooping off to California, we spent five days filming an iconic red Buick Convertible make its way from the bright city lights, across highways and byways, through deserts, forests and suburbia to the coast. Each stage of the journey represented a different artist.

VIRGIN
SPECIAL
PROJECTS
2001

VIRGIN
SPECIAL
PROJECTS
2001

VIRGIN
SPECIAL
PROJECTS
2001

VIRGIN
SPECIAL
PROJECTS
2001

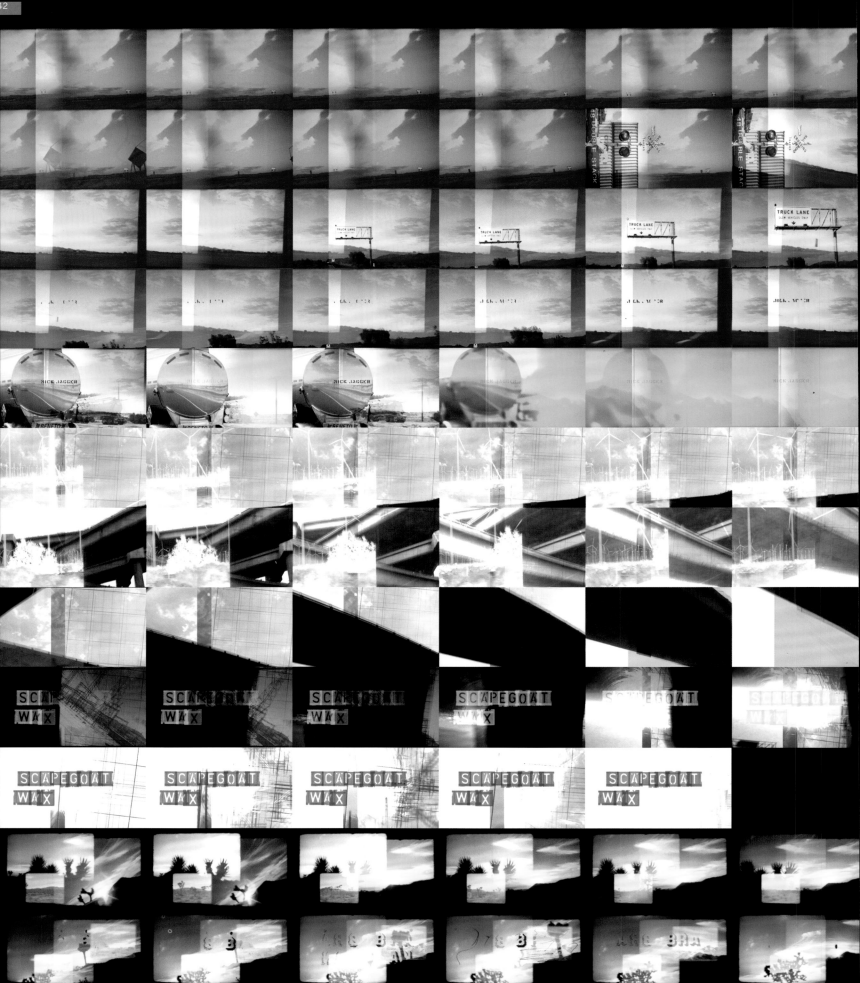

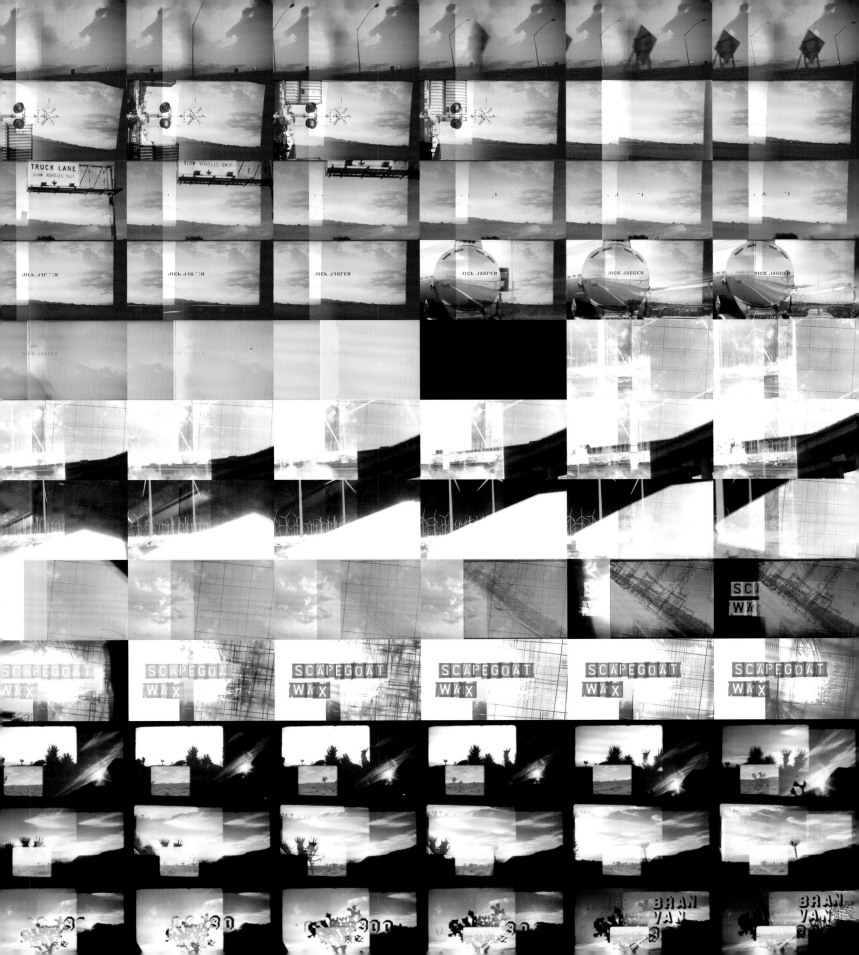

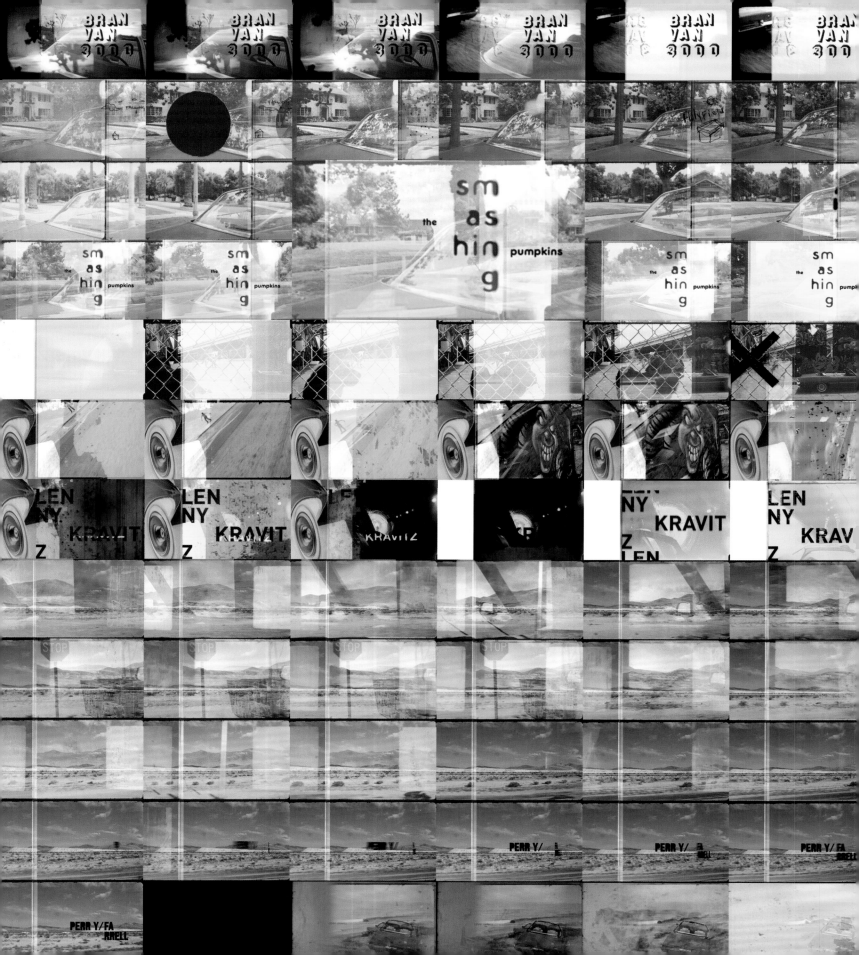

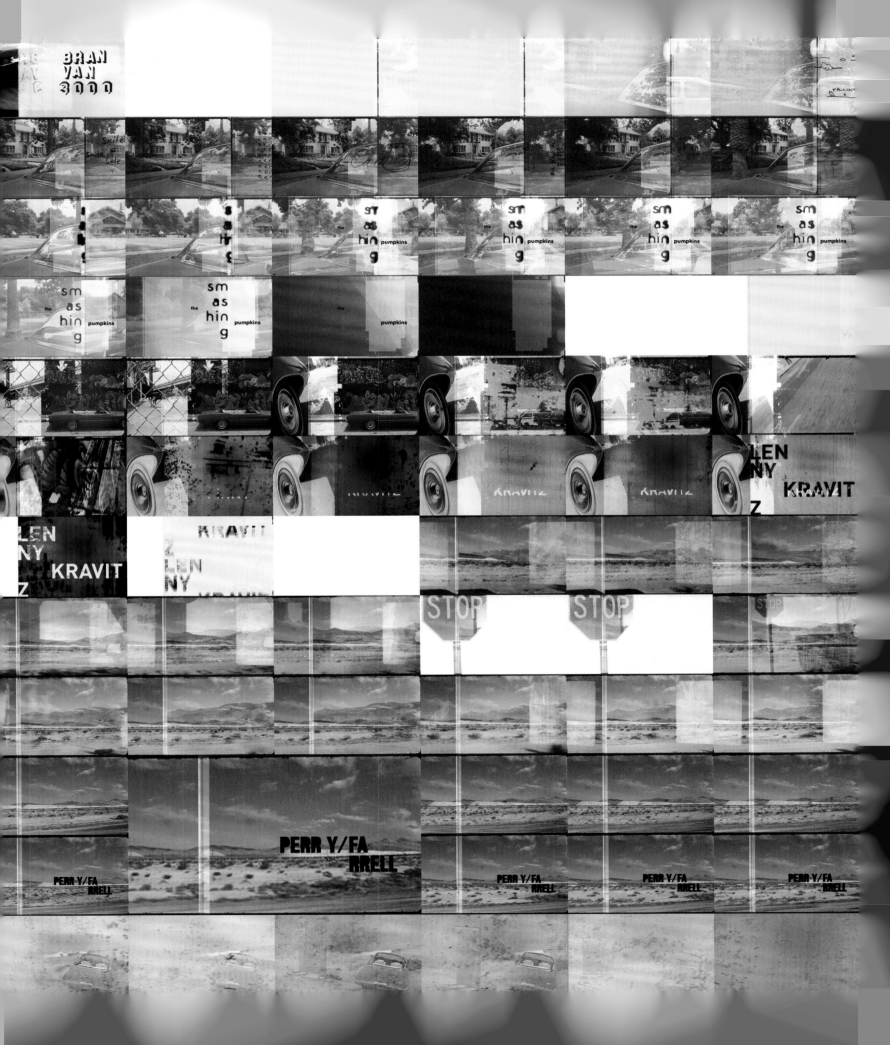

The Czech Centre in London originally approached Studio Najbrt and Why Not with the intention of mounting an exhibition of their graphic design. The aim was to highlight the differences and similarities between the two studios and the two cities. After everyone had met, however, we thought it much more exciting to produce a new piece of work that directly compared the two studios, and so the exhibition 'City Mesto' was born. We decided on a set of key words – river, souvenir, transport, faith, after hours, language, pavement, consume, sound – for both of us to interpret.

Each studio then designed a large-scale banner, printed on translucent film, for every key word. Neither company saw the other's designs until they were hung in the exhibition, where the contrasts and likenesses became evident. The banners for 'faith' were one of our favourites (see p. 149): we used a child's scribblings about God that we had found in a book, while Studio Najbrt expressed their thoughts with a banner that was completely blank apart from the title.

The exhibition was first shown at The Czech Centre, before moving to the Galerie Tunnel in Prague. On the opening night in Prague, a drunk student attacked and trashed most of the exhibition.

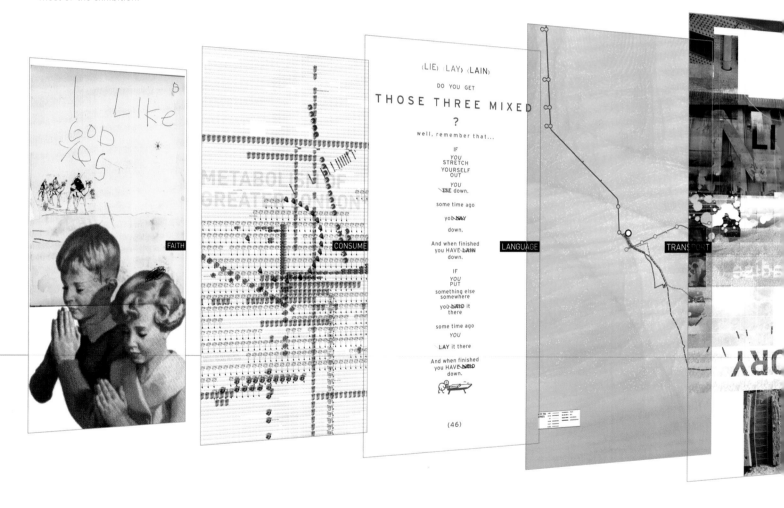

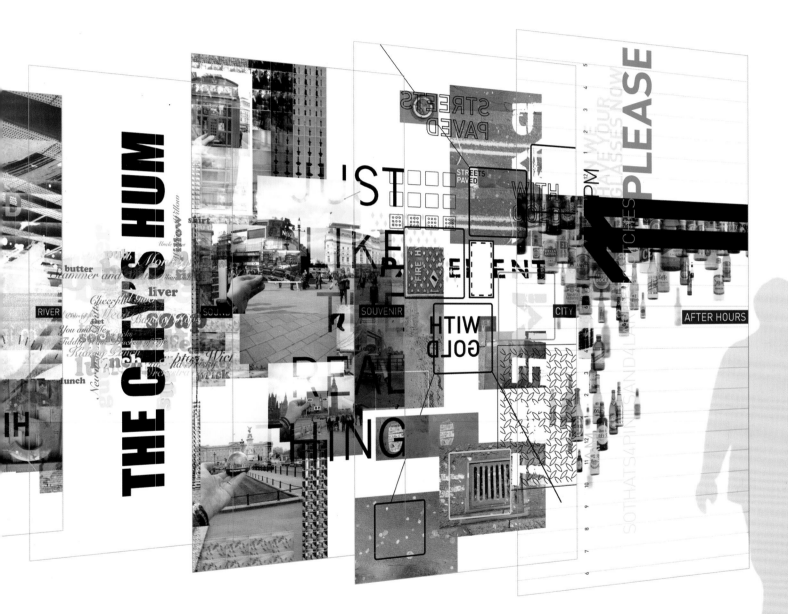

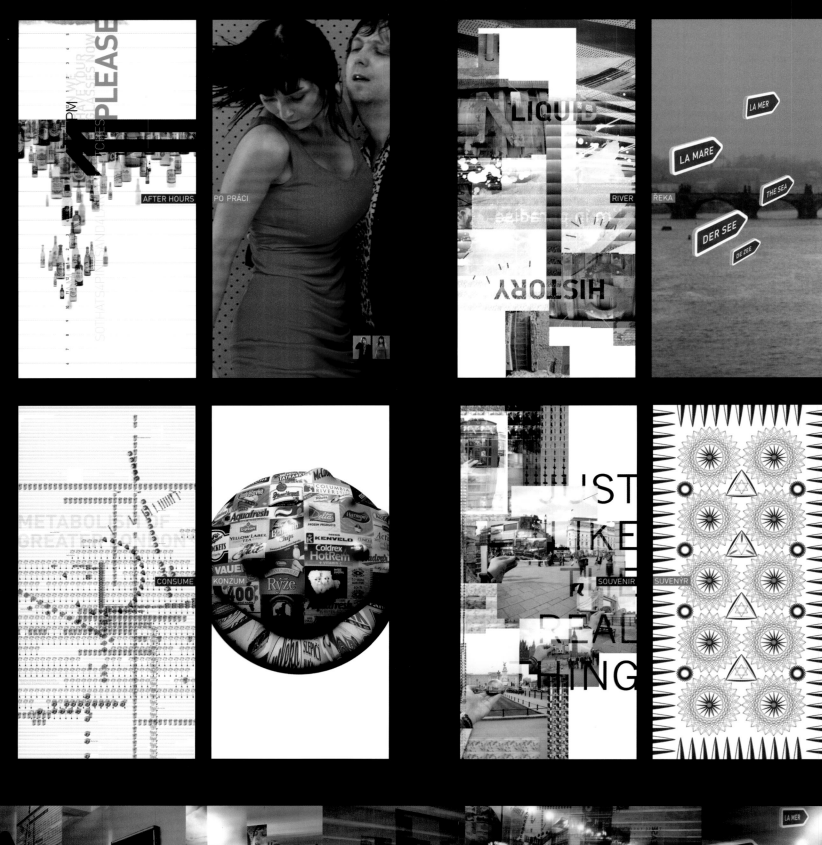

FAITH VÍRA

Our first conference film for Virgin led us to a similar job for cash-point makers NCR. Tim Ashton from communications consultancy Circus spotted the Virgin work and thought the combination of unscripted voice-overs, time-lapse photography and animated typography was the ideal vehicle for illustrating some fairly abstract concepts about relationship technology (the relationship between customers and companies who only meet in cyberspace, i.e., online shopping).

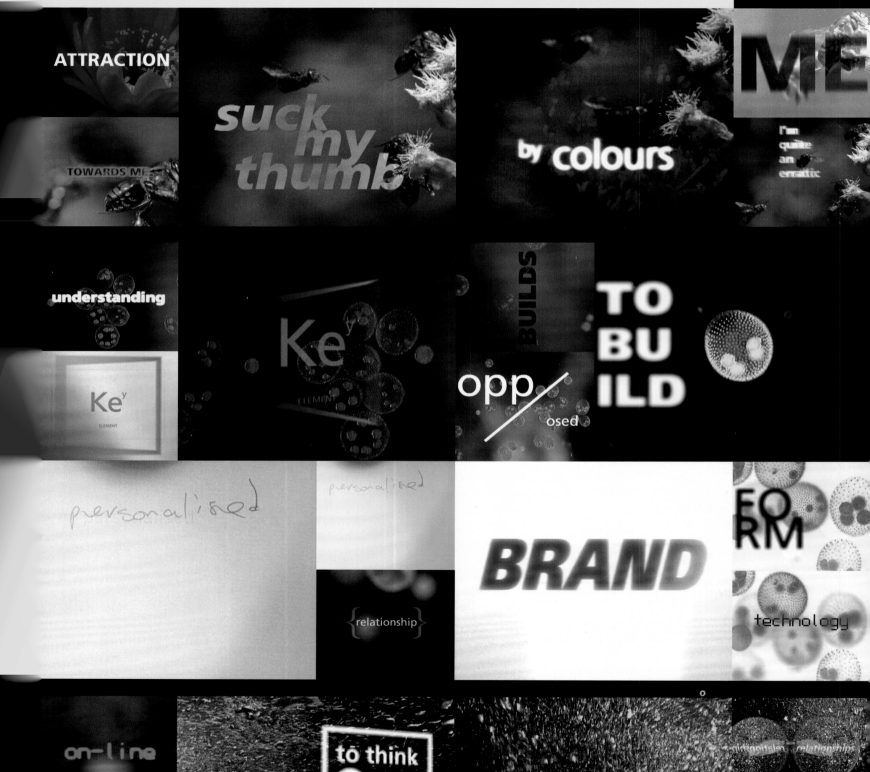

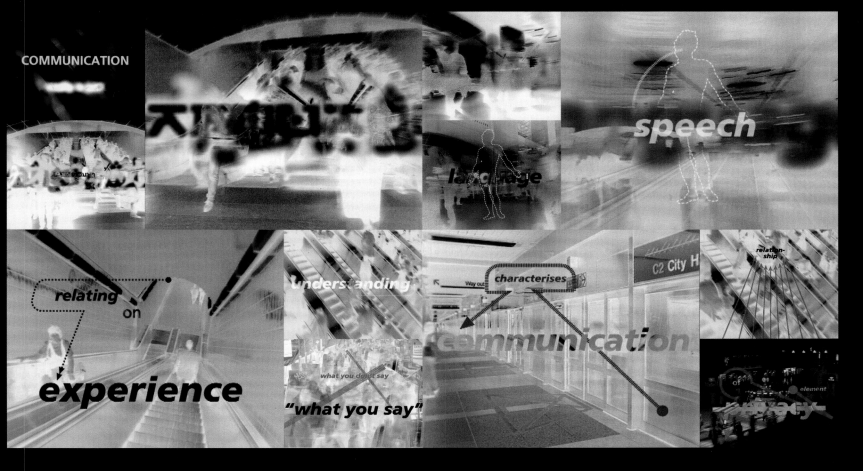

COMMUNICATION

speech

language

relating
on

experience

understanding

characterises

communication

C2 City H

relation-
ship

what you don't say

"what you say"

of element

TRUST

CONSUMERS

TRUST

worldwide

At first

worldwide

with your customers

INFRASTRUCTURE

they think it's

SAFE

into a strategic

weapon

YEARS

unique
opportunity

AND

EFFECTIVE

The Globe Theatre in London is situated on the original site of the open-air playhouse where Shakespeare worked and for which he wrote many of his greatest plays. The theatre is also on the route of the Bankside Walkway along the River Thames and was where Why Not and Gordon Young were commissioned by Patel Taylor Architects to incorporate text into the architects' designs for a handrail on the walkway; hence the choice of a quote from *Henry VIII*.

36

MEN'S EVIL MANNERS LIVE IN BRASS; their virtues wo

text cut out of stainless steel and stainless-steel lettering to be welded in and sit proud by 6mm

text water cut out of stainless steel and raised text 'BRASS'; in brass to be welded in and sit proud by 6mm

dots of Is to be cut out

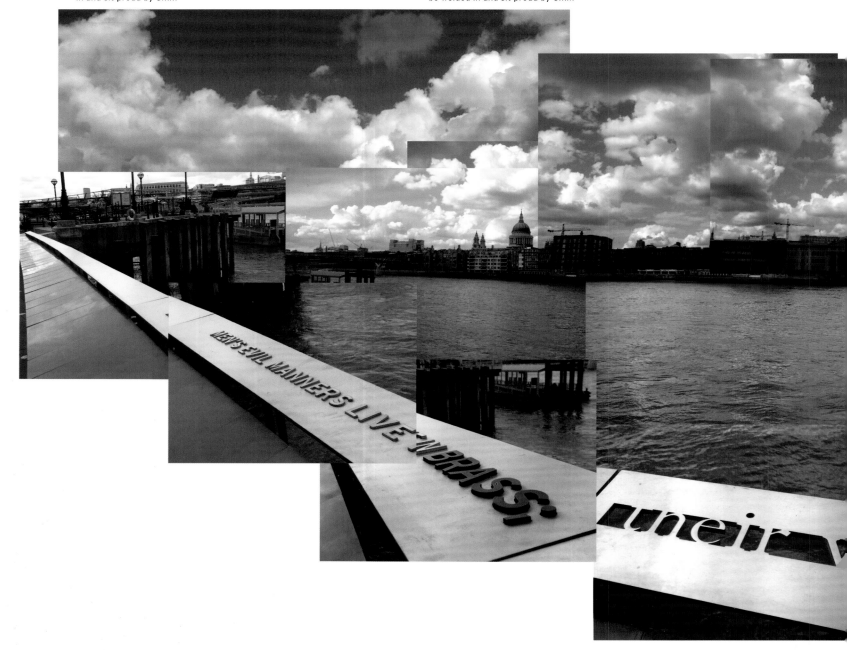

write in water

HENRY VIII ACT 4 SCENE 2 **WILLIAM SHAKESPEARE**

area around text to be cut
out to reveal water behind

text to be etched into steel

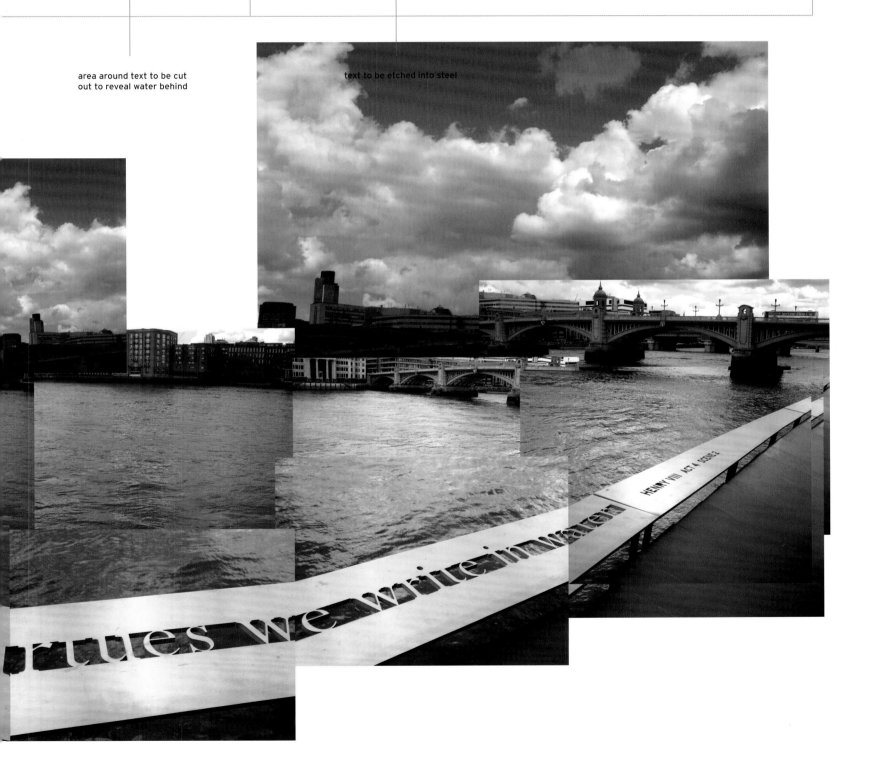

Nick Veasey has been creating still x-ray images for a number of years, but it is only recently that he has found a way to film moving x-ray images. We were very keen to direct the promotional film, which we set to some apt song lyrics by Cole Porter called 'I've Got You Under My Skin'. These pages show various stills from the film.

In 1994, Why Not produced the first corporate identity for the Soho-based post-production house Blue (see *Why Not*, pp. 134–37). In the redesign of their identity, we were careful never to use the colour blue in any shape or form, but we wanted the combination of colours to change continually. The result was that no two items looked alike, yet the branding was nonetheless consistent.

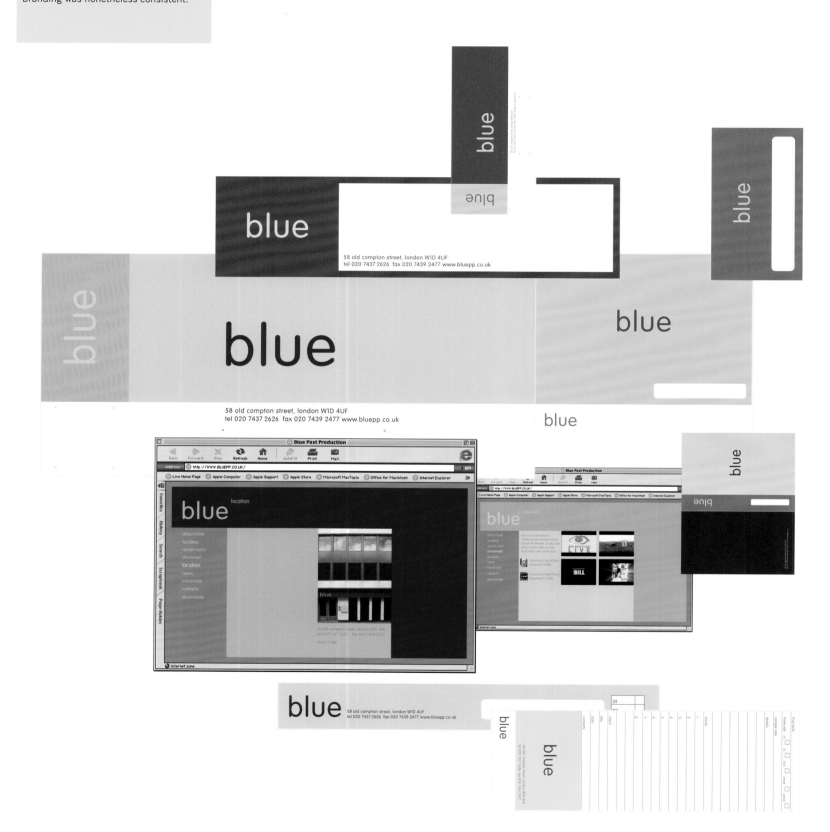

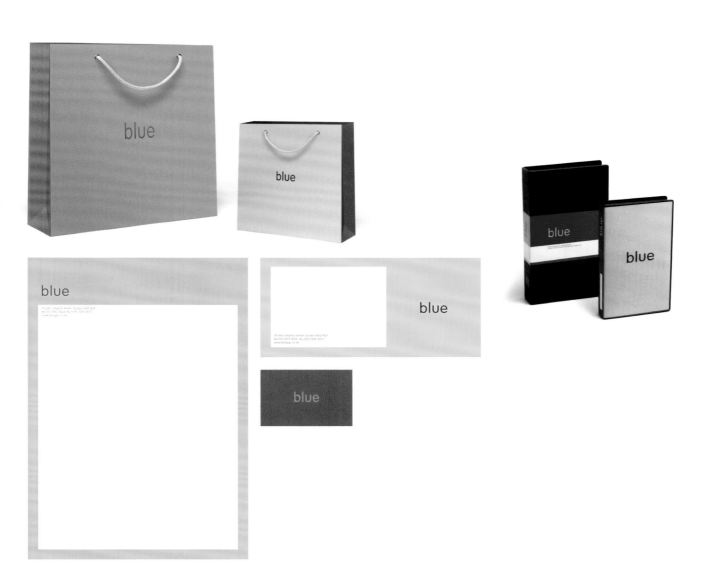

Why Not was given the theme 'four' and asked to decorate a car door to launch the four-seater Smart Car. We used a quote from Genesis, referring to the fourth day of creation – 'Let the waters bring forth abundantly the moving creature that hath life' – which, in this context, could be read as the birth of a new car!

FOURTH DAY.

1,19. AND THE EVENING AND THE MORNING WERE

1,20. AND GOD SAID,

LET THE WATERS BRING FORTH ABUNDANTLY THE

MOVING CREATURE THAT HATH LIFE, AND FOWL THAT MAY FLY ABOVE THE EARTH IN THE OPEN FIRMAMENT OF HEAVEN.

GENESIS

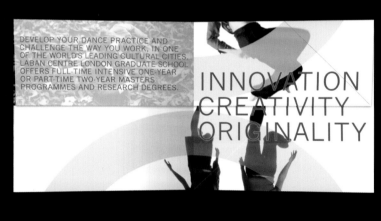

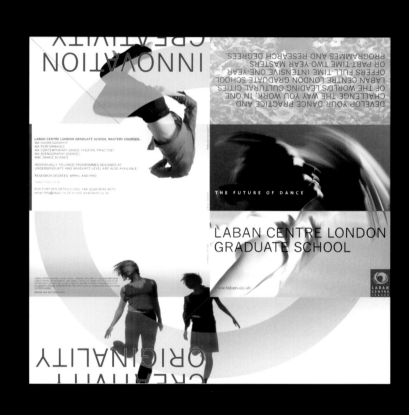

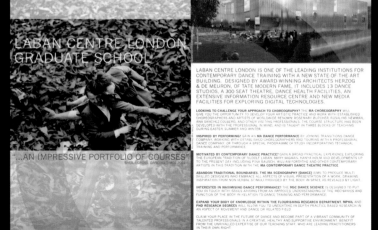

Initially, we were approached by Lincoln Cars to advise them on the typography for the dashboard clusters and the design of the interactive dashboard instruments in a new car based on the classic Lincoln Continental. Gradually, however, we became responsible for developing a complete graphic language for the car and even directed a promotional film and produced the press kits and brochures for the car's launch.

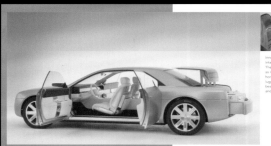

brochure design

promotional film

dashboard cluster design

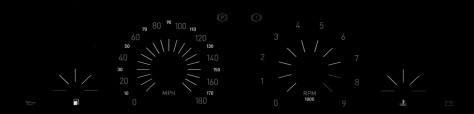

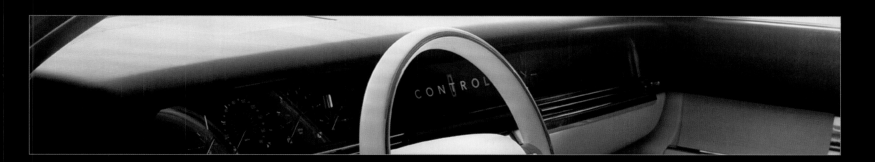

NAVIGATION

CONCIERGE

TELEPHONE

ASSISTANCE

CANDONTROLCOMFORT

 RESTAURANTS / JAPANESE

NOBU
8335 CROSS CREEK RD
MALIBU
TEL: 310 317 9140

You may have dined at Nobu NY, Milan, London or Las Vegas... Malibu is now a chic choice, too. Chef Nobu Matsuhisa discovered South American flavorings during his sojourn in Peru and his creations reflect this spicy infusion.

RECOMMENDATIONS:
Fresh uni on rice or black cod with miso. On a warm night, choose the outdoor patio under the starts with view into the Malibu hills

BOOKING
THANK YOU

◼ MAKE BOOKING
◼ NAVIGATION

NAVIGATION

CITY : **MALIBU** DESTINATION : **NOBU**

PCH

MALIBU BEACH

CONCIERGE

📖 ◼ PORTFOLIO
✗ ◼ RESTAURANTS
🍴 ◼ WEATHER

RESTAURANTS / JAPANESE

NOBU
8335 CROSS CREEK RD
MALIBU
TEL: 310 317 9140

You may have dined at Nobu NY, London or Las Vegas... Malibu is now a chic choice, too. Chef Nobu Matsuhisa discovered South American flavorings during his sojourn in Peru and his creations reflect this spicy infusion.

RECOMMENDATIONS:
Fresh uni on rice or black cod with miso. On a warm night, choose the outdoor patio under the starts with view into the Malibu hills

BOOKING
TONIGHT 7:30PM
PATIO, TABLE FOR 4

◼ MAKE BOOKING
◼ NAVIGATION

FRONT LEFT
VOL **5**
BASS **8**
TREB **2**

(((SURRO

FRONT RIGHT

SOUND)))

REAR LEFT
VOL **5**
BASS **8**
TREB **2**

REAR RIGHT

 PORTFOLIO / WORLD INDICES

INDEX	VALUE	CHANGE	2001-2002 HIGH	2001-2002 LOW
DJIA	10,385.49	0.26%	11,750.28	9,106.54
NASDAQ	1,930.74	1.71%	5,132.52	1,638.80
FTSE	5,427.20	0.84%	6,930.20	5,260.50
HANG SENG	11,765.92	0.21%	18,397.57	11,605.04

dashboard animation stills

AND PHOTOGRA

HY NOT ASSOC

BOOK NUMBER

ISBN 0-500-5113

FIE

DE

Thames & Hudson

The Yorkshire Sculpture Park is one of Europe's leading open-air art organizations showing modern and contemporary work by UK and international artists in five-hundred acres of eighteenth-century landscaped grounds and two indoor galleries.

Gordon Young and Why Not designed a one-hundred-metre pathway to connect the car park with the new visitor centre, designed by Feilden Clegg Bradley. The pathway was a fund-raising venture with the idea that visitors would pay to have their name inscribed in the path. Our initial tests used sandblasted granite, but this immediately appeared too funereal, so we experimented with steel, which had to have a raised chequered pattern to prevent people from slipping.

We redrew the stencil font WaterTower so that no parts of any letter were too thin in case they became rusty and broke off. The use of steel, which changes colour as it ages, and the stencil font allow the path to sit comfortably with the modern design of the centre. The poet Simon Armitage wrote a poem for the park specifically about the path.

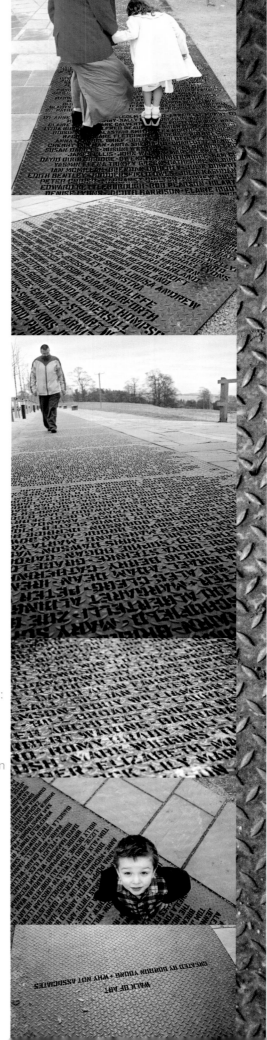

Making a Name

Here is a name – it is your name for life.
Loop it around your ears and toes – it works
like puppet strings, like radio control.
Try it for sound – slide it between your teeth.

Stitch that name into your socks and vest.
Sketch the shape of your name with a felt-tip.
Will it float or fly, or should it be screwed
to an office door, propped on a desk?

Once we were known by our quirks and kinks,
known by our lazy-eyes, our hair-lips.
Once we were named by the knack of our hands:
we were fletchers, bakers, coopers and smiths.

Don't sell your name to a man in a bar!
Don't leave your name in a purse on the beach!
Don't wait for a blue plaque – get yourself known
with glitter and glue, in wrought ironwork;

sign your autograph with a laser-pen
on the face of the moon. Here is your name
and a lifetime only to make it your own.
Then the mason takes it, sets it in stone.

Simon Armitage © 2002

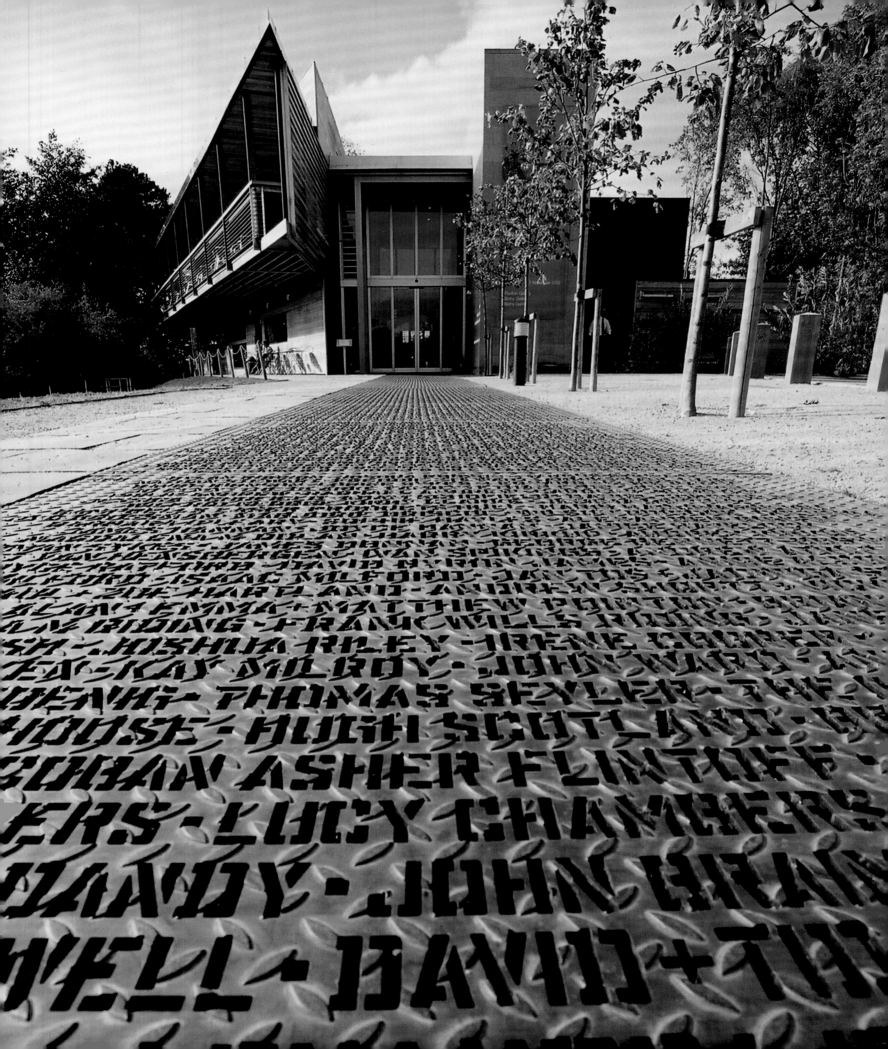

Our work on a corporate identity for the Rosemary Butcher Dance Company coincided with the need for publicity material for a new performance entitled 'Still Slow Divided'. Working on the two projects we soon realized that the identity needed to incorporate a way of treating performance images that would immediately make them 'Rosemary Butcher' images. We decided that the basis of the identity should be the combination of textures and simple typography in Helvetica, which could then be fused with performance images to clearly brand even a press picture.

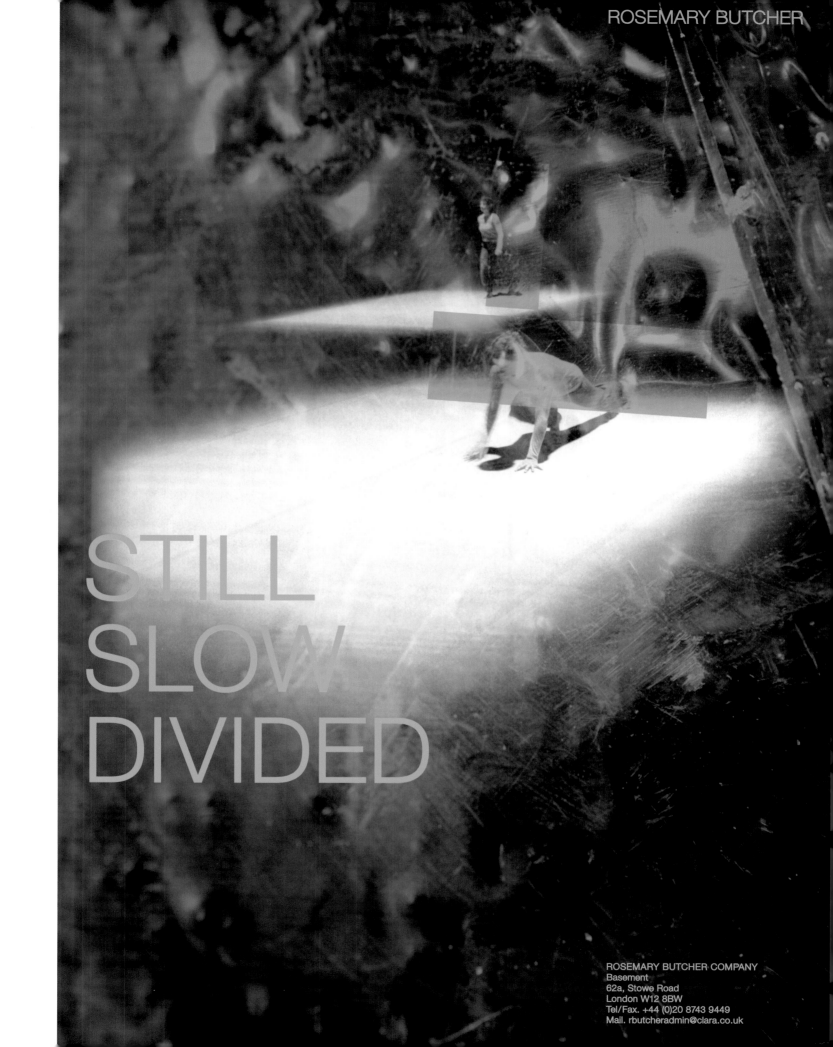

ROSEMARY BUTCHER

STILL
SLOW
DIVIDED

ROSEMARY BUTCHER COMPANY
Basement
62a, Stowe Road
London W12 8BW
Tel/Fax. +44 (0)20 8743 9449
Mail. rbutcheradmin@clara.co.uk

We produced the title sequence for a three-part documentary, *The Trust*, about the workings of a National Health hospital. The x-rays, supplied by Garvin Hirt's's dad (Garvin is a member of our studio) and Nick Veasey, were filmed on the office flat-bed scanner and animated using After Effects.

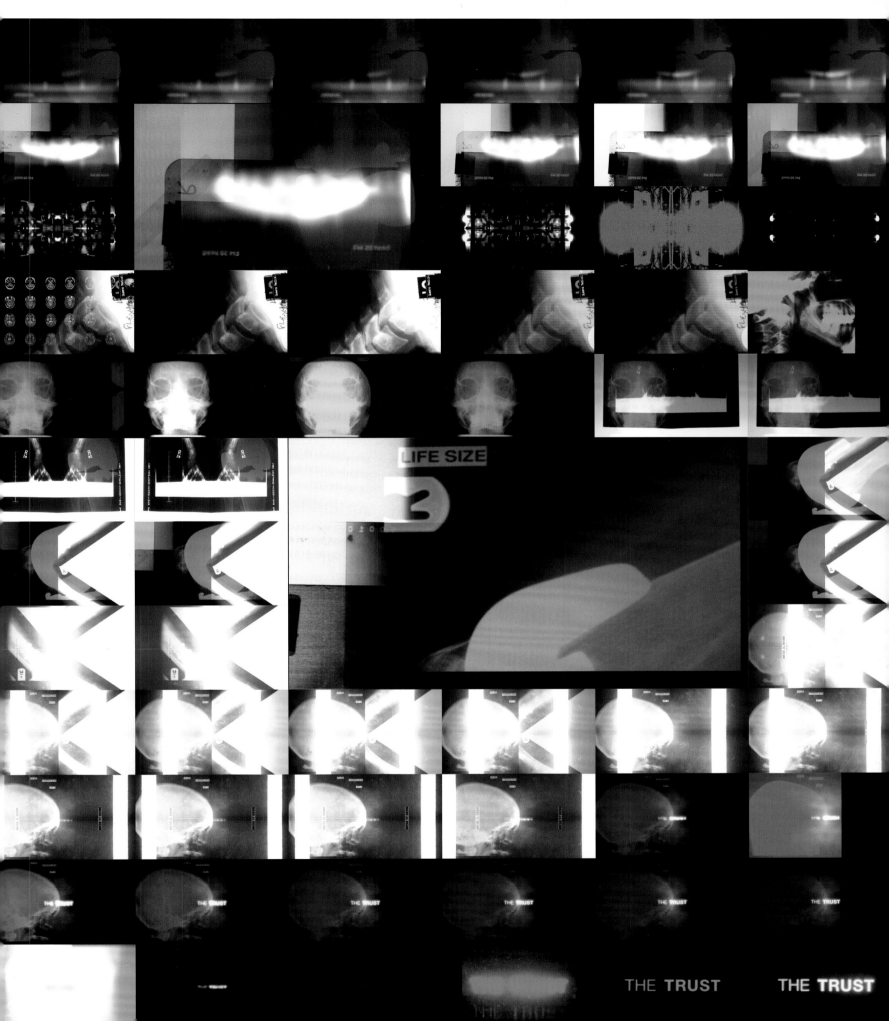

LIFE SIZE

THE TRUST THE TRUST

2003

With the celebrated architect Nigel Coates we created a guidebook to a place he calls Ecstacity, a personal interpretation of the modern-day metropolis. *Guide to Ecstacity* was described by *The Guardian* as 'a gloriously dynamic vision of what a city might be if only we stretched our imagination', which makes the case for a more sensual architectural vocabulary and an active role for the citizen.

As Coates explains, 'Ecstacity creates a hypothetical urban condition in which the actual and the imaginary can coexist. It prioritizes rather than predicts. It is built on the contemporary dynamics of multi-culture, drawing on seven existing cities around the world. Here Tokyo, Cairo, London, New York, Rome, Mumbai and Rio de Janeiro combine into a kaleidoscopic place full of cultural hybrids and occasional accidents.'

Coates had never before published a book, so *Ecstacity* simultaneously became a sourcebook, architectural survey, novel and autobiography. The format, a guidebook, brought together all the material and incorporated a variety of maps, a multitude of architectural projects, both built and unbuilt, and fresh, challenging theory.

From the outset, we wanted to bring a lush and vigorous design to Coates's concept, with a complex interplay between text, image and the space on the page. Overall, the book was devised to work like the city itself, encouraging readers to explore it and subject themselves to its chance encounters.

The project took a long time to complete; at the beginning we designed huge chunks of the book but had to stop for nearly a year because the text was in such a state of flux that the pictorial content was also far from decided. Finally, when the text and images had been finalized, we were supplied each page of text surrounded by notes, sketches and thumbnails of the images. We had to design all 464 pages in seven weeks to meet the publisher's deadline, which wouldn't have been so bad if Nigel hadn't been allergic to grids. So, each spread was composed individually, and the process became more like designing 232 posters in seven weeks.

We had been working with Branson Coates Architecture for over ten years, but this project strained the relationship somewhat. We can never praise enough the contributions from Sim Wishlade, Eva Bajer, Matt Galvin and Roger Tatley who stuck it out and went the full fifteen rounds. Also, thanks to Ceri for not divorcing David during the proceedings.

The final twist of the knife came shortly after we had received first proofs, when the publisher, Booth-Clibborn Editions, ran into financial difficulties. It was more than a year before another publisher stepped in and things moved along, however, it is important to say that without the vision, tact and patience of Edward Booth-Clibborn the book would never have made it past first base.

The final book only appeared with one ribbon, instead of the intended six, and the silk two-tone cover had to be abandoned, but we have left the original images here so we don't forget how good it would have looked if the costings hadn't changed.

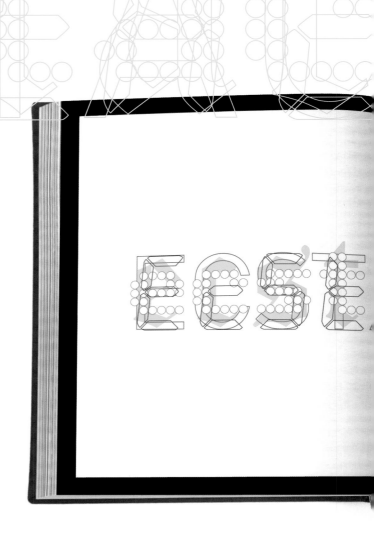

The original catalogue to Nigel Coates's 1992 Architectural Association exhibition called 'Ecstacity' (see *Why Not* p.118).

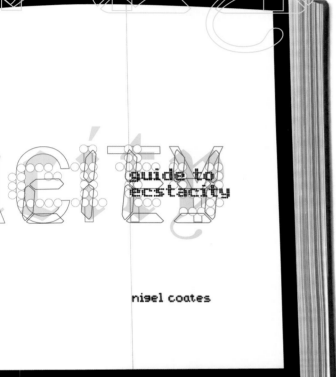

guide to
ecstacity

nigel coates

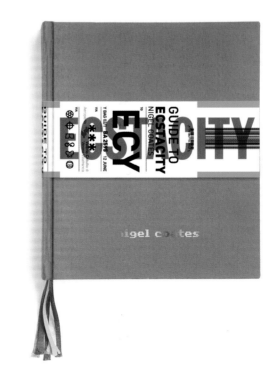

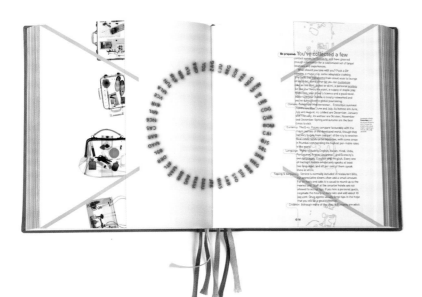

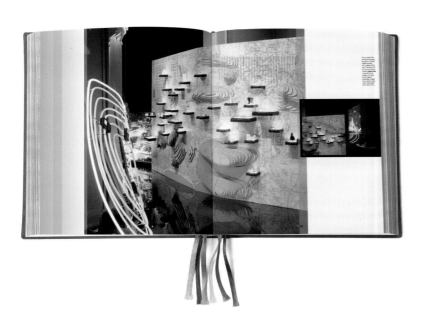

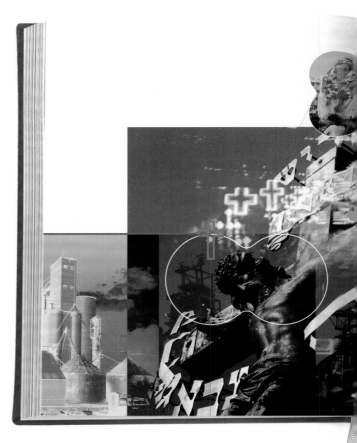

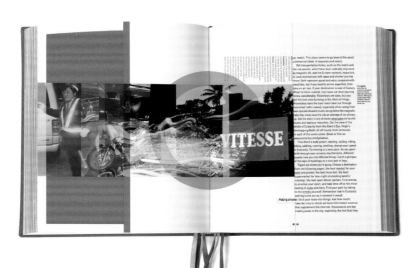

take the time
to flick through magazines
that you have no intention
of buying

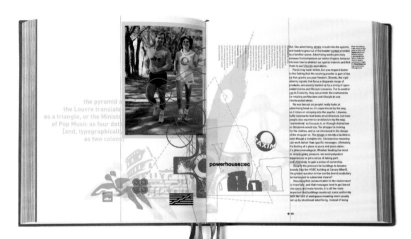

the pyramid at
the Louvre translated
as a triangle, or the Ministry
of Pop Music as four dots
(and, typographically,
as two colons)

powerhouse::ec

using spaces that architects have never touched. It may be much easier to do a cool one-night club in a railway arch with one light bulb than somewhere that's been designer lifestyled up to the hilt.

Do you hear complaints about shop environments, plane interiors or computer games? They aren't subjected to the same megalomania that the mere word 'architecture' normally summons up. When buildings don't need to prove their stylistic pedigree, they can get on with the business of communicating, and fulfilling the need to work with grit and story as much as with stylistic reference or tectonic panache. In Ecstacity, architecture is more about ideas than mere style. Gothic, modern, bond, deconstructive doesn't matter here. Design makes the most of how a view is framed, or a new building is sited. It works space between the fingers, making it kick in to the broader city vision.

One of the designer's favourite strategies is what they call 'narrative'. Whatever the project, they soon get to work on the story, often one chosen to have a stimulating effect on the function and location. They work these together into a single spacial configuration that carries the working process with it. The idea is to fuse an abstraction of place, use and story so that when you use the building, it triggers experiences on many levels. They don't so much want buildings to look good as feel good.

The sacred heart: Because it is a process, narrative architecture can transcend ordinary experience and, in so doing, can solicit the user into a dynamic role. Whether they're public buildings or private dining rooms, our current efforts may not often be to the glory of God, but they are our modern temples. Despite the eternal contest between the body and soul, the profane often turns out to fit the sacred pattern. Symbolic space always has the potential, in some way, to induce a sacred experience. A ruined chemical works have a certain spiritual dignity. The railway viaduct cutting through the city divulges some greater power; the sheer scale of the Colosseo is awe-inspiring; the

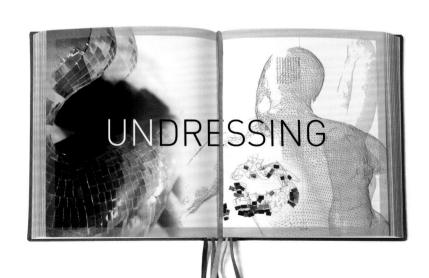

UNDRESSING

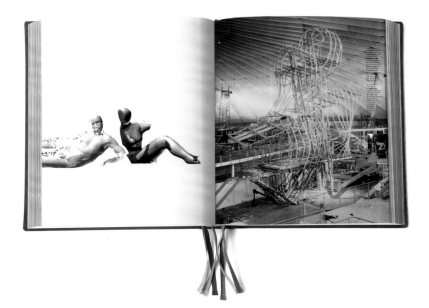

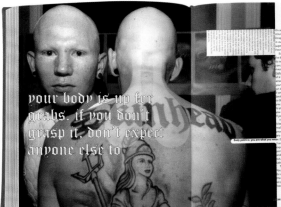

your body is up for grabs. if you don't grasp it, don't expect anyone else to

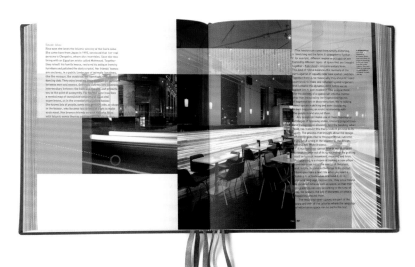

Never naked:

Never naked:
Sottsass says he's never been naked, though has wanted to be, he too is weighed down by cosmopolitan knowledge. He hates the rich, who feed off ordinary folk. The rich never invented anything, never really achieved anything and dressed in other people's efforts.

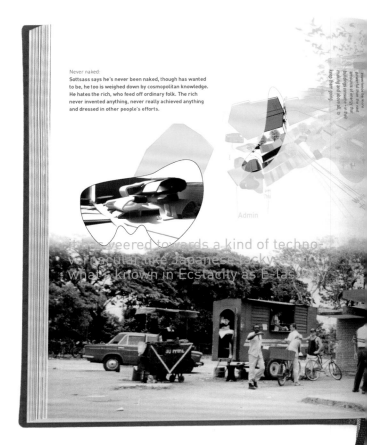

against security breaches, terrorist hackers, digital pickpockets, extortionists and tricksters of every kind.

The Field's very ordinariness tends to syncopate closely with the landscape of which it is a part. In the Field, the ordinary prevails, at least in terms of how things look. Few buildings try to be visually special. It's the way they work that counts. Unlike Campo Marzio, the cyburbs self-structure so as to respond intelligently to the will of their inhabitants and elected strategists. No Versace here, more garden shed and (wilfully) artificial landscapes. The Field has no need for displays of 20th-c. luxury, instead adding to the commonplace to transform it existentially rather than aesthetically. It has veered towards a kind of techno-vernacular like Japanese tacky-tech; what's known in Ecstacity as E-lasticity.

Digital E-lasticity: If you imagine the infrastructure of the burbs as elastic, like skin, and hence the praxis of E-lasticity, you can understand how the latter can respond to shifts of collective desire. Interactivity in space links up with the more quixotic identities of its inhabitants. Neither confined by age nor profession, kids of 12 can be architects for an afternoon. And 80-year olds can try at being kids again. No one in Ecstacity unionizes his or her identity and no one has only one job.

With the burbs growing very much as the web does, without regulation or control, there's a certain communal responsibility in everyone's right to protest at bad behaviour. The burbs don't need the kind of overtly showy buildings that help to give city centres their identity. As a medieval town, the architecture is generated by the genes that dictate spatial syntax and experience, and not by acts of vanity or structural acrobatics.

The burbs demonstrate that architecture has crossed into the world of interactive digital communications and that there can be a symbiotic overlap between communication systems, individual desires, experiences and the physical city itself.

♡ 337

A change in the approach to local government has spawned a new generation of town halls. Jason Scott's design for **Hackney Town Hall** allows its social, administrative and political functions to bask into the arts are little more than elaborate meeting points

Under the only remaining arch of the original London Bridge, this **corpuscular pavement** installations by Eric Parry lights up the ground beneath your feet

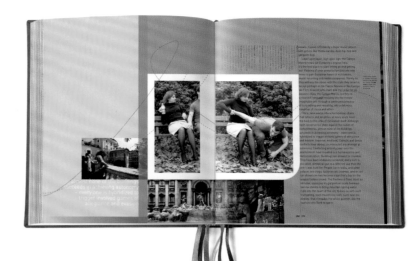

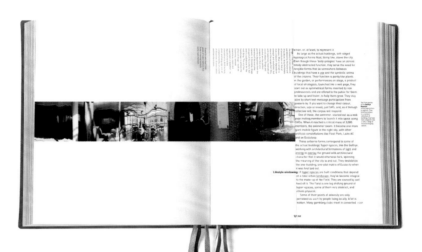

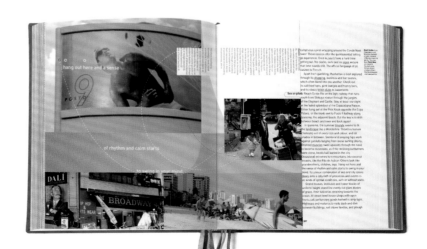

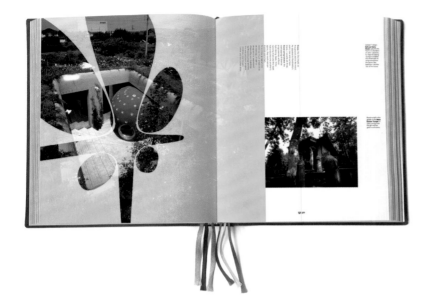

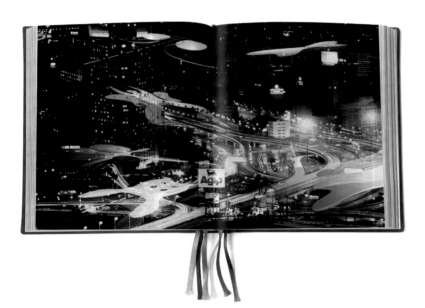

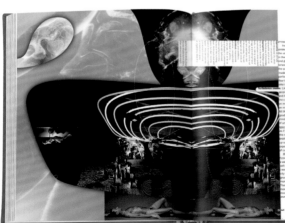

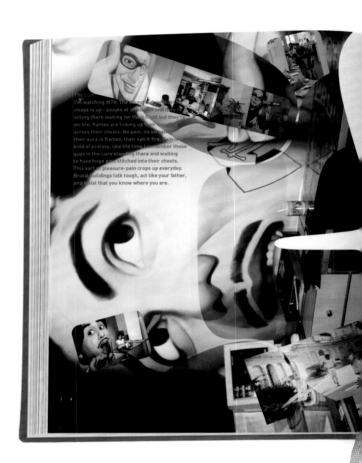

The I am watching MTV. The round-sound-image is up – people at airport and they're sitting there waiting for their flight but they're on fire, flames are licking up their faces across their chests. No pain, no scream, their aura is flames, their spirit fire. Pain is kind of ecstasy, like the time I remember these guys in the Lure standing there and waiting to have huge pins stitched into their chests. This sort of pleasure-pain crops up everyday. Brutal buildings talk tough, act like your father, and insist that you know where you are.

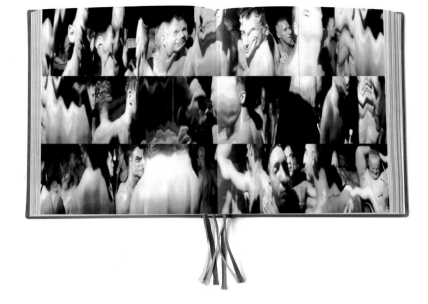

join it to the banks at Embankment, the Biannual site, to the north, Shibuya to the south. Inside, an elaborate set of elongated spirals designed to coerce a collective drift succeeds in confounding any sense of what level you're on.

Could you or I transfer this experience into other smaller spaces like <u>home</u> or workplace that normally would exclude this? Imagine working at a version of St Luke's, the no-desk, all-try-all ad agency, or an updated version of Bloomberg, the financial cable tv company. Activity options – from the computer <u>screen</u> and the digital lab to the most extreme cross-program of loud music or food in plenty – would define a work ethic that represents the creative <u>community</u>. You might swim to your meeting through some kind of <u>media</u> fish tank past individual play compounds that offset the usual electronic cemetery of desks.

Anyhow that's how I am at <u>work</u> or home: my real space of work is somewhere between my imagination and my IT palette and so I don't really care where I am. Place is more about mood and people. Some places stimulate, and others nullify.

What speed? Slow down: It is a strength for Ecstacity that it has been built layer upon layer, <u>situation</u> over situation, and condition upon condition, one era superimposed on top of another. Because each stage was built with a force and courage, its history of accumulation and adaptation is itself a sign for the multiple dimensions of the present. The molar media of the past – like newspapers and <u>books</u> – now interacts dynamically with the molecular techno-media of the present, each being a coefficient of the other. Books will never disappear, but nor will the desire to superimpose digital displays on every surface.

You see double images, like the rotating hoarding that's got stuck, with one image to the left and the other to the right. Like two-tone fabric or the surface of the Body-plex, to be <u>hybrid</u> does not mean to blur into a sludge, rather to keep the

⊕ 407

Some of the wilder work-spaces are inhabited by the music industry. Based in the Mumbai zone, **MTV Asia** has giant hand-painted murals of Bollywood stars. Meanwhile **Dazed & Confused**, a music and fashion magazine, plays the same trick with giant images of some of its ideas.

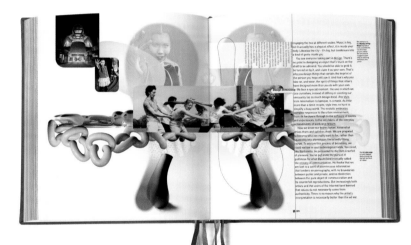

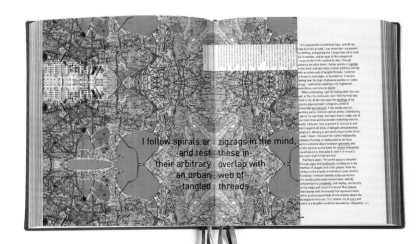

I follow spirals or zigzags in the mind, and test these in their arbitrary overlap with an urban web of tangled threads

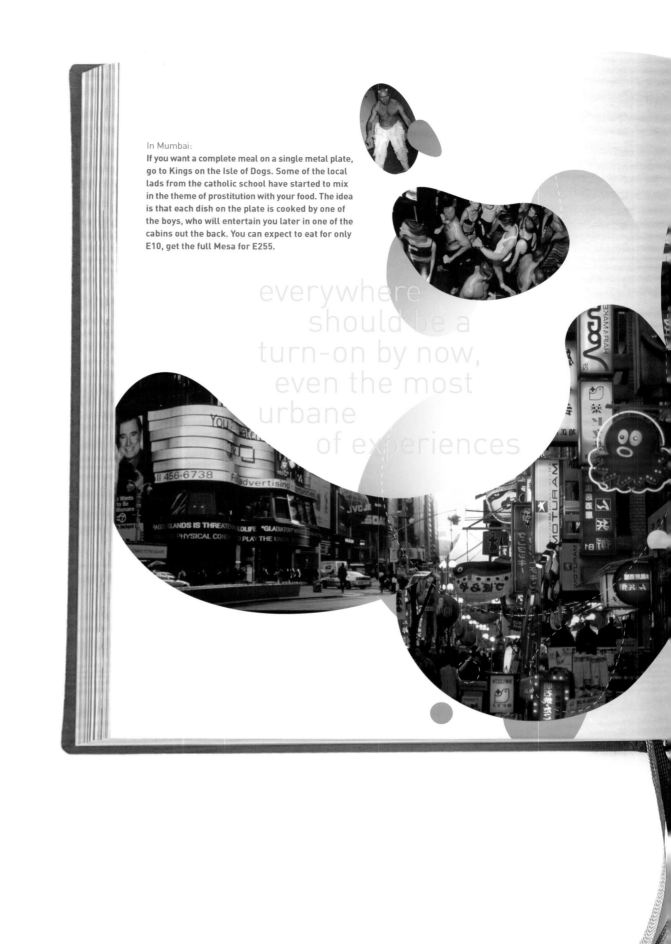

In Mumbai:
If you want a complete meal on a single metal plate, go to Kings on the Isle of Dogs. Some of the local lads from the catholic school have started to mix in the theme of prostitution with your food. The idea is that each dish on the plate is cooked by one of the boys, who will entertain you later in one of the cabins out the back. You can expect to eat for only E10, get the full Mesa for E255.

everywhere
should be a
turn-on by now,
even the most
urbane
of experiences

Hedonism versus ecstasy: In Ecstacity, there are so many cross-currents of places, roads and people that it sets up a matrix for drifting, for roaming. Of course you can always get from A to Z, but there'll always be a choice of routes, and a whole lot of surprises along the way.

At some point there is no distinction between the real and the virtual, the mind and the minded. It's all scratch music. We have doubles in the mind and soul. Although ultimately architecture starts and ends in our bodies, we love to displace ourselves and play with being in other spaces. It's now a common occurrence to feel you are somewhere else: six out of seven people in Ecstacity say they have regular out-of-body moments. Of course we still cluster. We're social animals. In the gap in culture left by a disillusion with modernism, fragmentation and uncertainty may at times have appeared to strengthen the traditionalist voices. But the public has more wit and strength than the Luddites had given them credit for. A new imagination is underway. Traditions have been swept into communication as a kind of base material. Designers often quote the abject as the launching pad for ironic pleasures. If the message contains a link to the commonplace, it is all the more likely to trick the imagination into leaping out from the situation. Stressing the real is a way of validating the abstraction of the artificial. These are the substrata of an urban ambience saturated with events and information. Everywhere should be a turn-on by now, even the most urbane of experiences.

A hall of exotic mirrors: Whether seen from the air, or close up, every aspect of the city has an erotic coefficient. Usually the sexual suggestion is just beneath the surface, and nothing more than a nuance. It's exactly because it's latent and out of reach, that it creates the tension that motivates desire. Erotic potential is built continuously into Ecstacity's structures, ready to be triggered unexpectedly by anyone's antennae.

The wavy digital billboards of **Times Square** give a fluid undulation to the corporal enclosure around the square. As data tracks across it, you are reading the message more through your flesh than through your mind

395

This poster promotes a dance piece by Rosemary Butcher in which one dancer performs, to a specially composed score, alongside and in response to multiscreen video projections.

For 'White', Rosemary Butcher embarked on a radical departure from her usual method of working by commencing with a more abstract concept and developing it visually through the use of video imaging within the studio. The piece is formed around images that are responses to such words as 'exploration', 'experience', 'broken surfaces', 'divided', 'cracked' and 'transparent' and to the circumstances surrounding the predicament of an explorer, both environmentally and emotionally. Images were built up from the ideas that emerged from these words, for example, emptiness, lack of visibility, transparency, emergence and disappearance. Figures are shown in relation to themselves, advancing, receding and disappearing.

For the actual performance, eight very large screens sloped up from the floor and surrounded the performance area on three sides, extending into the audience. The computer images were then projected onto the screens, while in the centre one dancer performed for fifty minutes. It is the contrast of the lone live performance with the constantly moving images across the line of screens that provided the dynamic counterbalance between the dancer and the images.

TANZ

ROSEMARY BUTCHER
Choreographer-in-Residence München

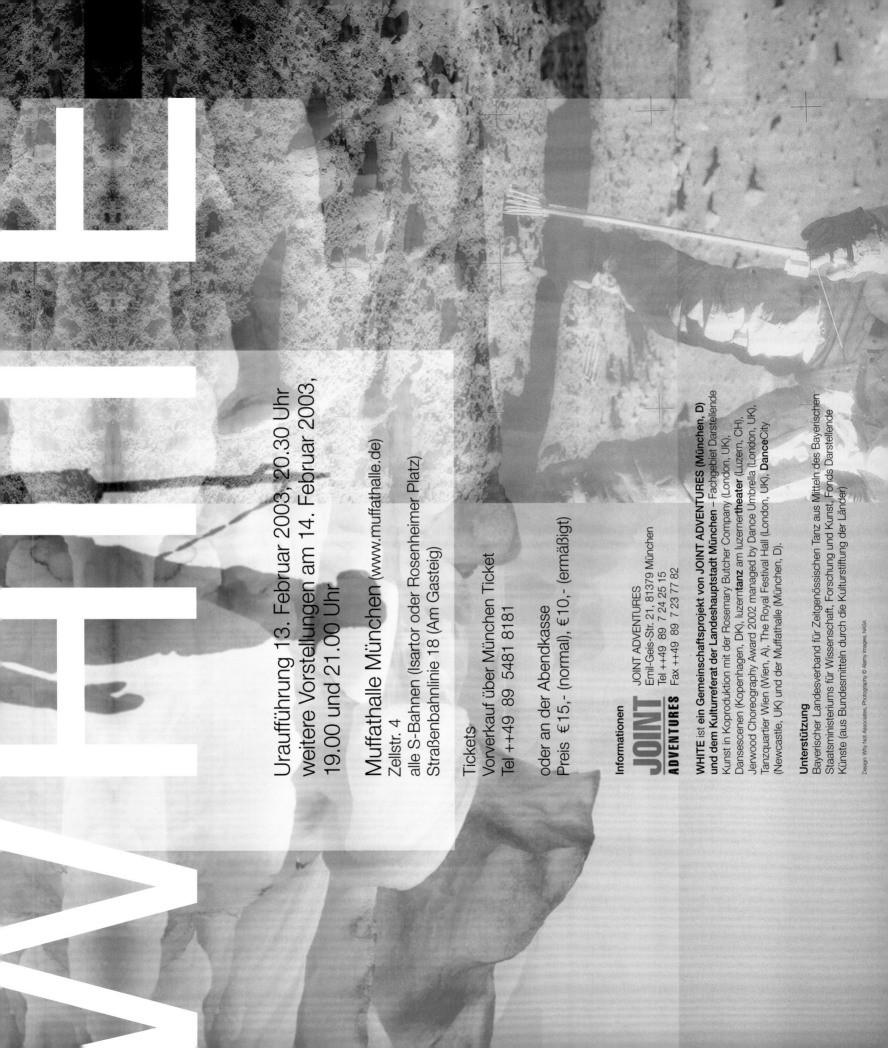

Uraufführung 13. Februar 2003, 20.30 Uhr
weitere Vorstellungen am 14. Februar 2003,
19.00 und 21.00 Uhr

Muffathalle München (www.muffathalle.de)
Zellstr. 4
alle S-Bahnen (Isartor oder Rosenheimer Platz)
Straßenbahnlinie 18 (Am Gasteig)

Tickets
Vorverkauf über München Ticket
Tel ++49 89 5481 8181

oder an der Abendkasse
Preis €15,- (normal), €10,- (ermäßigt)

Informationen

JOINT
ADVENTURES

JOINT ADVENTURES
Emil-Geis-Str. 21, 81379 München
Tel ++49 89 7 24 25 15
Fax ++49 89 7 23 77 82

WHITE ist ein Gemeinschaftsprojekt von JOINT ADVENTURES (München, D)
und dem Kulturreferat der Landeshauptstadt München – Fachgebiet Darstellende
Kunst in Koproduktion mit der Rosemary Butcher Company (London, UK);
Dansescenen (Kopenhagen, DK), luzerntanz am luzernertheater (Luzern, CH),
Jerwood Choreography Award 2002 managed by Dance Umbrella (London, UK),
Tanzquartier Wien (Wien, A), The Royal Festival Hall (London, UK), **DanceCity**
(Newcastle, UK) und der Muffathalle (München, D).

Unterstützung
Bayerischer Landesverband für Zeitgenössischen Tanz aus Mitteln des Bayerischen
Staatsministeriums für Wissenschaft, Forschung und Kunst, Fonds Darstellende
Künste (aus Bundesmitteln durch die Kulturstiftung der Länder)

Design: Why Not Associates. Photography © Alamy Images, NASA

In 1992, Gordon Young was appointed lead artist on a public art project in the small English coastal resort of Morecambe. This became Tern, an arts-led regeneration project for Morecambe, with the mission of physically and spiritually refreshing and re-imagining the town to set it apart from its recent past and surrounding resorts. Gordon invited various artists to produce work that related to the abundant bird life in Morecambe Bay, which welcomes more migratory birds than anywhere else in Europe. The majority of the results represented birds in an illustrative fashion, and Gordon and the then Chief Planning Officer Reg Haslem came up with the idea of a three-hundred-metre typographic pavement with the text taken from any reference to our feathered friends found in poetry, prose, traditional sayings and song lyrics. It was at this point that Gordon approached Why Not Associates with a view to collaborating.

SEAFRONT

Two researchers proposed the possible content, which was then edited down to material that would have a broad appeal to children and literature buffs alike. The resulting texts range from excerpts from the book of Genesis to Shakespeare to Spike Milligan. Constructed from granite, concrete, steel, brass and bronze, *A Flock of Words* physically connects the new railway station with the seafront, visually and thematically linking them in a way that informs, entertains, educates and stimulates the user.

Seawards, the path is punctuated by a nine-metre typographic column that leads the text from the pavement into the sky. The path then continues towards the magnificent Art Deco Midland Hotel designed by Oliver Hill in 1933, with interiors by Eric Gill. In homage to Gill, the greatest letterform designer of his generation and possibly the twentieth century, all the fonts used in the pavement are his.

We were faced with certain basic problems right from the start; for example, we walk forwards but we read backwards and the size of the pavement meant that it had to be designed to scale in eight sections rather than one. This resulted in us having to print out each section and tape it to the studio wall to discuss its progress – we quickly learned that trying to analyze it on a computer screen was virtually impossible. We even printed out some sections at full size so we could walk up and down or across them to get a realistic feel for the experience. All in all, it took quite some time to plan!

Artist Russell Coleman was also a key figure in the project, working with Gordon on the manufacture and installation of the path. Between them they devised and tested several new techniques that pushed the latest technology to its limits. It was a truly collaborative project involving the skills and experience of not only the artists but also the landscape architect, the engineers, the builders and the steel and stone workers. The project was a huge learning curve for us as we had to grasp the concepts and consequences of construction, materials and space. A big thanks to all involved – it was quite a journey!

Pavement prior to construction, looking towards the Midland Hotel.

Images of the holiday resort as it is now.

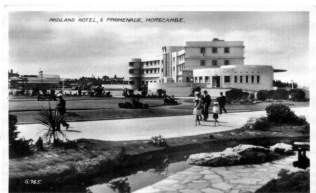

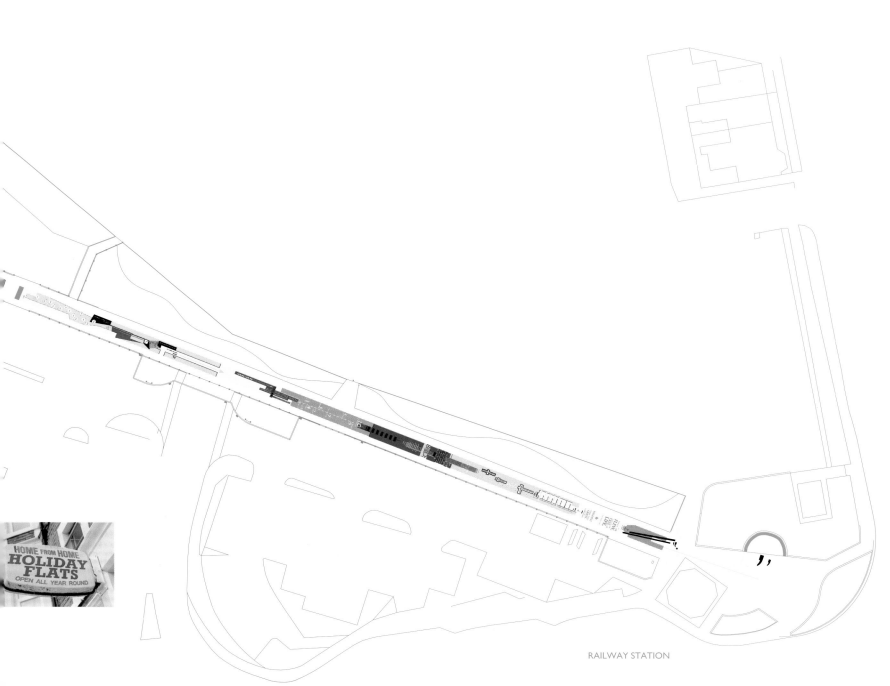

RAILWAY STATION

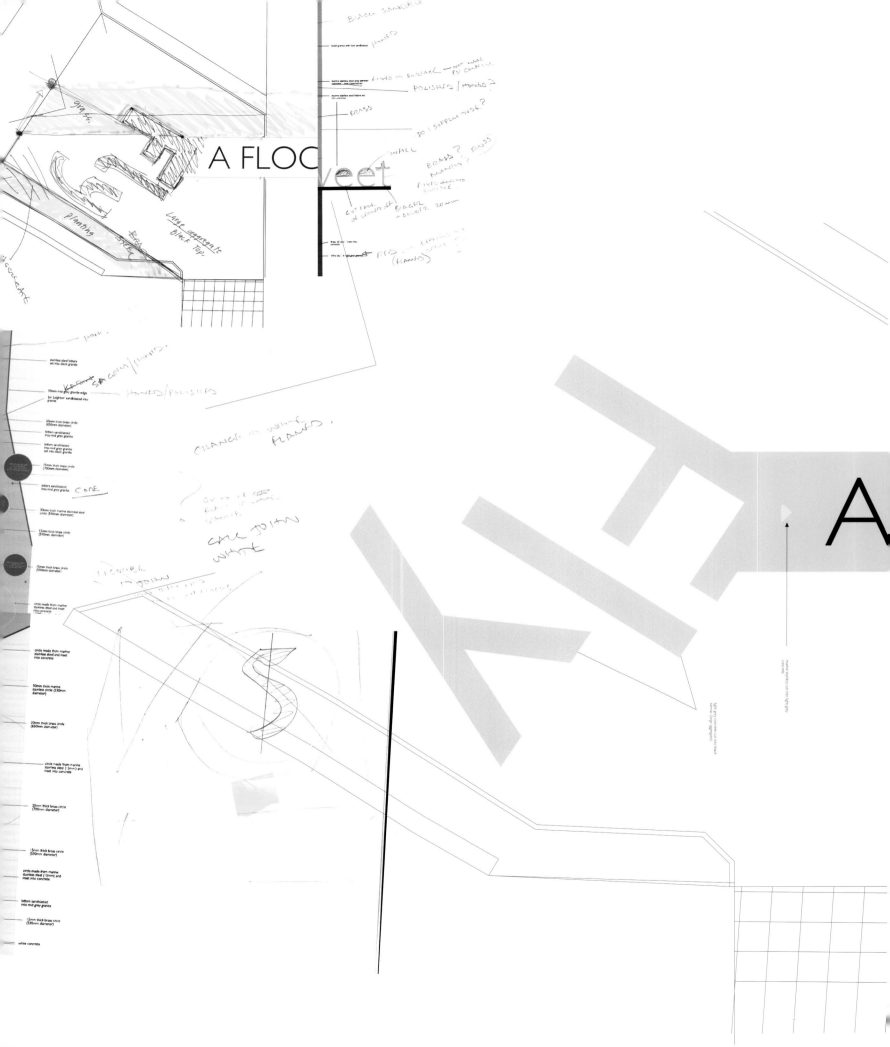

A FLOO

A

FLOCK OF WORDS

black granite (honed) once with sandblasted text

50mm white granite (flamed) edge between two concretes

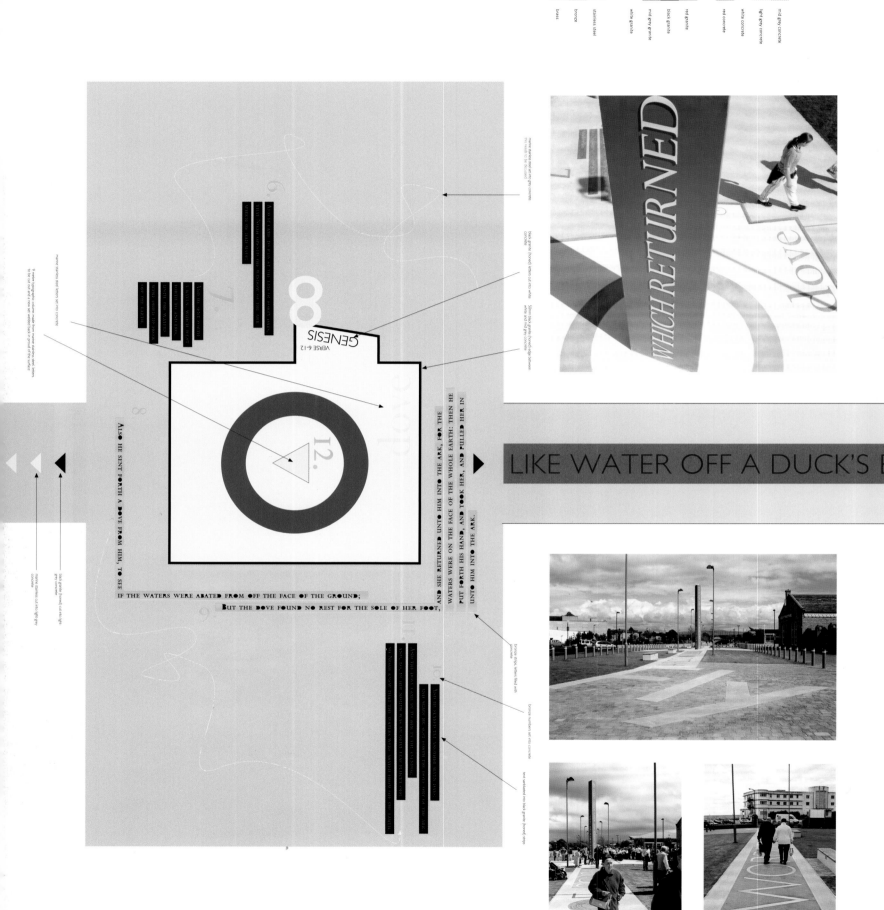

brass
bronze
stainless steel
white granite
mid grey granite
black granite
red granite
red concrete
white concrete
light grey concrete
mid grey concrete

marine stainless steel set into grey concrete
this needs to be discussed

black granite (honed) letters cut into white
concrete

50mm black granite (honed) edge between
white and mid grey concrete

GENESIS
VERSE 6-12

8

12.

ALSO HE SENT FORTH A DOVE FROM HIM, TO SEE

IF THE WATERS WERE ABATED FROM OFF THE FACE OF THE GROUND;

BUT THE DOVE FOUND NO REST FOR THE SOLE OF HER FOOT,

AND SHE RETURNED UNTO HIM INTO THE ARK, FOR THE

WATERS WERE ON THE FACE OF THE WHOLE EARTH: THEN HE

PUT FORTH HIS HAND, AND TOOK HER, AND PULLED HER IN

UNTO HIM INTO THE ARK.

9 metre typographic column made from marine stainless steel letters
to be cut out and a new set welded back in proud of the surface

marine stainless steel letters
set into grey concrete

black granite (honed) cut into light
grey concrete

marine stainless steel cut into light
grey concrete

bronze strips, letters filled with
concrete

bronze numbers set into concrete

text sandblasted into black granite (honed) strips

WHICH RETURNED

dove

LIKE WATER OFF A DUCK'S B

EAGULL
FLYING,
ACROSS
CAMBE
BAY,
THOU
"IT

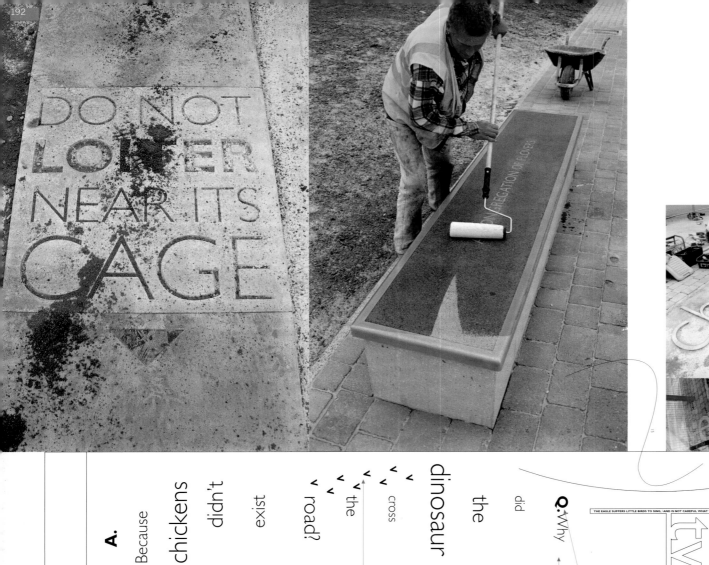

DO NOT LOITER NEAR ITS CAGE

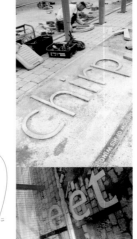

chirp

tweet

chirp

Q: Why did the dinosaur cross the road?

A. Because chickens didn't exist

THE EAGLE SUFFERS LITTLE BIRDS TO SING, AND IS NOT CAREFUL WHAT THEY MEAN THEREBY, KNOWING THAT WITH THE SHADOW OF HIS WINGS HE CAN AT PLEASURE STINT THEIR

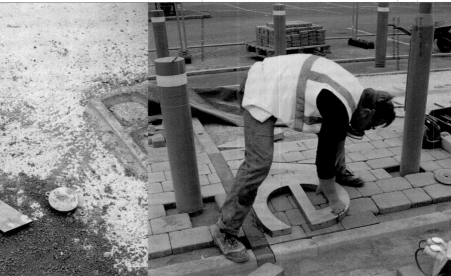

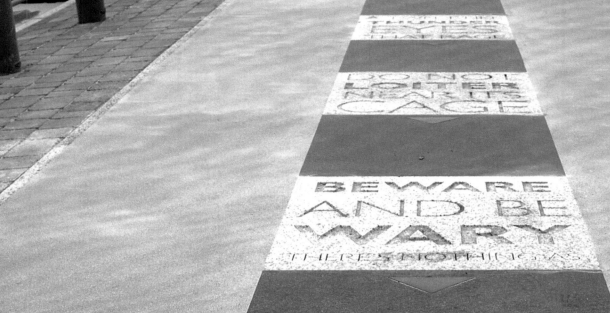

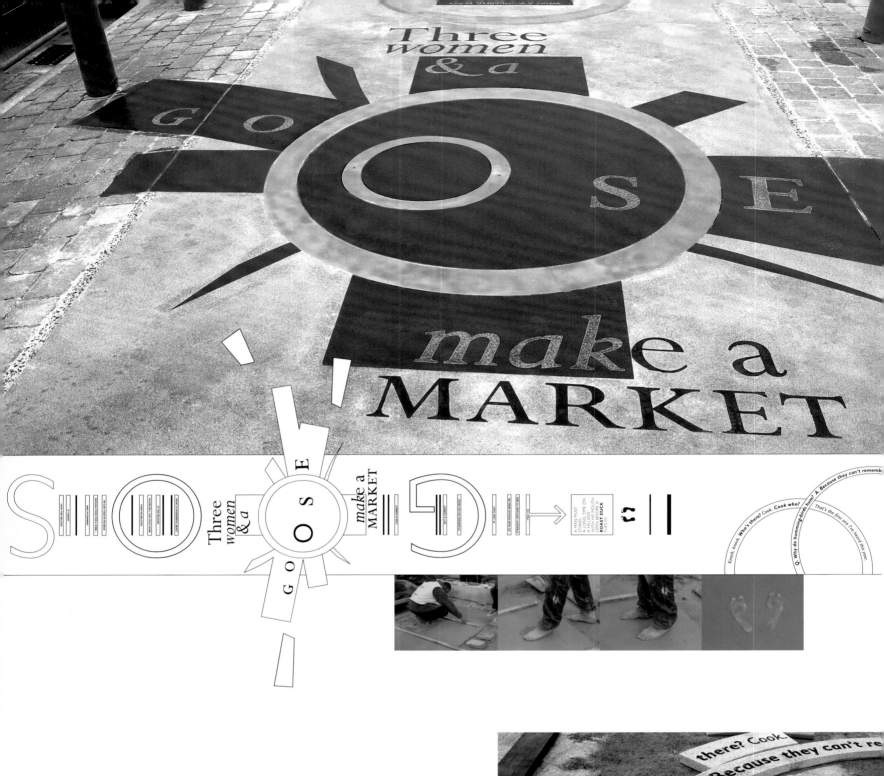

Three
women
&a

G O
O
S E

make a
MARKET

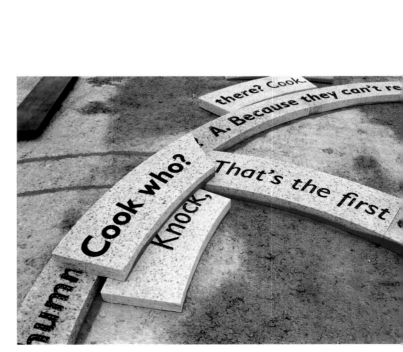

Cook who? A. Because they can't re
humn Knock, That's the first
there? Cook.

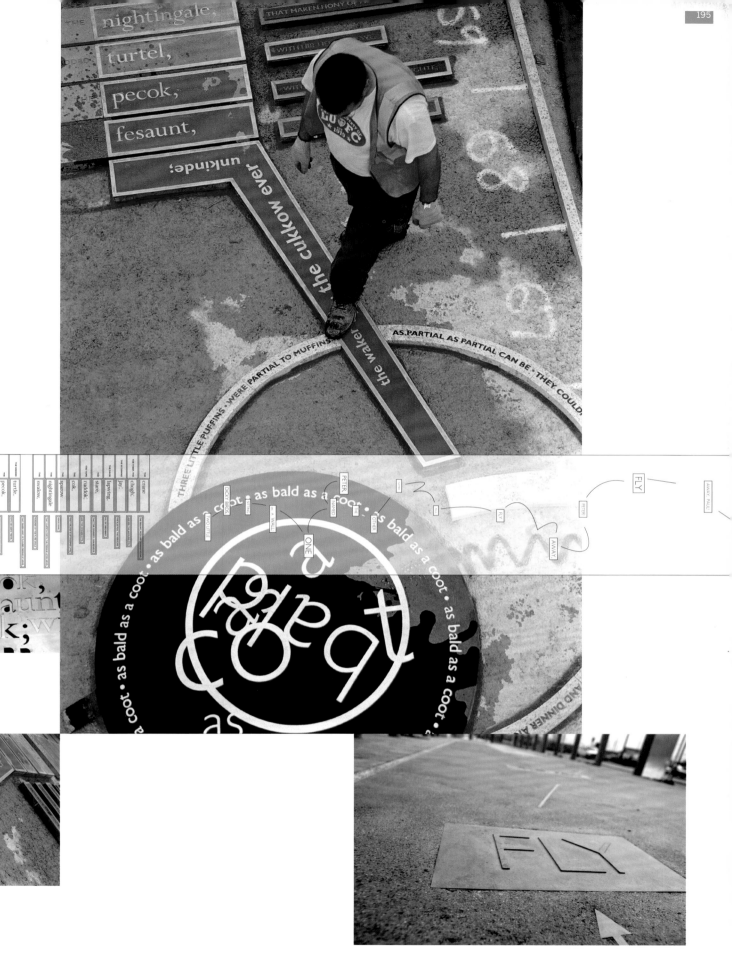

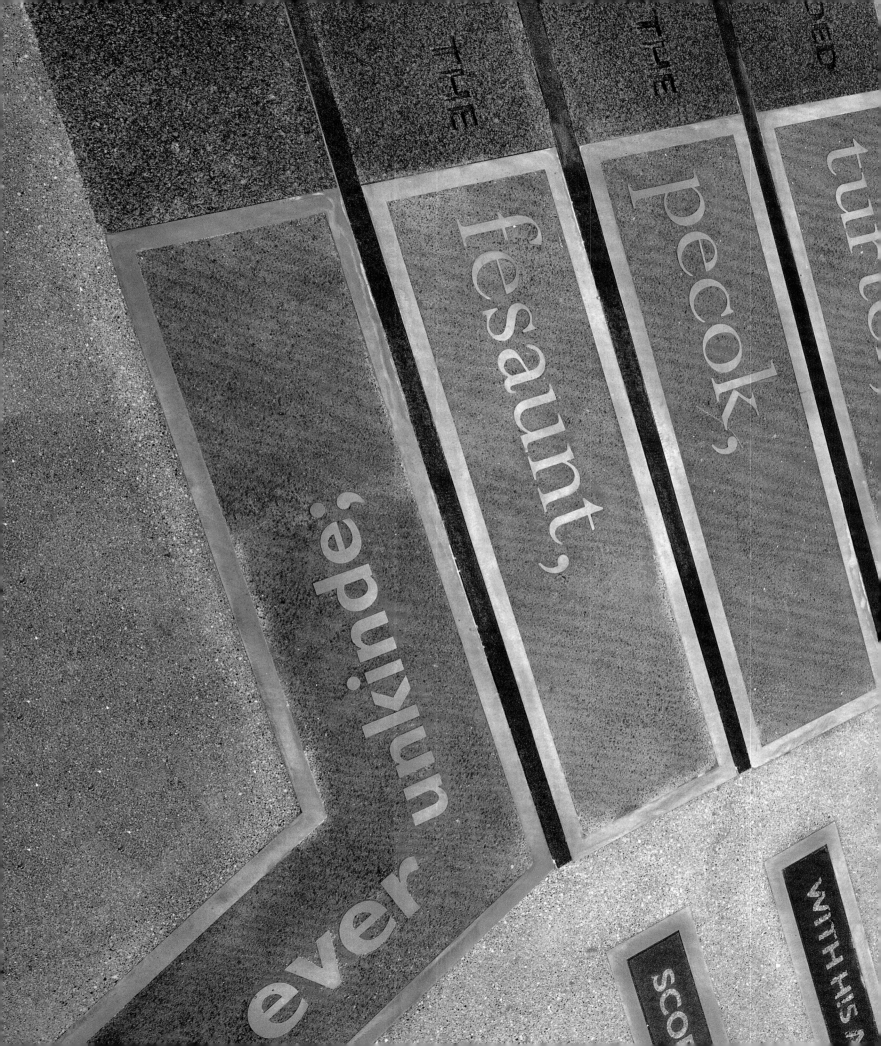

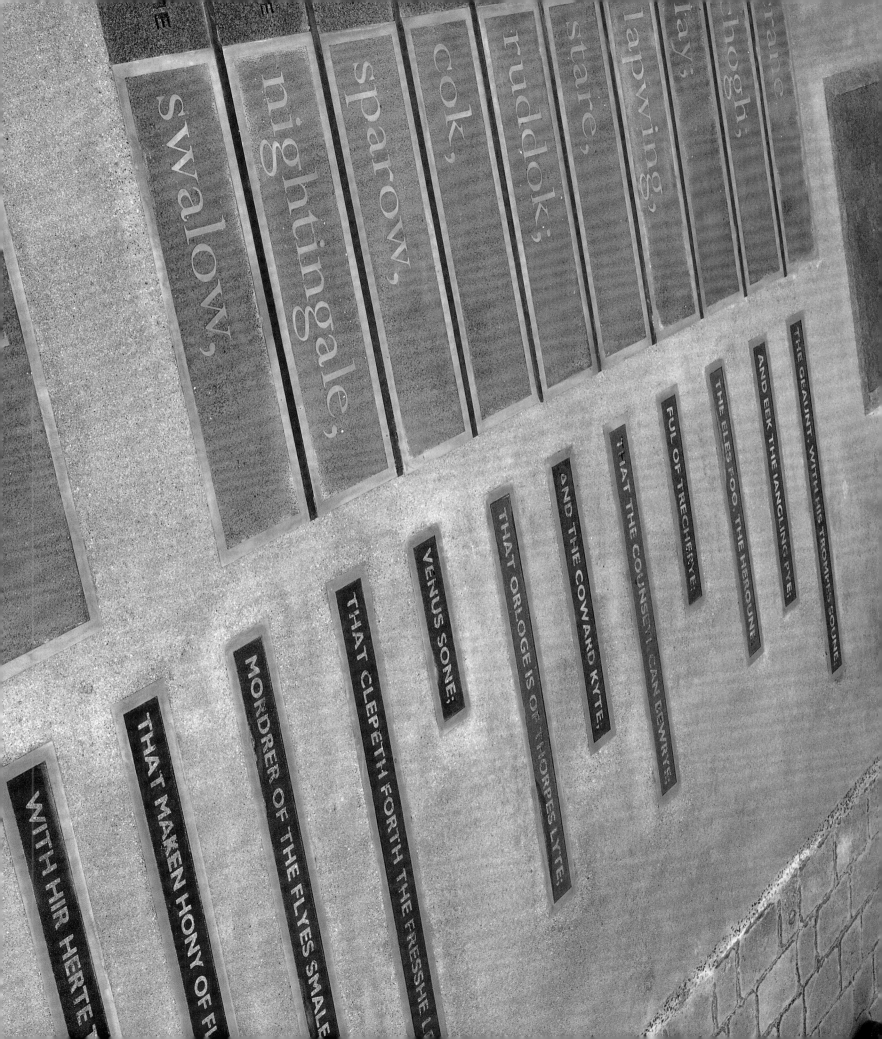

swalow,

nightingale;

sparow,

cok,

ruddok;

stare;

lapwyng,

Iay;

hogh;

rane

THE GEAUNT WITH HIS TROMPES SOUNE

AND EEK THE IANGLING PYE;

THE ELES FOO, THE HEROUNE;

FUL OF TRECHERYE;

THAT THE COUNSEYL CAN BEWRYE;

AND THE COWARD KYTE;

THAT OR.LOGE IS OF THORPES LYTE;

VENUS SONE;

THAT CLEPETH FORTH THE FRESSHE

MORDRER OF THE FLYES SMALE

THAT MAKEN HONY OF FL

WITH HIR HERTE

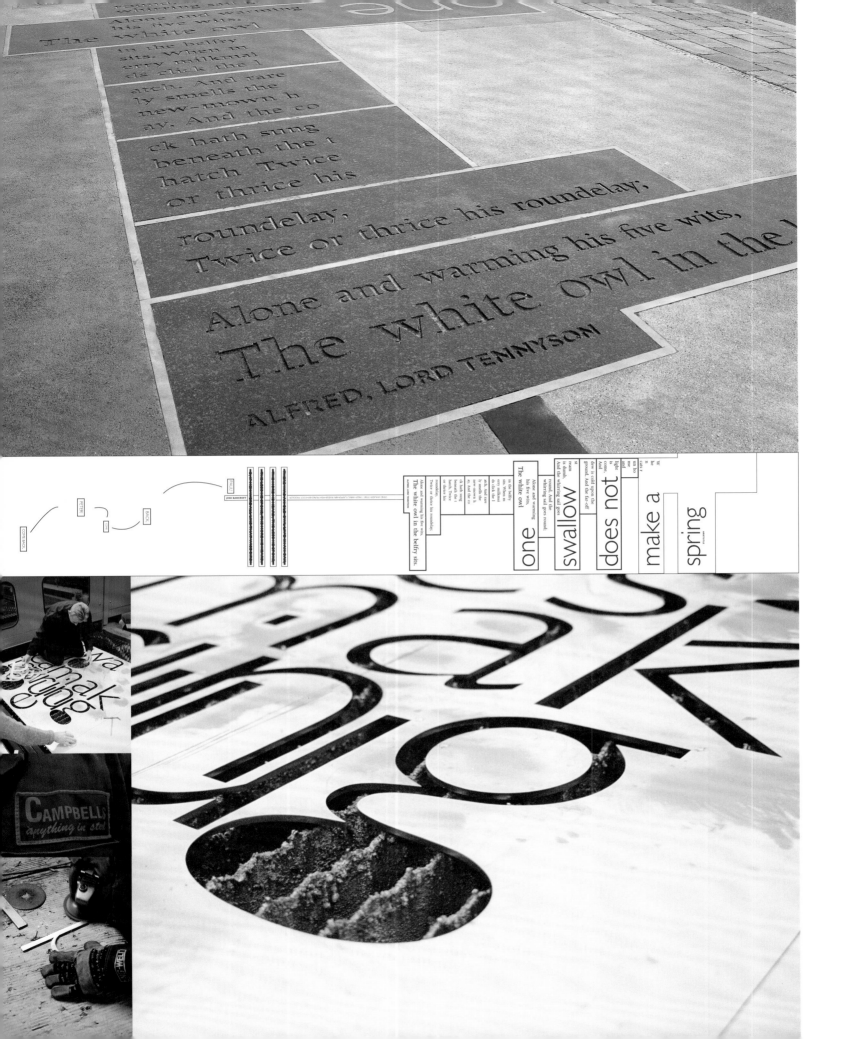

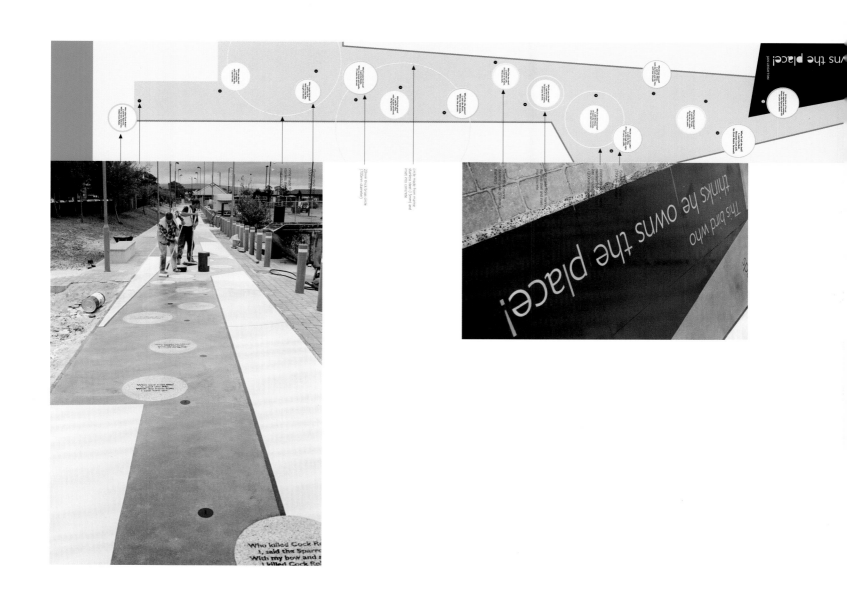

This bird who owns the place!

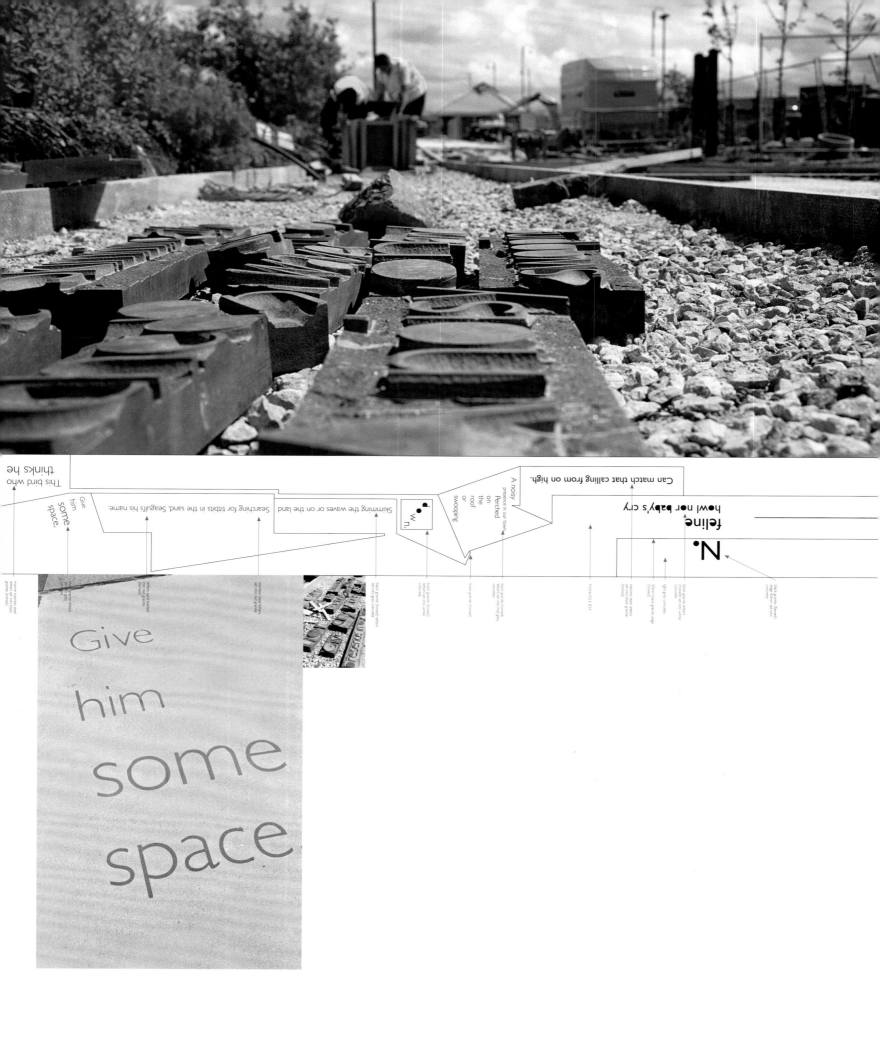

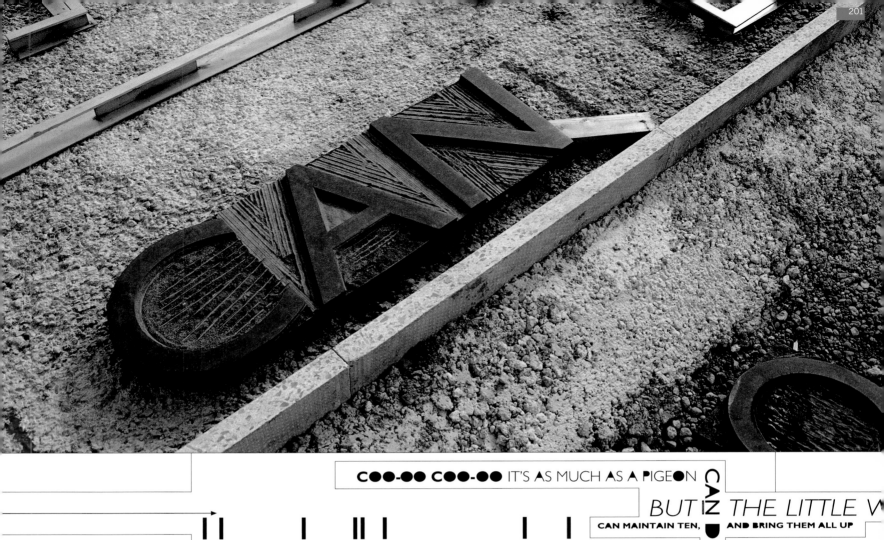

COO-OO COO-OO IT'S AS MUCH AS A PIGEON CAN DO

BUT THE LITTLE W

CAN MAINTAIN TEN, AND BRING THEM ALL UP

LIKE GENTLEMEN

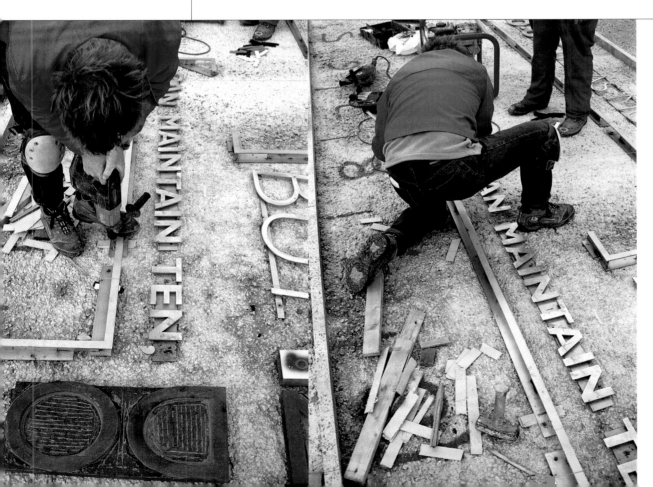

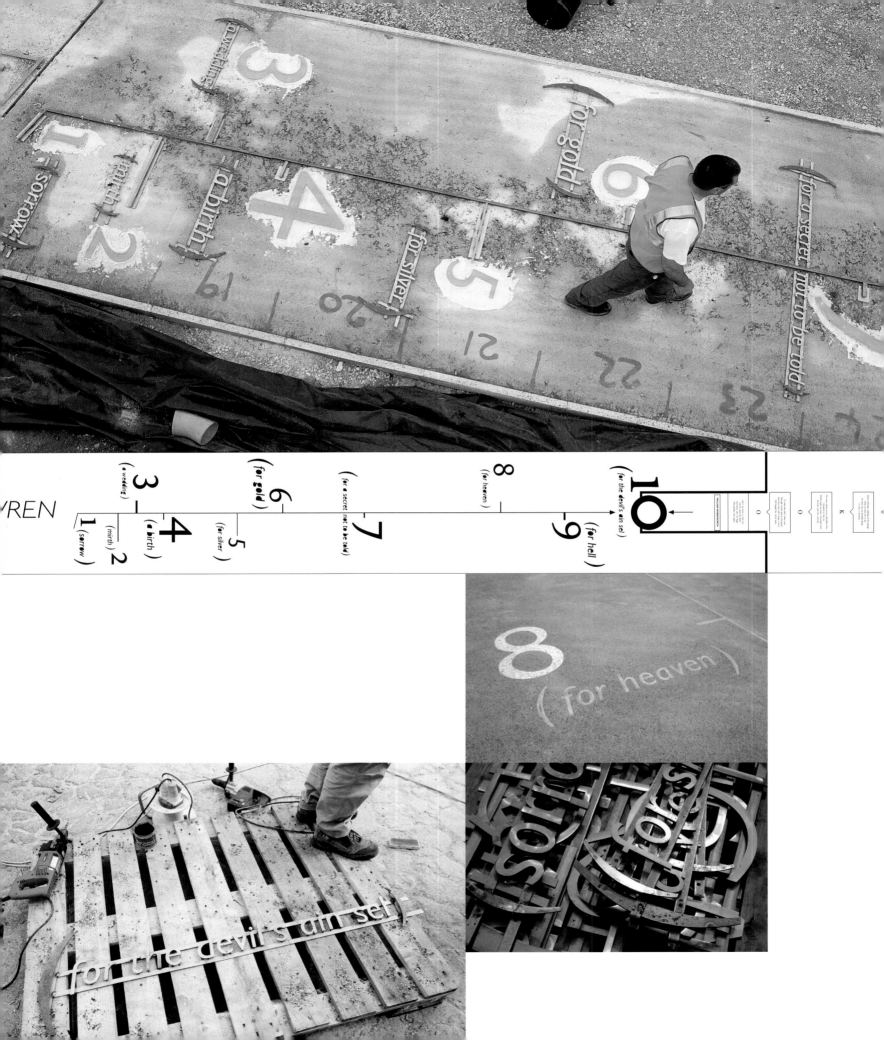

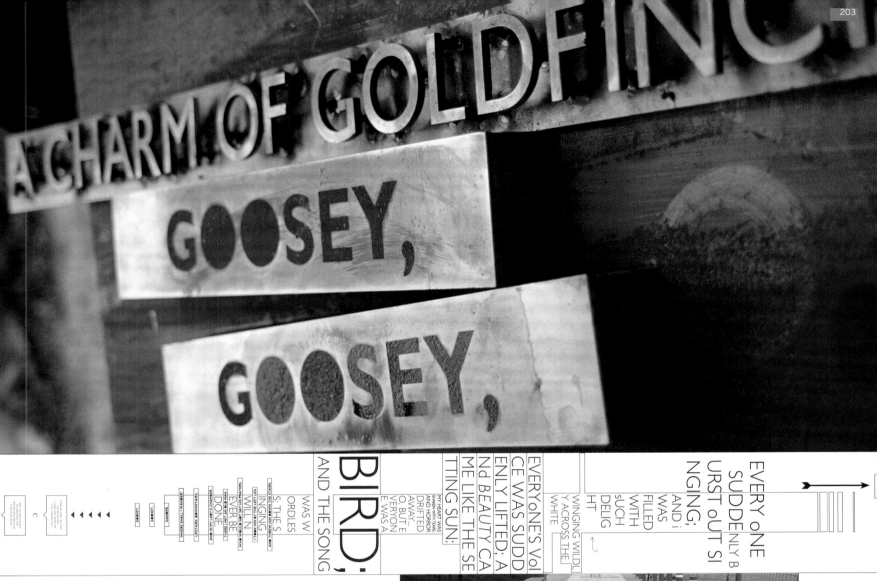

A CHARM OF GOLDFINCH

GOOSEY,

GOOSEY,

BIRD; AND THE SONG

EVERY ONE SUDDENLY BURST OUT SINGING; AND I WAS FILLED WITH SUCH DELIGHT WINGING WILDLY ACROSS THE WHITE EVERYONE'S VOICE WAS SUDDENLY LIFTED; AND BEAUTY CAME LIKE THE SETTING SUN: MY HEART WAS SHAKEN WITH TEARS AND HORROR DRIFTED AWAY... O, BUT EVERYONE WAS A BIRD; AND THE SONG

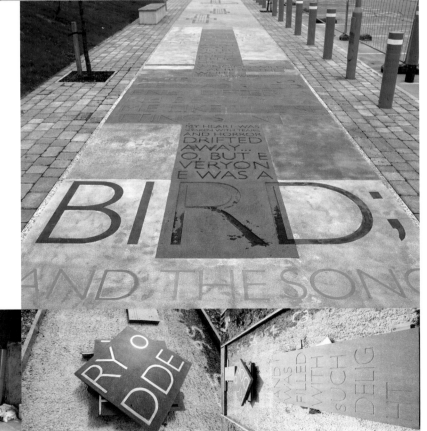

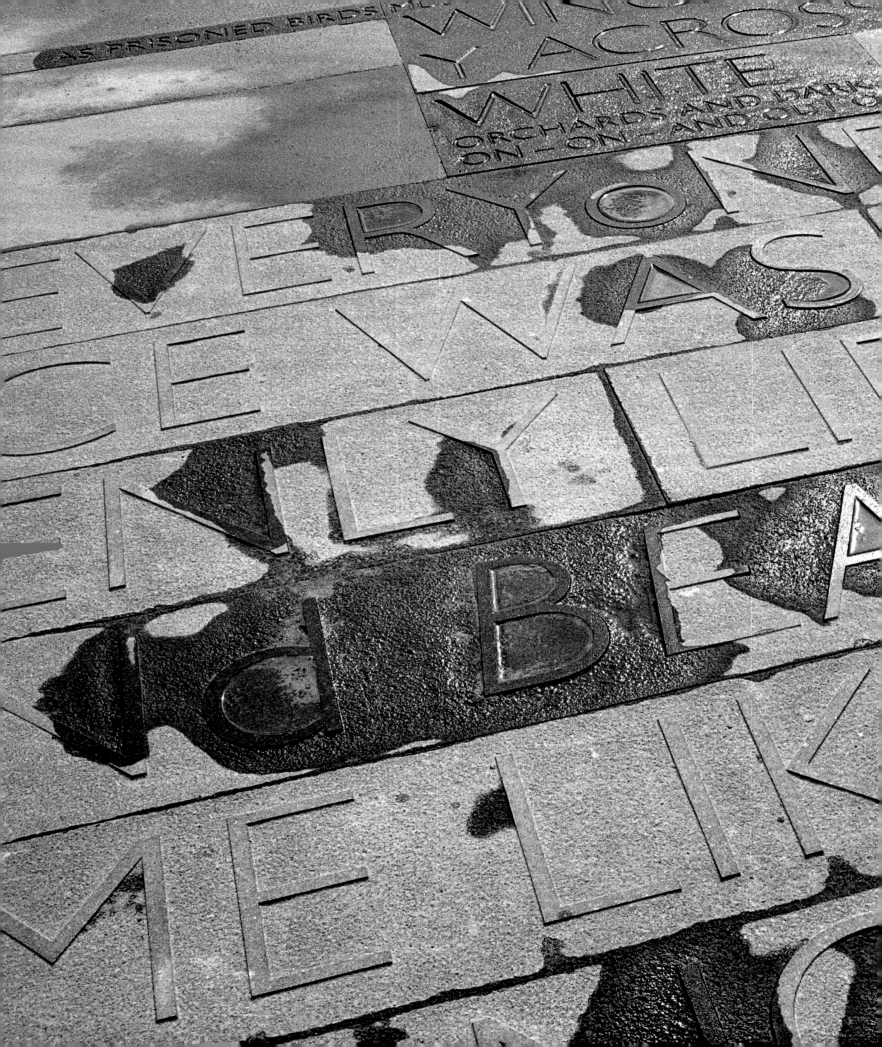

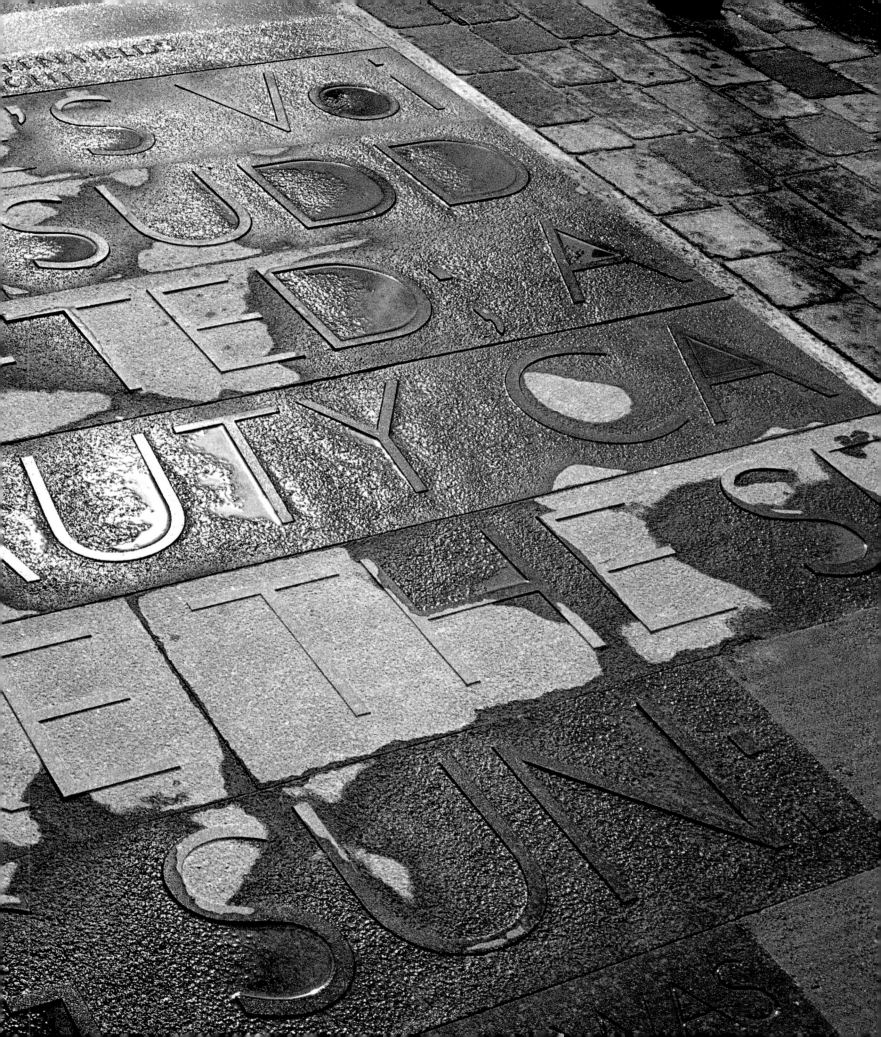

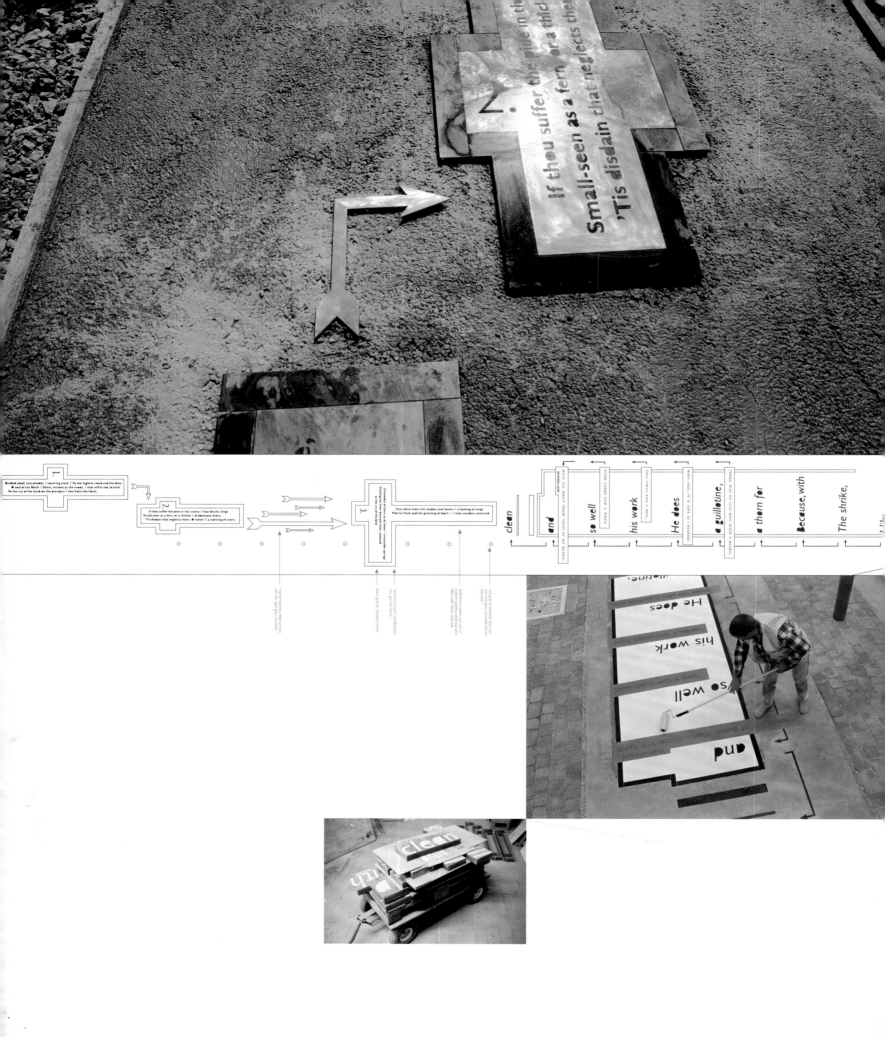

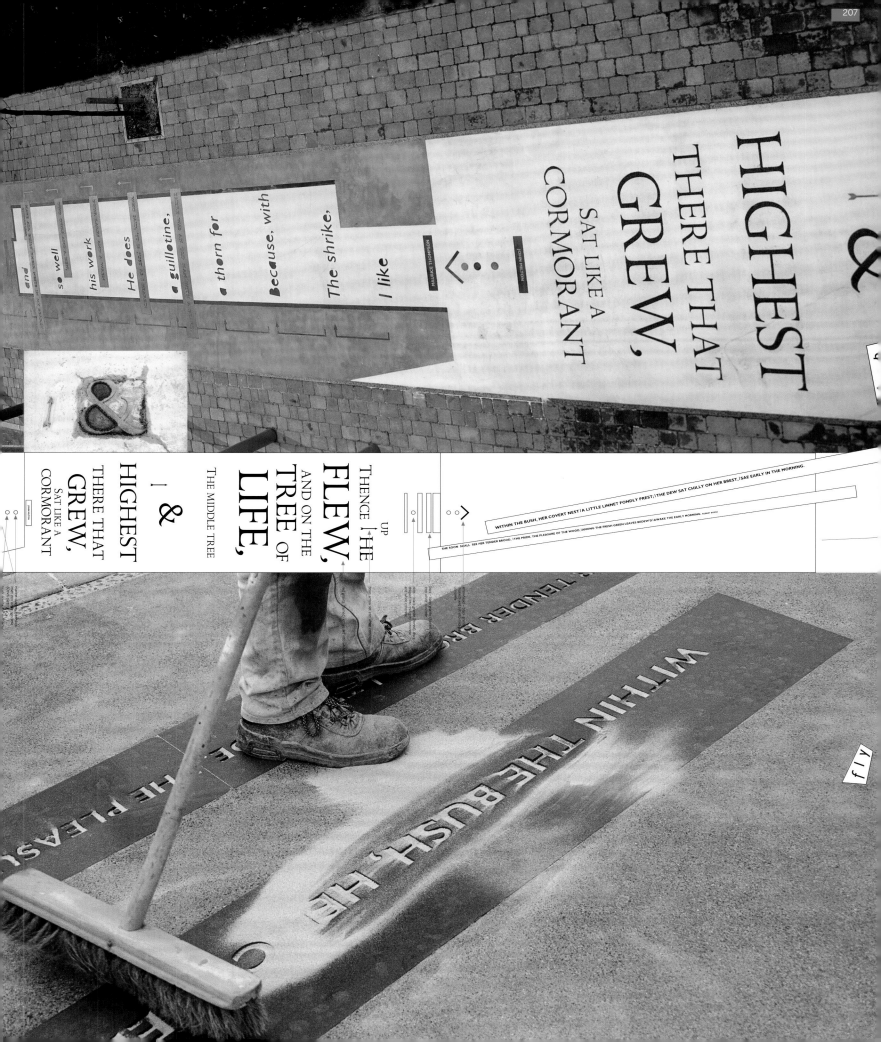

fly

flap

flutter

flutter

"

flutter

flap

flutter

flutter

"a flock of words"

finally... a big thanks to all our families, friends, collaborators and clients –
we won't list you all, as we forgot to include a few people last time and even
managed to spell some of your names wrong!
w.n.a.